How to Become
A Famous Artist

And
Still Paint Pictures

By W. Joe Innis

EAKIN PRESS ★ Austin, Texas

TO THE READER:

The use of the neuter pronoun "he" is not intended as a political
or sexual statement, an argument the author would have trouble
making if he had to choose between he/she and she/he.

Also by W. Joe Innis:
In Pursuit of the Awa Maru
The Better Times

*This is for Suzi, whose idea it was to write such a book and who has long been the best part of "The Better Times."
And, of course, for Sunny.*

Don't expect coherence when a painter tells you what he does for a living. He's not good at coherence. He's good at painting.

Contents

Preface

I'm going to be straight forward with you as I spell out your trip, your road to success and everlasting fame as an artist. So, I've got to say something to you up front: Once you get down that road, once you achieve the goals you're setting for yourself now, or resurrecting the ones you've harboured from your disastrous past, once you arrive, you're not going to be all that happy. In fact, there are days you're going to be downright disappointed.

I know that's hard for you to believe right now, but trust me — even as you continuously upgrade and achieve your goals — you're in for a letdown, and I feel obligated to warn you so you're not blaming me for what happens to you once you get there.

Here's some of what you're going to find:

— Though you're painting full time now and have left that nine-to-five job far behind, a lot of day-to-day stuff is going to get between you and your painting and you're going to get frustrated and you're going to yell at your family just like you did before.

— You're not going to believe how much day-to-day stuff there gets to be in managing a successful art business, and manage you must for no one can take your place and no one should, for you've got your paintings at stake and with them, as they say in the East, your face.

— You're going to worry about it all and not sleep as you once did. And that's going to make you as grouchy as you were when you couldn't pay your Sear's card.

— You're going to be surprised at how little anyone cares that you're a successful painter with shows all round the world. It's not going to change the way people treat you in the supermarket.

— You're not going to be able to keep your good paintings. Just as sure as you like them, they'll sell first. Even as you continually move the prices up on them in an effort to preserve them, buyers will ferret them out and they'll be gone forever. This hurts because, like me, I suspect you enjoy looking at your paintings. Perhaps nobody likes to look at them more. It's another one of life's injustices.

— You're going to have money to worry about. You're going to have accountants you don't understand and little letters from income tax people who express great interest in you and would like you to recount the details of the last three or four years.

And all of it is going to make you yell at your family more than you did. Or at least as much.

— You're going to remember back, before your life turned around, when you said that all you wanted was to earn enough money to continue to paint, and for it you'd have sold your soul, but nobody would buy it.

Take me. Here I sit in my studio just off a picturesque harbor on a Mediterranean island which some have described — perhaps rightfully — as the last paradise. It's a bright day in November, and I'm having trouble starting my next painting.

It's the money thing again.

I've got a canvas set up in my new crank-up easel, a great towering structure I had built from finely grained Swedish hardwood, a piece of poetry that would make John Singer Sargent pause. Though you can move it round the studio like a yacht rigged for full sails, I generally dock it under my old shop light suspended from the ceiling. Though I've got a lot of height in the room, towering windows with plenty of light, mostly northern, it's a matter of habit.

The stretched canvas is clamped into the maw of this beast and, since I work in relatively small sizes, it seems

somehow at peril of being crushed, chewed and digested by the two great timbers that secure it.

I look at it. It looks back. It carries a wash of sienna and maybe some ultramarine blue, the underpinnings for what may one day be my first painting representing my second price rise in a year. I had agreed to it only this morning. It was something my wife had been discussing with my agent since the recent multiple sale in Dubais, which resulted in the tragic loss of five good paintings.

I had agreed to their proposal because in order to staunch the outflow of paintings and keep everyone enjoying the inflow of money, a price increase was the best solution.

It's a small team that comprises my art business — three of us full-time — and since my part of it is inordinately important to the others, I try to keep my misgivings to myself. I try not to let on that for years I've been embarrassed by what the paintings bring in the marketplace.

I've got a collector friend in New York. He's a Madison Avenue lawyer with a Central Park East address, a couple of blocks from the Metropolitan. An amiable guy, he rose from humble surroundings. He seems stunned by his own success. I delivered another painting to him — over the years he has collected eight — and we were having a few drinks in his living room overlooking the park.

In a weak moment I admitted that I couldn't get over how much money my paintings were selling for, and it made me nervous.

"Nervous?" he said, shaking his head. "I can't get over how much I'm willing to pay for the things."

So the latest rise this morning makes what I get for paintings look like a bank hold-up, a feeling strengthened by what I'm told we're all living under: a world recession of historic proportions. I'm reading newspaper stories of the dive in art prices, galleries folding in New York, Paris, Rome, London with crashing economies in Britain, Germany, and Japan. Curiously, and within the last several months, I sold paintings in each of these cities.

But I'm worried now, looking at this yawning canvas,

that we've gone too far over the last ten years, that commerce has been the kiss of death. I haven't got the drawing yet and I'm thinking inventory, insurance, shipping, crating, what currency it will be paid in, what it will cost me or the buyer to get it in one I can use, what exchange rates work best, whether a bank transfer will get it where I want it, and how to keep it to a size that will not attract a drug investigation from Interpol. And I haven't even squeezed out my pallete yet.

It wasn't so long ago when I couldn't give my stuff away much less sell the lot for a month's rent. I suspect you know the feeling. And I'll tell you how I got over it. But first I have to fill in that empty canvas across the room, clamped there looking at me in what could become next year's entry in the America's Cup.

I don't want you to doubt that you're going to be successful following the path I blazed. But you will come to yearn for the days when you could find all your paintings safely under your bed or covering the stains on your walls. But I wax nostalgic.

And you'll worry what to do with this money. Don't shake your head. You will. Yesterday, I took my money out of the stock market, having read the news about New York. I put it in a money market account. I did this by fax. This is the third time this year I've done this.

My broker doesn't understand me. He sends me graphs and statistics and personal letters. He says I buy high and sell low and as a business strategy, it has weaknesses. He shows me how much money I lost. He encourages me in these letters to leave the stocks alone. He tells me I do too much reading and worrying and that I should stick to painting.

This advice usually arrives by post which is generally two weeks in the coming. It would be less if I attended my mailbox more regularly. I figure that in that time he'll have changed his mind. Even — at that moment — he might be composing a fax advising me to sell.

I've tried to be more patient, but I've taken to reading the business section of newspapers. I buy the *Financial Times.*

If you haven't heard, there's been a lot of talk about trade deficits recently.

To be honest that's not one of my favorite subjects and until the last several years it didn't occupy much of my attention. My main concern used to be centered around my desire to eat. Keeping a job was what mattered, something I was never very good at. And maintaining a wife who was demonstrating ever more visible tendencies to abandon her husband's poverty and unrealistic dreams for someone more inclined to pay the bills.

So this second wife and I spend the mornings now having coffee at the harbor, she, excited with our growing business and her part in it. I, glancing at the papers and composing in my head a new fax to my broker announcing still another shrewed financial decision or silently stewing about my agent who is getting rich from selling my paintings and what painting I'm going to lose next if I can't get her to slow down.

My agent is a high-powered self-starter. At least that's how the want ads I used to read would probably describe her. She speaks more languages than you can find on short wave. She faxes me from places like Ankara, Lisbon, Tokyo, and Milan. It's almost always about sales — will I take this or that for a painting — almost always bad news.

You'll get one like her. You may be surprised to learn that you'll have to train yours as I did mine, because established dealers — including most major and minor galleries — don't know how to sell art.

But don't despair. I'll teach you so you can teach your homemade dealer in a way that he or she will believe you knew it all along. And then *you* can start losing paintings.

Don't get me wrong. You could do worse than learning what I have to teach you. There are worse things than being a successful artist living life on a Mediterranean island.

But if I'm going to tell you everything, first you're going to hear about the pigeons.

I didn't know they came with the house. We moved from a less suitable place last spring, also in the heart of downtown

Kyrenia, a harbor village that mostly sleeps at night and wakes to the roosters, which is more or less my schedule. We had enough international moves behind us to know that, however picturesque the setting, a house out of town means driving into town. Forever driving into town. In town we've got markets, fresh fish at the doorstep, and a hotel we can drink coffee in and observe the undying ways of the British colonialists when we want to test the accuracy of Somersett Maghaum. Of course there is the proximate supplies of a local gin made passable more by its label — Lord Jim — than by its dubious contents.

The house had been unoccupied for months so the pigeons took our moving in as an affront. They had long since taken over the house next to us, having broken through the windows on the second floor. They were intent on doing the same to this house. It brought the horror of Daphne du Maurier's "Birds" to life in a way Hitchcock failed.

On the first morning the pigeons collected, jousting for space on the transom window over the balcony doors at the foot of the bed, shifting silhouettes in the rising sun.

They cocked their heads, preened, and jabbed at the glass with their beaks, while breathing laboriously in a chorus of obscene coos. Others came and fought a flapping battle for purchase and position. They wanted a better view of the room and those in it.

A thin pane of glass stood between the flock and our bed. A buck pigeon drove in on rusted wings. There was a flurry of feathers and several gave way with injured complaints. The buck eyed me and blinked. He leaned back, the malevolent eye still on me where I lay. He hammered his beak into the tentative glass. It trembled but held. Then, as on command, he and the rest of the birds fled with a thunderous flapping like wind in a loose sail.

Later they stood murmuring and chattering on the roof ledge across from me and watched as I pounded long nails into the wood of the transom and wired their roost against their return. They watched me shovel a half-inch of guano off the balcony porch.

The old man across from us, the one who had allowed them to turn his second story into a roost, has the Ladies and Gentlemen's toilet concession on the seafront. Whatever he earns he sinks some of it into pigeon feed, which he scatters liberally on the street in front of our houses each morning, either to appease the creatures against breaking into the remaining part of his house or because he's partial to squab.

From all their roosts they descend at once upon the feed. They mill. They strut. They coo. They make their little asthmatic noises. They eat. They defecate. And then by some predetermined signal they're off.

Sometimes from the window ledges of my studio they watch me paint. Silently at first. I know they're behind me because I feel watched. When I ignore them they begin their heavy breathing with that clucking undertone. As they get more excited, the tone rises. They loudly respire, dragging the air through tremulous throats. Then, simultaneously every pigeon in North Cyprus takes flight.

Reluctantly, I've become a student of pigeons. This is sadly curious as I started my art life as a sculptor. And anyone who has ever valued an outdoor piece of sculpture will understand the sculptor's inherent disaffinity for pigeons. Though my medium has changed, my enmity has not.

So we pass the days together, these creatures and I. I paint at my easel, and they do what pigeons do.

What I've noticed is that pigeons don't do anything, mostly, but whether they do anything or not, they need to do it together. They need a whole lot of company around. They spend the day in a great crowd periodically hurtling themselves off the top of one building and, just before they dash their tiny heads on the street below, desperately beating their way up to the roof of the next. There they'll squat iridescent, noisily catching their breath. Then, and at once, they'll do it all over again.

They'll do this all day long.

No pigeon leads the way. If there's a signal at all, it's an involuntary shudder just before the group, as one, is catapulted into space in a whack-smack of a thousand wings.

The pigeons you see flying singly from building to building are not leaders, as I once thought. Careful observation proves they're just catching up to the others. They were asleep when the train left.

In the evenings, just before sunset, they'll pair off to make little pigeons.

Another thing I've noticed is they're hard to dissuade. They still flutter and dance at the bedroom window even on the heads of newly installed nails. They play the wire like a harp. They're once again fertilizing the balcony floor.

I'm not an ornithologist, nor have I taken the interest Michelangelo is said to have expressed in the bird, but where I live it's pretty hard to avoid thinking about pigeons. No matter what you're doing, you're doing it in concert with the pigeons. And always in the background there's that throaty, warbling sound they make, like old ladies singing in a distant bathtub. You paint to the cresting passions of the birds' soft coos, their muffled cries for help as they scrabble for footing at the rain gutter.

It's bound to have an impact.

I'm not saying I've grown to like them any better, but then I don't like them any worse. What I've come to do is accept pigeons for what they are, which seems reasonable enough, and for what they do, which is (when they do anything at all) pretty predictable.

So, naturally, I began drawing parallels between pigeons and people, who, on the whole, are also a fairly predictable lot. When I thought about it, those engaged in the arts were no less predictable than anyone else, despite — or maybe because of — their efforts to the contrary.

Particularly, I noticed many behavior similarities among the great unwashed population of these birds and that other unwashed population, those who want to pursue life as artists. I thought it would be useful to point out these parallels as I went along, to underline the principles I want you to consider.

To make it easier still, I decided to warn you when I was about to issue one of these formidable insights. I thought I

would label them as **"Pigeon Factors."** As a further convenience, I've numbered them consecutively so that you don't get mixed up when you refer back, if that's the kind of person you turn out to be.

The tricky thing is that I start at **Pigeon Factor 51.** You're not to worry that you've lost some pages. I just figured there must be at least fifty of these things that I haven't had a chance to think up yet.

Introduction

I've never been a deep thinker. So far it has saved me a lot of time and trouble, allowing me to get on with painting, my mind pretty much unfettered by conventional wisdom.

One of a host of things I never thought about occurred to me while buying art supplies recently in Istanbul. Since I'm one of the few privileged painters to make his living at Fine Art, I'm in and out of art supply stores in a variety of countries in both hemispheres.

As you might guess one store looks a good deal like the next: logos of the big name art companies and their supplies from England, America, France, Italy, the display cases of paint and brushes, shelves of paper, fixative, varnish, the guilted pieces of frames on the walls, and the clerks who can't find anything. If it's any kind of store at all they'll use the word "professional" in a lot of their displays like professional brushes, permanent, light fast professional paints, and tested, top quality professional artists' canvas.

I ought to tell you, going in, that I don't spend a lot of money in these places. Though I paint full-time (when I'm not traveling or setting up still another studio) one can only use so much art material a year, so many tubes of yellow ochre, so much gesso, canvas, and the like.

The thought, therefore, was this: Who buys all this stuff? Take England and America. There must be thousands of art stores, branches of stores, shopping mall stores, warehouses peddling barrels of supplies, discount stores, mail order stores, book and drug stores with art supply sections,

department stores devoting a quarter floor to the stuff. All seeming to do a pretty brisk business.

They can't be making much money from the professional artist. You're interested in art. How many of these guys, these self-supporting artists have you met? I'm not referring to those with private incomes or personal fortunes or generous spouses or those who haven't yet been nursed from Daddy's collection of credit cards. Nor am I speaking of those still squeezing grants and aids from withered governments with ever-constricting budgets, or from overloaded private agencies. Nor from those who would have you believe that they are professional artists. After some thought you should come up with my answer: there are not many self-supporting artists.

If those of us who do support ourselves from the making of pictures, the professionals, were to divide up and adopt a store, each of us signing an exclusive buying agreement, there'd be hundreds possibly thousands of shops homeless. Those who got lucky wouldn't earn their month's electric bill from what we spend all year.

Talk to a supplier. If he's forthright he'll tell you he's not all that interested in the business that professional artists bring. He'll tell you the bulk of his sales come from those who aspire to be a professional. He'll tell you he makes it from the students in high schools, colleges, junior colleges, from universities, from night schools and private schools and classes in galleries and museums and in the back of shops and from those who are motivated enough to find the "How-To" section in the bookstore or library. With every class and every book there's a different list of needed supplies.

Of course the proclaimed hobbyist and Sunday painter constitutes a share of the supplier's business. But these are aspirants in disguise. Show me who among them is not yearning for recognition and sales and the day he will shed his title as dilettante. Show me one who does not call himself an artist, or want to.

So they come, these hopefuls. They buy. They dabble.

xviii

They quit. And for the supplier there's always a new crop sprouting.

What's wrong here can't be a news bulletin: While almost all those who buy art supplies aspire to a career selling what they paint, they have a better chance of finding a missing Gauguin lining the kitchen shelf.

Since most people give up pretty easily, my next thought was this: what do they do with their leftovers? Where are all the faintly dented tubes of paint, the fancy smocks, the sable brushes, the abandoned easels? And where are the dreams of those who bought them?

Sadly, I'll tell you. In over thirty years as a sculptor-painter, I've met 'em, I've talked to 'em and I've commiserated with 'em. Fortunately, I stuck with it, got lucky, and learned. I was a successful painter and they were cleaning pools, selling insurance, pushing buttons on computer terminals, operating burger franchises.

My sadness was compounded by what I knew and didn't say: I could buy their businesses with the sale of a few paintings.

They were friends and we went to school together and we stayed awake into the nights over wine, heady, less with the grape than with our ideas of painting and sculpture and history and how color was and behaved, each of us sure — absolutely certain — that we owned color in a special way. Over the years I met them. There was little to talk about.

Or they became teachers of art, these friends of mine, and there was even less to discuss, for they were the circus acrobats and had made that spectacular leap from learning to teaching, and they hadn't touched sawdust. Unlike the others, these friends did not avert their eyes or change the subject. They shrugged off the marketplace. They disdained commercialism. They spoke eloquently of the purity of art. With a salary, they could afford to.

"Then what do you tell them?" I asked the young teacher, head of the art department in a well-known university in America's romantic deep South. She kept shaking her

head. I persisted, "I mean, they finish here and then what? How can they practice what you teach if they can't earn money?"

"We don't discuss it," she said firmly. We were talking about her students after she had ushered me through her well-endowed painting, sculpture, and printing facilities. She and another faculty member held MFA's from Yale.

"How can you not discuss it? It's a part of life. How can you avoid it?"

"We teach art here," she said sharply enough to discourage further question. "We don't talk about money."

Well, in these pages I'm going to talk about money. I'm going to show you how to earn it, because, if you're anything like me, you need to pay your way in the world. I'm going to teach you how to earn it directly by the best means possible — the sale of your paintings.

It's true. People still like art, and there are those with money to buy it. I'll show you how you can find them, and allow them to buy your paintings. Then I'll show you how your collectors will work for you and by accumulating them how the power of numbers will propel you to where you want to go, to however far you want to take it. You'll learn how to turn success into international recognition and more success. I'll teach you in the most straight forward way I know. I will not insult or confuse you with "Art Drivel," the speech impediment of those writers about art who are reluctant to descend to the level of us readers. These are the slick masters of contemporary art prose, the heavy stuff. You'll find a lot of it around.

Yes, you'll be asked to invest in yourself and in your talent. Brace yourself, I'm going to ask you to make some concessions to the marketplace. But I won't ask you to turn tricks. I'm not going to ask you to make flattering images of double-chinned matrons, nor to paint handsome, if slightly soiled, street urchins, sad clowns, breaking waves at sunset, or white poodles on black velvet.

Though I know it's a lot of trouble, I'm asking you to be

an easel painter, to use colors and brushes and paint things. And I want you to do this in the face of the last thirty or forty years of video art and performance art and installation art, all of which must be a lot more fun.

If you are a nonobjective painter, I'll not ask you to turn objective. If you're figurative, you need not become abstract.

I'm talking originals here. You know, single paintings, uncorrupted by limited editions and all the other factory stuff on paper that everybody's had their fill of.

I don't care what you paint as long as you apply your talent honestly and diligently and are smart enough to put yourself in a direction where you and success are most likely to collide.

I'll show you the path as I know it, where the boulders lie, the heavy grass, the snakes. I'll reveal it to you step by step, how you begin, and what you do after that. While I urge you to follow the direction I suggest, I also urge you to stray, to apply the advice I offer to your own needs, ideals, talent.

But don't get too far off trail. While I haven't found all the problems, I've scathed my shins on enough of them over the years as artist to save you some time and abrasion. If success is where you want to go, I've got a way for you to go. But you've got to give up failure. For a lot of artists that's pretty hard.

I'll take your questions and criticisms along the way because I've read some of these books too and understand your skepticism. There'll be a dialogue between you and me and you've got my word — I won't try to rig your questions, nor my answers.

I'm not asking you for a degree in art from a prestigious university, nor any particular formal training at all. However, you came to understand your talent — even if it is only the *sense* of knowing — you should feel obliged to yourself and others to develop it. And you won't do it eating cold beans from a can in a wintry loft in SoHo and fighting the world.

If you want to fail, you're going to do that on your own. But I'm asking you to give up failing as a lifestyle and with it

the image of the poverty stricken painter that everyone feels sorry for, if only because its a romantic myth that won't stand the scrutiny of history.

If you haven't started, I'm asking you to begin. If you began once, I'm asking you to take a look at what made you stop.

A good deal of what I learned and will pass on to you I freely admit stealing from countries I've been banging around in over the years; some of it I lifted from the age old philosophies of the East — in Korea and Japan — where my three-month visit became five years and an important turning point.

My job is to help you recapture the dream that led you to buy those first colors, to fit that first stretcher, to face that first milk-white canvas. I'm hoping to get you up in the attic, to uncover that old box of supplies you'd stored, to see what you can still use and what more you'll need.

Remember the arrogance of the ambition you once had? How you liked it all: the paint as it roiled from a buckled tube, the drum of a taut canvas, the sweep of a well-worn brush, how paintings were almost always wrong until finally and surprisingly right.

Life is like that sometimes.

PART I

PAINTING

You've seen the photographs. We are to believe that an artist is unable to paint unless he drips some of the colors on his smock, his shoes and in his hair. Whatever else his merits, grant him this one: It's not easy to get paint in all these places.

1

Chapter I

How to Begin as an Artist

irst. Stop fooling yourself. You're either going to make this work or you're going to damn well forget about it. You've got your family, your relatives, your friends, your dog. They're behind you whatever you're doing. You don't have to be an artist to get their attention. They've heard the talk and they no doubt have figured that, like soiling your nappies, you've outgrown painting, or will some day.

And you've got your job, such as it is. You've got credit cards, mortgages, a car that needs work, your fortnight's vacation already booked with a cancellation clause running against you, and a boss who depends on you, right? You can't let old what's-his-name down. Not in the way that would cause him to dump you if he needs to.

And let's think about the children. There's an excellent chance they're not thinking about you. How can you do anything until they've grown up? Don't we have to sacrifice ourselves for the children, give them the best schools, opportunities, gym shoes? Give them what we didn't have, right? It's written somewhere, isn't it? Somewhere it's etched in stone that you defer your ambition for theirs and they, in turn, for

the little wretches they will one day bear. You don't need to be an artist for them. Just keep the refrigerator filled.

So stay with what you've got. Don't rock the boat. You can still dabble on your day off, between phone calls and errands, after the week's groceries have been put away, and the lawn's been mowed to your neighbor's satisfaction, and after you've taken the car to the shop and stood in line in order to be sassed by the guy who may fix it, maybe, if he's got the time, which he tells you he won't have if he has to stand around answering frivolous questions like the one you voiced.

And you can still read art magazines and advertise your choice of subscriptions by leaving them around on the coffee table when you have your friends over. They'll put two and two together. They'll remember that you once wanted to be an artist. They'll see that you've still got those paintings up that you did in art college, the ones, years ago, they had told you they liked. Remember how they told you that? And after they left, and when you went back to the paintings one by one, they didn't seem so bad. Though your friends haven't said anything recently, I'm sure they haven't changed their minds.

But I'd take down the painting at the office. Old what's-his-name wasn't much impressed anyway the day you brought it in, though he did tell you he liked the mood. Remember, how you had to look at him to see if he was serious? Mood? This guy's got the sensitivity of a clam. This is a guy who still uses "bottom line" and "level playing field," and he's talking mood.

So I'd take it down. It makes him nervous, anyway. If you paint like that, one day you may run off to color sidewalks for wine money and it'll be three days before he can get a replacement. So give him his "level playing field." Take the painting home. There aren't all that many collectors that come to the office anyway.

And don't talk about your art ambitions anymore. Settle in for the long pull. Go for the pension. Don't get folks all hyped up about what's going to happen once that

museum fellow offers you a show, and those people who told you they would buy a painting from you finally show up in substantial numbers, and the magazine on your table does the spread you're sure they'll do once they see the talent that should be obvious to anyone, after you do some more painting, which will be after the kids leave home.

Anyway you'll retire in twenty years. At half-pay and with some insurance and government benefits you'll have a base for launching your career. With the kids grown and all. That's how you got it figured, right?

Launch? You won't be able to launch yourself out of bed in the mornings after twenty years with the "level playing field." Face it. Those kids are welded to the fridge.

So forget the dream. Do yourself a favor. Give this book away. It'll only get you stirred up, and that's not going to help what's-his-name's bottom line. He's going to find this book in your desk drawer and he's going to blame me. And I'm not liking this guy any more than you do.

Those somedays make for good cocktail hour chat and little else. Once you wrap yourself around a martini or two they seem near, those foggy images, those distant hills. So you've taken to spending more of your after-five talk on it and less of your spare time with it. Each time the talk is a little harder to resurrect.

Here's something I'd like you to consider: You can't be an artist without also leading the life of one. Now, there are some problems with that. The life of an artist — particularly in the formative years of his work — isn't easy. There's no participation with the rest of the world. It's life on the outside looking in. But it's focused, and paintings reflect that focus. That single, to hell with it all, mindedness that constitutes an artist's life and the singular drive behind it: his need to communicate what he feels and how he feels about the things he sees.

No, I'm not asking you to dump the kids and give notice at work so you can move to SoHo. You don't need SoHo, the Left Bank is history and nobody can afford the Ginza. You don't need them now. You won't need them

ever. What I'm asking you to do is own up to what you've been talking about through the years. Do you want to continue to talk about it or do you want to do it? You choose. Then leave yourself alone.

"OK," you say, while thinking maybe I can sort of sneak up on this thing, without disturbing anyone or raising expectations or causing others to believe that I'm not doing the sensible thing or risking my reputation for toeing the line despite this penchant for drawing and picture making, which everyone agrees I ought to do something with as long as what I do with it does not interfer with my relationship to those who make the suggestion. I'll continue to take my place in volunteer committee meetings, planned camping trips, and bowling nights.

If you're serious, you must break from the flock. You must do what pigeons don't, bringing us to **Pigeon Factor 51:**

> Pigeons are not known for their independence. The only
> time you'll see one alone is floating face up in wine sauce
> as a main course for two in a pricey restaurant.

There's an Eastern saying (maybe Zen) about sneaking up on a butterfly which would apply here if I can remember it. Better to stand still, it goes, and allow the butterfly to land on your shoulder. Like a lot of sayings it's half right. What's right about it is that it's tough to sneak up on butterflies. What's wrong about it is the standing still part. You're not going to get any butterflies that way either.

Likewise, you're not going to sneak up on a life of art, and it's not going to sneak up on you if you stand around and wait for it. What you do will have consequences, and you'll have to own up to the fact that as your life changes the changes will effect those around you. Even if you tiptoe through the tulips you'll still be tramping on flowers.

Make a decision. Go find a mirror. See who's looking back at you.

Before you commit one way or the other, take a weekend off. Go somewhere you won't see people you know. If possible, go somewhere you won't see people at all. Go to

5

the woods, a lake, a mountain, a desert, the ocean front. Check into a cabin. Get one without a TV, or if you can't, unplug it and lock it in the closet. You don't want the glassy stare of it breaking into your thoughts.

Go for walks. Start early in the morning and take a sandwich. Treat yourself to the luxury of being a first-class grouch. Don't talk to anybody, however friendly. Sit in the dark at night. If you know how, meditate. If you don't, talk to yourself, or just listen to the silence.

Ask yourself what you really want, whether you believe that you can achieve success and whether you're selfish enough to put yourself and your ambitions *ahead* of those who want something from you and expect you to be what you've always been.

These are, like all conflicting desires, hard decisions.

Ask yourself: is my life as I've lived it a lie, or is this thing I've been talking about, working myself and others up about, merely a dream? You can't have it both ways.

If you make a decision early, wait out the weekend. Reinforce it. Remember, you're going to check out of the cabin either as an artist or as someone who will never be an artist. There's the good and bad of it however you choose.

If you decide in favor of those around you, break out the TV. Crank up the game shows and the all-night movies. Get yourself a big bag of potato chips and some heavy beer. Get to chatting with those around you. Call home. Have a party.

When you get back home see if your bookstore will offer a refund for this book. Let this be the last day you delude yourself or others.

If after two days of serious and singular thought you've made an honest decision to begin a difficult but fascinating journey, if you've promised yourself that from this day forward things and your relation to them will change, that art and your painting will take precedence even as you face hardships, read on. You're the one I want to talk to.

If for any reason short of World War III, you feel com-

6

pelled, for however short a period of time, to turn on the damned TV, it's all over. You're fooling yourself.

Now that we got rid of that crowd, we can talk. Affirm, confirm, reaffirm your decision, but don't go back on it. Don't look over your shoulder. That's where you've been. Look ahead. You're going to need all the forward momentum you can muster, and if you're looking back you'll only fall over something.

Don't ask others what others think. Don't ask whether you'll fit in, for you're alone in this. As an artist you'll be as alone as it gets. You've chosen to be an artist. There aren't going to be any meetings or election of officers or summer picnics. You've got to blame or praise yourself.

If you made your choice based in part on a precocious ability with a pencil or brush which set you apart from others as a youngster and channeled you into art classes and got you sprung from Algebra when a poster or the set for a school play needed painting and if you spent your school years using teachers as models for hideous caricatures or if you made drawings of the class sweetheart with endowments she couldn't hope to attain, you'll be in the good company of many master artists. If to this day you haven't picked up a pencil or brush with artistic intent, you're also in good company, for just as many artists didn't get early encouragement or deserve it. And there are some pretty notable late bloomers.

Despite claims to the contrary, there are no little Mozarts or the equivalent of three-year-old concert violinists in the visual arts. Little Picasso did not cause his old man to throw down his brushes in despair when confronted with the talent of his son, though the story's a good one. Since the genius of this great artist was also a marketing one, I suspect he helped such a good story along a little.

My story may be closer to yours.

Her name was Veronica and she was, as they say, a mere slip of a girl with blue eyes and cotton socks. I had the great good fortune to draw a seat next to hers in the first days of kindergarten. It was my fortune, not hers, for she ignored

me totally. She opted instead to share her attention with the boy on her immediate right.

The hilarious noises I had during the summer perfected by blowing against my wrist were met with an arched brow and a straight face. As was the clever way I drummed at the back of her chair with a ruler.

When the teacher distributed an outline of a farm — a barn, a couple of trees, some hills, the sun — for each of us to color, I sought to dazzle my reluctant friend with the surety of my talent. We were to share the same box of crayons. She bent to it immediately, her face a lopsided study of intensity, as she began the red of her barn. I chose a warm yellow. At least she had stopped talking to the kid next to her.

At five years of age I had not yet done a lot of work in this medium. I did not own a set of my own crayons. On the few occasions when I had shared a coloring book with a playmate, I had come to learn that my strength lay in speed and a certain carefree line. So I fell to the competition.

I won handily. Looking around, I had beaten the entire class. It only remained for me to claim my victory by stretching, expelling my breath noisily while saying the word "done," then settling in with my seated tap dance routine I'd also worked on during the summer.

Veronica, I noted, was still working the side of her green crayon along the hills behind the barn. I had wisely considered the lines of the hills as nothing more than low clouds and since it all could be considered sky, had not bothered to differentiate. Throwing the sun in as well, I had done the whole thing with the end of a thick black crayon, which set off my yellow barn nicely, though it rose a little high.

The teacher brought our two contrasting styles to the front of the class to illustrate a point. Clearly, we were set off from the rest of the class: two hitherto unrecognized talents facing the philistines back to back. I glanced around Veronica just to see the look on the kid's face on her right. He wouldn't even look at me. The teacher chose to start her praise with Veronica's drawing, holding our papers side by side. It seems Veronica had conformed to the principles of

recognized coloration — her blue sky, blue and her red barn, red. She also had paid tribute to the lines. Her work, the teacher told the class, represented a careful attention to detail and had therefore earned the visual rewards of hard, honest labor.

For the first time Veronica looked at me. It was not the look I had expected from a fellow craftsman. It was the same arched brow, this time with a smug grin.

Curiously, the teacher found no words to express her feelings about my drawing. She deposited it instead in the wastebasket as she made her way to return Veronica's. She brought with her a damp rag which she gave to me. She asked me to clean my desk of the black marks that I suddenly noticed had exceeded the page in my enthusiasm.

This was fifty years ago. I would have earned far more credit for the drawing if it were done today. But then I didn't know how things would change. Maybe for good reason it was thirty years between that first effort and my next. It took me almost as long to get through Algebra.

In those thirty years I looked at and liked paintings. I read books about the arts and went to museums. I saw paintings as marvelous things other people did. Like Veronica, those who painted them were different from me. For thirty years I tried to look like a pigeon and sound like a pigeon, when all the time I was clearly a duck.

So if you made your decision despite an early disinclination to draw or paint, you're not alone. It will be painfully slow for you to learn. You will probably never be facile. And you'll find advantages in both these failings. You won't have an easy time expressing your ideas on canvas or paper. And if you're lucky, the pain will show as it does in Van Gogh's best work and as it doesn't in Sargent's worst.

A painting is a path. The mistakes, the bad ideas, should show. It is only partly the destination.

Chapter II

Why Drawing Still Matters

But it can't be all pain. And it will be unless you learn to draw first. If you haven't had an education in art, drawing is where you'll start.

You can learn this in one of two ways: you can learn to draw everything in the world or you can draw from the life model. Since it's hard to catalog everything in the world, I suggest you work with the figure. Nature endowed the artist's model with every conceivable drawing problem and an infinite number of positions with which to multiply those problems. But for the lascivious among us, you're in for a disappointment: it will become the single most sexless thing you've ever done. The most exacting, the most arduous.

And of course you're never done with a human figure. You must learn line, proportion, shade, perspective, foreshortening, the weight of the model, the turn of limbs, where the tense and relaxed muscles lie, how they change as the weight is shifted, how the model feels, and you must learn to convey it all within the limits of your drawing page — learning it all over again as you move from pencil, to charcoal, to conté, to ink and wash.

You're going to find that it's a lot of trouble to learn to

10

draw. You'll find that it's a lot of trouble to be an artist. It's easier to sell shoes. People need shoes. This is supported by **Pigeon Factor 52:**

> Pigeons don't do anything that requires a lot of effort. That's why they don't migrate to some place sensible when it gets cold.

You told me you were in this thing for the duration. So let's get into a life drawing class and stay in it until what you do on paper looks and feels like what you're seeing. You won't have to go far to find a class. Drawing classes abound, night or day, big village or small. Public schools, colleges, and junior colleges offer night classes. There are museum classes, club and art association classes, and classes you can join or form where the modeling fee is divided up among the members.

Ah, but wait. I see you shaking your head. You're not into this. You want to get right into the art part. You're New Age. You're burning up, you tell me. You've got things to say and you've seen enough of what's going on to know you don't need to be pushing a burnt stick to get there. Come on, you say, where does this dude get off telling me about drawing. Sure, the naked chick's OK, but get off my back with the drawing scene. That's history, man. I'm into the Now. I'm into what's happening. There's a parallel in sculpture. This one comes from another generation. The result's the same.

When I taught clay modeling and plaster casting in Mexico, I found there were many who did not like the working part of art. A woman I can remember is a typical example. I cast her piece for her because she was afraid to get plaster on her shoes.

She was about fifty with a strong nose and very little in the way of an upper lip, and she leaned a breast against my arm as I tried to explain the process. But she pretended not to understand. I showed her how to place the thin metal shims so as to divide her clay piece in two and then how to mix the plaster and how to throw it, cupping the hand and

11

flipping it backhand onto the clay. I told her how you had to work against time as the plaster would begin to set up and could not be thrown anymore.

But she would not take the bowl of plaster and try it. She was afraid she would ruin something. She had a ring that wouldn't come off, she said, and was afraid to dip her hand in the plaster. She had worked on the piece for a long time and was afraid she would ruin it in the casting. She stood in her embroidered pink smock and watched the whole casting process. I noticed that she stepped back when, with a sharp crack on the chisel, I broke the two-piece mold away.

Later, she had other reasons for not cleaning the clay from the mold, and when I had wired it together, poured it, and let it set, she was afraid to chip it out. She did not want to get pieces of dry plaster in her hair. Also, she was afraid to damage the piece. Even when I showed her how, if she handled the mallet and chisel correctly, the mold would break away evenly, cleanly, and if she did it the way I explained, there would be no cause for concern, the surface of the piece would be spared, she shook her head.

She did not want to do it. She did not like all the work of it. She told me that she was an artist, and as an artist she was more into the creative part of sculpture.

The New Age guy with no time for drawing, and this student have laziness in common. Worse than that they share ignorance, a stupidity their insolence prevents them from correcting. It is an ignorance that will condemn their work to shallowness, however much one may seek to lead and another to emulate.

Neither understand that process IS the product in art as it is in other important things, that the getting there is all mixed up with the tag end of it. In other words, the end contains the beginning and all else that contributed to it.

Most everyone has seen enough of a Japanese tea ceremony or films of one, to know that serving is more than being slung a mug of steaming coffee in a late night diner looking like something out of Edward Hopper. Is it the tea

itself or the process of serving that flavors it? It is both, of course.

So own up to it. You've got to learn to draw. For whatever you plan to do in art, you'll need the discipline drawing entails. Trust me. Wherever you're heading, it will strengthen the result.

So, OK, you say, but I'm not going to walk into a drawing class and reveal to God, the model, and everyone else that I can't make a straight line with a T-square. You won't need a T-square, and I'll get to this straight line problem. (I've got one that will put yours to shame. I'll tell you about it a little later.)

But you bring up a sensitive point, i.e., being sensitive. I suspect this is a disease which a great number of us in the art field quietly suffer from. We're not an outgoing lot, most of us. As a rule we don't talk much, and when we do, we don't do it well. We tend to fumble around with our speech, moving our hands when our words fail. We think as much, maybe, as the next guy, but we don't think it very fast. A casual conversation with us takes on a glacial pace. We get a lot of use out of beginnings such as "Well . . ." or "First of all . . ."

Rembrandt was so afflicted. One cold winter he painted through hunger and despair. The money was exhausted and there were no commissions in sight. His students had left him. At least one biographer was puzzled why he didn't call on the wife of a burgher, a strong admirer of his work, who had offered him a standing invitation to call on her if he needed help. Her house was less than a half-mile from his icy studio.

Was it pride? I don't think so. He could have accepted a commission from her or her husband. There would have been no shame in that. Rembrandt's problem is shared by many of us: we don't know how to ask for things. We haven't learned to gracefully bring a conversation to bear on our needs, to package what we want in social niceties. I can imagine Rembrandt mulling the possibility of visiting her and putting it off day by day. I can understand him and the way he would weigh cold and hunger against his making a

13

clumsy plea. I can imagine him turning back to his easel rather than face rejection, however remote.

We come to art because it's privately done, and once done, we'll not be called on to make a speech about it or parade in the streets astride an elaborately braided horse while holding the painting aloft.

When we bathe, we close the bathroom door. We don't set up a folding easel on a pedestrian thoroughfare, and we marvel at those who do. We marvel in the same way we'd marvel at seeing a tarantula crawling across our pillow at night. Let me tell you about a pastel artist I knew:

She was a California girl and came to setting up in malls and the lobby of tourist hotels to sketch portraits at ten dollars a pop. Problem was she couldn't draw. When I came across her first, I stood behind her with a group of people. She was working on a middle-aged woman, sketching her in colored chalk on blue paper. It was impossible that she was this bad. I glanced at my fellow spectators. They did not flinch, grimace, snicker or shake their heads, all, it seemed to me, appropriate responses. I knew she had finished with the drawing only when she signed it on the bottom right with a flourish and handed it to the woman.

I waited for the reaction. It never came. The woman smiled and rummaged through her purse for the money. She asked for and received some paper to sandwich it between to keep it clean. Meanwhile, the fellow next to me took the seat she had vacated.

We became friends for a time, this artist and I. In California friendship is always for a time, little more. I was burning to ask the question, but waited until we had seen each other several times. Finally, over dinner and after wine I tried:

"What brought you to . . . uh, drawing?"

"Something I always wanted to do," she told me without hesitation. "I always wanted to be an artist. Even when I was little I liked it that people did things like that."

"But, you . . . when did you start?"

14

"After I got the easel. It was at the Hilton. I was there for a week about two months ago now, I guess."

"I mean, when did you start drawing? How long have you been at it?"

"Since then," she said, taking a sip of wine, carefully returning it to the circle it had made on the tablecloth. "Awful, aren't they?"

"What do you mean?" I asked innocently. She laughed and told me the story.

She was an out-of-work actress, and an artist friend suggested it. He was the one who lent her the easel, and she was brazen enough to carry the idea off. Her friend knew what most people don't: that most of us look, but don't see. She was an artist because that's what we expect from people who stand around and look like an artist. Anyway, who else would charge money for portraits and carry it off with such aplomb? As to her work, we see what we expect to see. We make allowances. We squint our eyes. We factor in the trappings, professional looking stuff. She's an artist, after all. So she must be making art.

When the middle-aged woman gets home with the drawing, her husband will ask how much she paid for the thing. She will tell him and wait out the agonized groan. She won't bother telling her husband about the art of it. She knows her husband to be the last person to appreciate such a thing. She tells herself that she fully expected his crass reaction. When friends express the same reaction, she will put it in the bottom drawer of her dressing table. It will be a long time in the drawer. Later, when she chances upon it, she'll show her husband again. They will both laugh about it.

While most of us have better drawing skills than this California girl, we haven't had her training to walk on stage. Also we don't have her nerve, which is why we can accept the truth when we find it in **Pigeon Factor 53:**

Pigeons don't mind that other pigeons watch them. That's why they're famous less for what they do than for what they leave behind.

Chapter III

Degrees Are For Burn Victims

Whatever your education in the Fine Arts, what you don't need is a terminal degree. I hold one. It's called a Master of Fine Art degree. It's terminal because you can go no further in the studio arts. You can't get a Ph.D. doing this stuff. Terminal is what you'll become if you feel a degree like this is going to enhance your prospects for becoming a successful artist. Education you need. What you don't need are degrees. Degrees are for teachers who want to teach others to become teachers, thereby insuring that in the process nobody does anything but pay lip to the art experience.

Trouble is, colleges and universities are set up to issue degrees if somebody goes the distance. It's hard to attract funding otherwise and it works pretty well for a lot of programs. In surgery, for example, we'd expect a degree from the guy assigned to hack at our innards. We'd want to see some proof that he didn't just walk off the street before he got hold of a scalpel.

In art we don't need such assurance. If the artist is serious, the end product will reflect who he is, where he's been, what the weather was like, and how he feels about it all. We're

not interested in his academic pedigree. We either like what he does or we don't. We're not interested in the quality of his parchment or his grade point averages.

Let's take a look at these degree-granting universities and colleges and why they should be avoided by someone innocently seeking to become an artist. There are two kinds of teachers in these places; there are good ones who are interested in teaching and have the time and devotion to spend with their students, and not so good ones who use teaching as a means to pay the bills and who put their time and devotion into what really interests them: getting to be a successful enough artist so that they can quit.

This second group of teachers must not be viewed unsympathetically since it's not easy to pay bills and there are not a lot of work places that will have an artist. But these fellows are artists, and by definition are singular-minded and necessarily selfish people. They have little to offer the student except, perhaps, by example. And that example is not the best if their appearance on campus is a product of their inability to get off it. They are neither successful artists nor are they successful teachers, a lamentable condition that has no doubt been clear to their students and to the rest of the faculty since they accepted the position.

But I've got to carry this further in order to look at the good teachers, those with the time and inclination to teach. The problem here is that they've chosen the wrong field. They're teaching what can't be taught, as anyone who has spent more than twenty minutes in a studio arts degree program could surmise. The service they render, these good teachers, is to provide students with studio space and to stand by to answer questions on technique as they arise, like how do you get titanium white off your shoes or where is the nearest restroom.

If the teacher is good and careful and has established an equable relationship with his student, his critique of a student's work can be helpful, as long as he's not training the student to paint like he paints. If he attempts to teach painting like he paints, and the student succumbs, that student is

17

fated to produce second-hand stuff pleasing only to his instructor.

So, what do they do in these degree programs? Not nearly enough to justify the expense of the education or the dangers inherent in linking the artist to academia and to an intellectual system that has nothing at all to do with creating art.

Why, then, are rational human beings taking undergraduate and graduate level studio courses leading to a degree or two in the Fine Arts? Two reasons, and I'll start with the ludicrous but benign reason: in order that the art student can grow up to be a teacher.

It's ludicrous because there's little else than the techniques of painting which can be taught, and they can be learned in afternoons at the library. It is likewise ridiculous for a student to earn a degree or two in order to teach. He'd be better off taking a home-study course in mathematical probability, and he won't need to get very far in it to equate the two factors working against him: the vast wasteland of Fine Art graduates churned out each year by colleges and universities throughout the world, and the scarcity of faculty openings. What right-minded faculty member who has contributed to this wasteland of nonartists and nonteachers is going to give up his ride for the sake of infusing his institution with new blood? He'll chain himself to his swivel chair before he turns in his keys. He knows what it's like out there. He won't take time out for a heart attack.

The second reason is less benign and accounts for much of what we've had to accept as the best of contemporary art for too many years. It's called The Fraternity, *Le Club Exclusif,* that grab-ass chumminess that prevails between the directors of contemporary museums and name universities, an insular arrangement not unlike that of teaching teachers to teach that which can't be taught.

The museum has been chartered to introduce the public to what has been going on in the relatively brief history of contemporary art. That is pretty easy since a handful of influential New Yorkers in concert with some pretty fast-

footed dealers had long ago decided what constitued contemporary art, who were to be its practitioners, and what their art museums ought to buy for their permanent collection. The second part of the museum's mandate is a little less rigid and a little more fun: to show the public the new trends and where contemporary art is headed. This is where The Fraternity comes in.

The director often owes his first museum position to his alma mater, since there wasn't a whole lot more he could put on his resumé. No responsible selection committee will advance a name unless it comes attached to a "name" university. Then the director hires his curators. Who best to fill these jobs? Those he knows, and he knows best those whom he studied with. Since we look to the museum to showcase rising talent, a purely subjective and nebulous matter where you're up to your gumboots in circus stunts, the director and his staff are going to get on the safe side and use the network in choosing artists to show. They're going to call home to The Fraternity and between them they will advance the up and coming Andy Warhol for the month.

The director will owe his second museum position — for these guys move around a lot, fund-raising being the tough job it is — to the experience he gained in his first job and his "name" university. He'll bring his curators with him. As a team, they'll move to each succeeding job, their university ties intact.

It's incestuous and you can't expect much from the offspring. And if you've been to any of the shows lately, you don't get a lot. Nevertheless, the working press is going to assign space to it, the critics will critique it, and those who have the most visible contributions — the generous folks with cultural bucks — will be there to sip champagne and see it off. Before you and I show up, it's the rage: bought, paid and delivered, no matter what it is.

Where does the artist fit in you say? He's furniture, a stage prop. Who's to tell one from another, anyway. He's baggage and has nothing to do with who's driving the cart.

The Fraternity is tighter than the Salon jury system, the

nineteenth century academic strait jacket of France. But it doesn't have the commitment to excellence the French Academy had, whatever its authority, whatever its mistakes. And it doesn't have the commitment to art. The commitment of *Le Club Exclusif* is to itself and its own aggrandisement. However, in the face of growing internationalism in the arts and a return to aesthetics, it's showing cracks and, like the academy before it, it will fall.

Anyway, I wouldn't recommend it to you. Neither the teaching life at a university — should your lottery number come in — nor your associate membership to The Fraternity, which you might gain if you attended the right university and played the art game as you were told, will serve you as the artist you intend to be.

The university teaching job which you may covet is not, as you may think, a means to an end. It is an end in itself. You have a better chance of being an artist and reflecting life as a bank clerk, punching up grocery lists, or herding cattle. Take your evenings, your days off, your weekends and paint. You'll not be awash in the morass of cultural politics and university chairs. Your conscience will be clear. Since art is the search for truth, it's hard to find it if you're lying to yourself and others.

So, get an education. Don't get a degree. Don't teach those who seek one. If you've got a degree and have taught, I'm sorry for you, because you and I have had the same problem. We've been pigeons and have listened to teachers, curators, writers, dealers, parents, wives, husbands, and other various people when they talk about art. We've been swayed by the hype. It's how you flap when they flap and perch when they perch. It's not how you do art.

I don't like the association between academics and artists. They ought not crawl under the covers together. And since they aren't getting married, they oughtn't fool around. There's no reason for the student of studio arts to be on a college or university campus. None. The training can be offered in so many better ways in other places. What comes of mixing academia and art is clearly damaging to artists and

what they produce. With the association, art risks descending to the cerebral — the intellectual piping of the tune.

I have nothing against art scholars. Nothing. Unless they apply their scholarship and dubious taste in order to influence and otherwise cloud the eyes of those who might see.

The artist is not an intellectual. He oughtn't be taught by intellectuals. He oughtn't be held captive in an intellectual environment. His home is of a visual — a visceral — terrain. His work should not come from his head, at least not without the juice of day-to-day life refreshing it. If his work is any good, it comes from the inner recesses of an organ we've not yet identified. It lies within a black hole of our being, cloaked in mystery and contained in spirit. You don't need a lot of clever conversation, astute lectures, witty expostulations, and campus chatter to get it whipped up. If you've got one of these organs, you shouldn't fool with it.

Go to Japan. Sit with an ink and brush painter. Sit quietly because you'll soon learn there are three of you in the room. Watch how the painter pays tribute to the third force. Look how he sits. See how straight his back, how he holds his brush. This is how he respects both the third force and those artists before him who for centuries employed this force. Watch how he loads his brush, how it pauses over the bleached sheet of Mulberry and moves to the lower left. Watch the brush now as it takes on a life of its own. Watch how it dips to the edge of the page. Then, in a single, fluttering sweep, see how it rises diagonally across the snowy sheet. In its wake lies a vivid stalk of bamboo, delicately curved against the breeze.

What I'm saying is that there's not a whole lot of chatter involved. And later if one better equipped than I were to engage this man in conversation, we wouldn't expect eloquence, and we wouldn't expect him to tell us about quantum physics or the design merits of Grecian earthenware. If we got it, it would be a bonus completely apart from what he does on that handmade paper in the quiet of his room.

While the association between the artist and the intellectual on campus is flattering to both for different reasons,

21

it is foolish. It's a lopsided match played in the wrong terrain. Out of it comes an avant-garde dripping in pedantry. Art sinks from aesthetics to the depths of sociological and political banter. We get "Save the Whales" where painting ought to be; we get written expostulations in place of art. We get Tom Wolfe's *The Painted Word*. We get performance, we get happenings from golly-whiz students, and then we get to hear what it all means. With all this comes university support, government subsidy, and the prof. as prompter beneath the footlights:

"You mean you want me to stand on stage in front of all those people, take off my clothes, and smear chocolate on my body?"

"Look. You're an artist. I don't expect you to understand. I'll write the release."

"But chocolate?"

"I told you about the interior and exterior worlds, the disenfranchisement, the categorization derived from the patriarchal nature of linear constructionism. Now, take off your clothes and get out there."

Stay away from universities and their degree programs in studio arts. If you're partial to earning a degree, let it be in art history or literature or something which will support your habit. Or get your own education. Take some classes. Read a lot of books on history and those artists who made it. Take it from the cave paintings forward and then, intensely, into the periods most interesting to you. Study the artists who made the times what they were. Ask how they lived and worked and drank. Find out who ran amock and died, or who was straight as a bank teller. Discover those who suffered, and those who didn't. But mostly look at paintings. Look at a lot of paintings. Then *see* them one by one. Go to museums. No teacher can compare to a painting speaking quietly from the museum wall. Travel to the big ones. These are your churches; here you'll find where beauty lies. Make love to a docent. Dance with a janitor. Take pride in your humanity, for those paintings on the wall before you are a product of the best of it.

If you cannot yet travel to the world's museums, use picture books to bring them to you. Remember color reproductions have improved. While still a step or two away from the original, they are close enough to be useful. Study them. They're the next best thing to an airplane ticket. Later, when you see the original, the shock will be so pleasant you won't hold a lasting grudge against the reproduction.

Choose a teacher carefully, remain at a distance and leave him the moment you begin to paint like him. But don't study under everyone. I've taught and listened to people who can cite along with their teachers half the entries of "Who's Who in World Art." They flit from school to school, class to class, art holiday to holiday, instructor to instructor. They wear their teachers like merit badges. Mostly what they retain from their encounters are a collection of paintings which were finished by the instructor of the moment. They're nice people, mostly, and you'll meet them when you travel around. You can recognize them by their sizeable vocabulary of art terms: negative space, heightened line, compositional tension, and the like. They don't draw; they discover things. Nevertheless, it's all pretty harmless.

I met a lady in Guanajuato, Mexico, once. She had set her easel up just off the *jardin* to paint the theater building. She was in a holiday class and asked me if I knew her instructor. I said I didn't. She seemed surprised and listed some others that she had studied under. I didn't know them either. She told me that she had studied under forty-three separate instructors. I heard she died recently. But I don't think it was because of that.

Finally, if you've succumbed to correspondence school, you already know what I've got to tell you. I hope it wasn't the one that runs a full page ad featuring six or seven grown and clearly distinguished men standing around and seriously reviewing a student's submission on the desk before them. Though the ad clearly indicates that six or seven judges analyze each painting, I have some reasons to doubt it. It would, if true, clearly reflect a seriously low enrollment. I hope so. Which leaves us **Pigeon Factor 54:**

23

By last count there were more adult pigeons in the world than there were registered students seeking a studio art degree from accredited institutions of higher learning. But the count was faulty. Some universities would not release figures.

Chapter IV

How to Find
The Handle of Your Brush

F ine. You've been turning these pages pretty well
up to now, but I've got some bad news. We've got to
make a cut again before we can move along. I've got
to ask about your leanings. Got to see whether you're the
sort who ought to go on with this. If you've taken care of
this book you can still turn it in. If you spilled soup on it,
you might as well read it anyway. Cheer up, you may make
the cut.

If you're an artist who wants to wrap up buildings, dig
trenches in the earth with the blade of a Caterpillar tractor,
suspend old tires and such on the wall with great globs of
Super Glue, urinate in bottles when not told to do so by a
medical doctor, perform a nonperformance in front of an
audience, blow up things, expose your genitals or other pri-
vate parts, hurt yourself or others, and you do these things
under the auspices of Fine Art, I can't help you a whole lot.
You want to read a different kind of book, and they're
around if you can understand big words and heavy messages.

By the time this book gets to you there'll be a lot of stuff
going on which hasn't been thought up yet, and I'm sure a
lot of it will be good. As you know, in order to be good it's

got to be new, and in order to be new, it's got to be different, right? I mean, what else is there in art?

But I've got to tell you I'm back in the two-dimensional era. Remember surface, as in painting surface? You know, where you mounted a canvas, a chunk of wood, or something on an easel and you put colors on it and later, after it dried, you could hang it on the wall? They called them paintings. Some went right on the wall and they called them murals. Some were on paper or they weren't painted at all but were woven cloth. All of them had what used to be called "lasting value."

We weren't smart enough to think of art in sociological or political terms; we let the paintings and the sculptures do the talking for us. We didn't distribute essays. Even when there were political ramifications, we made them emanate from the painted surface. This was when theater was a different part of the arts. You could find literature in books, and not used as directions for understanding something that was clearly and sadly evident in the thing itself. This was before we all became philosophers, politicians, activist, aestheticians, communication specialists, linguists, TV technicians, and university professors.

Anyway, I'm a long way back.

I still paint pictures. I'm talking originals here. I paint them for a vast, sophisticated international market comprised of most developed and developing countries east and west. This market and I believe that we haven't said it all on the painted surface. The market and I believe in the power of the visual image. We believe that good painting springs from the great reservoir of art history in which ancient waters embrace abstractionists, modernists, and, yes, contemporary thought.

They believe that art has not been reduced to the absurd, to titillation, to debasement, to shock. Are we freer for these challenges to conventional morality? Slightly, perhaps. However, the internationalists believe as I do that there has been no parting curtain to a rich, new era. In short, I don't care what you put on the surface, but I'll ask you, out of preference and personal prejudice to use brushes and

paints and put there something you feel in a way others can understand that feeling. Directly. Eye to eye. Abstract or figurative, it ought to speak.

I'm not going to take you through the basics of making this stuff. There are a lot of good books for that, but I will give you some advice. Mostly, I'm going to tell you what a good painting is and what it isn't. You can argue with me, and I can listen to you and respond. Unfortunately, we won't settle the argument here. There are no rights, wrongs, or formulae to make it easy.

And I'm not going to tell you how you can tap into government endowments or grants or fellowships or how you can buddy up to the Warhol Foundation. For that you'd be better off getting with the university crowd. Instead, I'm going to ask you to tap into your own resources, your own creativity. I'm going to show you how and if you've got that power or can develop it, that's all you'll need. You don't need all that bureaucratic paperwork anyway. Government's free lunch would cost you your soul. It and corporate endowments have never been enthusiastic about direct grants to individual artists anyway. With cultural bucks getting scarce and with scrutiny increasing, you're in for a long dry spell. It's going to be a long way between water holes. You need to consider **Pigeon Factor 55:**

> If you are a pigeon, it is not necessarily true that some klutz sitting on a park bench will feed you bread-crumbs. There are far too many pigeons and far too few klutzes.

So, if you're set on being a politician, call an election. Want to act? Study drama. Sociology turn you on? Find a sociologist and whisper words of cultural deprivation in her ear. But if you're a painter, read on.

Good. I feel better unloading the zoo. Those guys are a disaster looking for an ambulance. As soon as they get embattled — which clearly they intend — they plea artistic freedom and base their defense on the Impressionists who fought against the strictures of the French Academy.

"You don't understand why I pissed in a bottle containing a crucifix? Well, they didn't understand Monet either."

27

It's this kind of logic that worries me. In most of the world the war's over for artistic freedom unless you want to spend your life attacking the few remaining pornographic or religious taboos, or you live in North Korea or any of the few remaining countries where a fascist-for-life assigns a color-mixing committee to oversee your work. There's no war. There's nobody left to fight.

There was a war when Monet and others chose to fight it. A bitter one. To be a revolutionary then, you staked your life as a painter and in some cases your sanity. Governments weren't so benevolent. They didn't feed and nurture the rebels.

In the last half of the nineteenth century, if you painted in France, you painted for a piece of the wall in the national Salon show and you did it their way: big format, traditional subject matter, and finished surface licked clean of telltale brush strokes, smooth as warm butter. Selection meant credibility and without winning a place in the annual show you weren't an artist for still another year. At the time, getting in the exhibition was the only avenue leading to sales or paying students.

They weren't all bad guys, the members of the jury. Great painters were among them. But they were, on the whole, a conservative and a self-protective lot, and they didn't favor rebels. The jury and the system that spawned it was who you fought if you were a painter beyond the mold, if you were brave and so inclined. As "experts" the jury had the backing of the citizenry who, like every population, looks to "experts" to tell them what to like in art. Fighting the system meant risking your chances of being an artist and forever's a long time. You turned in your brushes, bought an apron, and took work in a pharmacy. You were still pushing purgatives when you dropped.

It was war when a few more than a dozen guys smartly took the system on.

Compare that to today. Governments, after consulting *Le Club Exclusif*, underwrite the avant-garde for fear of repeating history's mistake. It sends its appointed diplomats to cut the ribbons, to make vacuous speeches on culture and

the nation's commitment to supporting the Fine Arts. They'll make these speeches while standing knee deep in condoms, this month's lead exhibit at the Whitney.

So, I expected all along that you wouldn't be a neo-freak and that you'd choose the painted surface. Now all you need to do is to decide what to do with it; what you're going to put on it. This time you've got two good choices: objective or nonobjective, that is, painting something one can recognize, however vaguely, or allowing the paint and its application to do the talking. If the choices are defined by figurative and nonfigurative painting, objective and nonobjective are a whole lot like the same thing.

You've got to own up. The good news is that there is a strong international audience for both and your choice, your natural bias, will not alienate you from all the collectors you'll ever need.

Problem is you've got to be good at what you do, better than what's around. I don't believe you'd be reading this if you didn't think you are or could be. Just as I expected, you've long since made your choice. You gravitate to it each time you walk into a museum or gallery or pick up an art book. You've got your heroes or heroines, and when you look at their work the power of it hits you in the pit of the stomach, so hard, that sometimes the tears come.

Then, you're no longer looking at the painting. You're seeing. You're listening to it. You're hearing the sound of the colors, the music of it. You're feeling it with your eyes, the cold and the warmth of it, the way the texture is. You can sense the tension of it. You can smell the thing. You want to embrace it before it explodes from the wall. You cannot believe that others walk by with but a glance, that they are not haunted as you are. You want to take it gently from the wall. You want to make love to it if you could find a way.

These are your kind of paintings, and I'd be a fool to get in the way. But there's some bad news too.

However tolerant the objective painters have been to the abstractionists, however he's welcomed the dash and color flights of the nonobjective painter and has incorporated the daring in his own work, for the past forty years or

so there's been little reciprocity. They haven't been hospitable.

Until recently, if you were a serious painter in England, France, or America and favored figuration or something close to subject matter, you were thought uncontemporary, that fatal pejorative. You were out to lunch. You were "reverting," a bad word for being out of fashion and in a lot of trouble. Fashion is what drives the buggy. The best we can hope for as painters is to rattle the carriage, to shake up the steeds. There's a parallel of course in **Pigeon Factor 56:**

> Pigeons do what other pigeons do principally because other pigeons are doing it.

For almost half a century the objective painter was on the outside looking in, his nose pressed to the glass as he watched the world's hostesses embrace the abstract painter. To be sure, there were and are powerful abstract painters who have no need of fashion, but just as soon as they proclaim their independence from the herd, the hostesses will spring up to embrace them, to seat them at the head of a table of glittering crystal and draw them out. The hostesses will suck in their faintly rouged cheeks as they rise to the bait, forming perfect circles with their perfect lips as the artists hold forth.

And much of the good stuff gets smothered in chic. So, where has it gotten us, this single-mindedness for the abstract, this half-century in the in-crowd? Stemming from the genius of Braque and the secondary, but brilliant, outbursts from Picasso, we get a world-wide run on glass and steel framed wallpaper; we get hotel chains buying it by the square yard encasing it in plastic and welding it to the walls just north of the beds. We get psuedocolonial banks boasting tasteful little dabs and drips, framed side-by-side with the month's featured employee. We get it in the McDonald's chain, and we get it hanging with the brass lamps and with the imitation Formica tables in the home furnishing sections of decaying downtown department stores. In lobbies of insurance buildings we get color swatches and hanging

30

fabric where murals ought to be. We get pale, little geometries, polite and pallid. We get color scheme in place of art. Best of all, what we get won't offend a single customer. Like city architecture and the interiors of corporate boardrooms, most of it isn't interesting enough to draw attention to itself. There's no subject matter to compel, to distract, or to raise the ire of the chairman's bilious wife. It's the visual answer to the cover of the downtown telephone directory. It's chic. It's Warhol's Monroe. It's the two-foot-high plastic hamburger we have to straddle in order to sit on the aluminium couch.

With the rise of the global market there's been a parallel decline of the single trend-setter nations as exporters of world culture. Art is returning to aesthetics, the currency of global trade. No longer does it need to be abstract to be good.

So, let's get on with it. You say you went to the attic and the box of materials you so carefully packed the last time you were going to be an artist got raided and what was left had dried-up. Some brushes, some bits remain from years ago. That was when you had a studio, or rather, you had a rented room which you used as a studio, and others around you did the same. You had stayed in there with the radio on and worked for a while and came out from time to time with canvases to show your friends. Those around you had looked at them and praised them, and you looked at theirs' and found them wanting, though you didn't say anything. Nor did you say how good you felt that they were bad. Instead, you praised them a little, carefully qualifying, hiding behind language. All so they would stay and listen to you as you started in on success. Now, looking at the box brings the memories back.

Don't fade on me. You've lived some since then. You've made a new decision, and you've found this book about how to be a famous artist.

But my guess is that you're holding up telling everybody your plans this time around. You're a little guilty about last time, and you're not too keen on making any big announcements, right?

31

OK, let's surprise them.

So, before you worry everybody about where you're going to work, let's go get the stuff we need to work with. Sadly, we've got to go back to that art supply guy, but with a little luck he'll have forgotten us, what with all the pigeons that have tottered into his store since.

You've got another choice to make. It's called medium. For all practical purposes, you've got three: oil, acrylics, or watercolors. Though the brushes will differ, acrylics can be used as watercolors, which gives us an even two. If you are, or have been, a watercolorist, I'm going to try to talk you out of going back for more, despite or maybe because of your experience in it.

I like watercolors. I began in this medium with the mistaken impression that it was the simplest of the three. Of course, you know better, as I didn't. Watercolors are exacting. They require great experience in handling. They require finesse and planning. If used correctly, the colors and the surface behind it can dance. The apparent spontaneity of a well planned and briskly executed passage can be a Nijinski leap into space.

But don't use them.

I can't in good conscience have you burdened by medium. Watercolor is on paper. Paper is not as durable as canvas. Paper is what the print industry uses to sell copies of works of art. I'm here talking about the industry, not the artist-printer who produces singular pieces of work from start to finish. The industry has supersaturated the market with copies. The industry has cheapened works on paper. Obviously, there's an uneasiness about paper. The work on it is considered less profound. It's what sketches or color studies are done on. It's what hobbyists use, Sunday painters on holiday tours. Watercolor is not serious, they'll tell you. They forget, or never knew, about Mary Cassatt, Winslow Homer, John Marin, and so many others.

Watercolors are what Victorian young ladies absently studied while waiting to be ravaged by their instructor. The result of it all is that watercolors do not command high

prices or well-deserved respect. Remember, we've got to have it all going for you to make that success we're talking about and to make sure that the road to fame is not an everlasting one. So, if you are a confirmed watercolor painter, you'll need to work hard to prove me wrong.

Of choosing between the remaining two mediums, I can't make a demand, but I'm going to make a strong pitch for acrylics. Though they still don't quite command the respect of oil — they've been around for only 100 years or more — the respect for them has risen as their durability and flexibility become understood. Clearly, they surpass oils in permanence, though there hasn't been the 500 or 600 years to demonstrate it. Those collectors who do make a distinction favor oils only slightly and out of habit and sometimes out of ignorance.

An acrylic painting can resonate as deeply as an oil if painted properly.

You may have heard the story about the artist who in a single year submitted the same acrylic painting to three separate juried shows: one watercolor, one acrylic, and one oil. He won three blue ribbons. Since the painting was a good one, none of the learned judges could disqualify him based on medium.

As stories go it's not all that far off, though it stretches things some. But the principle that I want to communicate is there. Namely, you paint with acrylics, and you can make it look like anything you want. Only you and your supplier are going to know for sure.

There are many advantages using acrylics. All of which we're going to need. Art is tough enough without making it tougher. I like advantages.

Here's a short, blow-by-blow course on oil and acrylics:

OILS	ACRYLICS
1. You'll choke on the turp fumes.	1. You'll choke on the much less pleasant what-the-hell-is-it smell.

2. They dry slowly enabling you to work and re-work passages.

2. They dry fast enabling you to work wet over dry passages without waiting a day, thereby forgetting what you had in mind in the first place.

3. You're able to rub off, going back to scratch with a turped rag.

3. You're able to march over your misdeeds, knowing they'll add a certain crusty texture, which people will think you were trying for.

4. You can get a Rubens-esque quality to skin tone which emanates from the depths of a polished ivory canvas, which you can only approximate in acrylics.

4. You can get a build-up of warms and cools and cools over warms that stack nicely, one over the other, to read layer by layer.

5. To move a painting you better call Lloyd's. You better keep it stretched. You'll need to crate it and insure it for the damage it will no doubt sustain.

5. A day after you paint it you can take it off the stretchers and roll it face up with thirty others, tuck the roll under your arm and board the plane.

If they had acrylic paint in Rembrandt's day, you don't think he'd be into them? He's no Fragonard, you know. But you choose. And don't talk to me about waiting months for the final varnish when you have a show in Lisbon the next week.

When you get your list of colors and supplies, either go in and face down your supplier or find your own way down the aisles. Get in the right section. It's easy to buy oils when what you want is acrylics, or vice versa.

Buy big, paint small. You can have that tattooed on your right arm or you can remember it. There are two reasons why you should stay with the name brands of colors and buy them in the big 200 ml. tubes: they still use metal for the big tubes and since you're in this for keeps, you can

34

use the quantity. I'll explain about the metal.

Some bright guy many years back had two great ideas for his paint company. So great were his ideas that they were summarily stolen by all the other paint companies. His first idea was to put the paint in plastic tubes, thereby simultaneously saving the company money and driving its customers up the wall. His other idea came right on top of his first: let's make the cap the same circumference as the tube so that when we package these little devils they'll fill the box. His boss said they were such neat ideas they would try them unannounced. They didn't want to be confused by anyone who actually uses the paint. This brilliant guy got a thirty-dollar raise and a color calendar.

We, in turn, get the fun of finding where, if anywhere, the paint is hiding in a depleted tube of napthol red light since the plastic around it in no way conforms to what's inside, as anyone who has ever used those new plastic tubes of toothpaste could tell you.

But we pay a lot more for paint than toothpaste so that when we come to milk this thing from bottom to top, without warning we've got a four-dollar stream of lightfast, transparent color on the studio floor, and we get piqued. And when we come to screw back the oversized plastic top, the one that's so nice for packaging, we discover a whole new puzzle which needs solving then and there: how to rethread this plastic waffle on the relatively tiny opening without first stripping it.

These are two of the larger challenges you will face as an artist, problems that the paint companies cunningly placed so that only the fittest among us would survive.

So, buy the big tubes; they're metal, though their tops are still a hindrance. Don't save money on paints. And don't, please don't, come back from the supplier with those tiny tubes that comprise an acrylic set, the kind that come with a little brush in molting season. Though pricey, this little packet offers just enough paint in each tiny tube to dry within three and a half minutes of squeezing it on your pallet. Buy a set like this, and it will end your career in twenty

minutes flat. If you come back with one of these, you can trash this book.

Buy yourself an easel or make one, unless you've got thumbs like mine. Buy or make it so you can stand in front of your canvas. You've got a lifetime of sitting ahead of you. Don't add to it unnecessarily.

Get a large plate of glass a quarter-inch thick, roughly the dimensions of your kitchen table. That's your palette. You're not going to muck with anything smaller.

Find a bag of old bedsheets and tear them up in sizable squares.

Buy bristle brushes working down from size 16. You don't need them much smaller than size 10. Don't use small brushes, not ever. But keep them around if you've already got them. They make good pipe cleaners.

Then find four or five big bowls that will hold water and brushes and goldfish and stuff.

Then find yourself a shop light with twin three- or four-foot neon tubes. Don't tell the salesman what you're going to use it for or he will try to sell you "daylight" tubes, but they won't be daylight as you and I know it. It will be more like the color you get if you set fire to a stack of truck tires. You want your light neutral to cool. The original tubes, before they were mucked with, came that way. This will be your north light. It's a lot cheaper than knocking out a wall and a lot more consistent.

Get some stretchers, no more than two-by-three-feet and some rolled canvas. Unless you plan to show it in your paintings, you won't need costly linen.

I know supplies are expensive, and I think you know by now that I'm not making my money from the supplier. But chapters back you walked out of that cabin after your weekend of solitude as an artist. Success takes spending money. Carve that on your left arm.

Load up your car: easel, glass, stretchers, boxes of paint, canvas, the lot. This is where we surprise the wife, husband, roommate, dad, mom, or landlord. We're going to create a studio.

Chapter V

A Clean, Well-Lighted Place

I told you what Veronica did to me in kindergarten, and the resulting humiliation that stripped me of my artistic manhood for thirty years. As a middle-aged journalist, crippled with doubt, I again faced that blank sheet of paper and overcame. Hah! Where is she now?

All right, it's a little strong. There were moments in those years when I was tickled by the muse, like once on a rainy day in late August. I was seven and had exhausted every form of entertainment short of drowning the dog. I found a sheet of poster paper in the attic. When I unrolled it, it stood about my size.

"Mom, can I paint on this?" Prolonged pause. I had been out of school since June. It had been a long summer. She had grown suspicious.

"Where?" It was a question I wasn't prepared for. Absently, I indicated the floor beneath us. We were standing on the oriental rug in the living room.

She shook her head.

"The kitchen?" I bargained. Another pause.

"Only if you clean up afterwards. As clean as you found it," she demanded unfairly.

Maybe you had a mother like her, and you'll understand. They don't listen. There's no way to tell her that an artist can't possibly clean up after himself, not if he has any integrity at all. And I had that in spades.

Fortunately, I had the advantage of knowing something she did not. Painting to her meant using the still unopened box of guaranteed washable watercolor that I had received on my birthday. I, however, was into something far more experimental. I intended to use the four cans of enamel housepaint I'd found in the garage, three off-white cans, one red can for the house trim. The five-inch brush had gone dry in evaporated turpentine, but it would suffice.

As you know, a painting doesn't pop into the imagination in full bloom. You've got to water it. I had gotten no further than what it would be like to pour the three white cans and the red can on the paper and to stir the result with the stiffened brush. It would no doubt be something abstract.

I knew it would take some space because there would be a lot of moving around and kneeling and stuff. I wasn't stupid. There's no way you're going to work up the composition I had in mind without slopping the paint around a little. And if she expected me to clean up that mess, the deal was off.

I'd wait until she went shopping. I'd use the living room. Take the rug outside when I was done. As long as the rain held, it'd wash off on its own.

You'll need a place too, if only somewhere to put all this stuff you brought home from the supply store.

At this point, I'd strongly advise you to come clean to those who may confront you as you're hauling it through the front door. You're an artist and what you need is a studio. Since you're carrying an easel and rolled canvas, they'll not believe you've come to study medicine.

I told you it may come to others as a surprise, but stay with it. Set your packages down, roll the easel to one side, and have a long sit-down with the doubter you need to convince. You need to get him or her on your side. For the rest of your life, you'll need that. You're going to have a lot of

38

people on the other side, so you better get some support from your own. Presumably you carry some weight with your wife, husband, mom, dad, or roommate. If it's your landlord, tell him you're studying medicine.

The reason you need to win immediate support is that you're going to have to declare some personal space in the house or apartment you share with your family. It's going to be your studio, and you're not going to be cleaning up and putting things away each time you use it.

The mixed news is that you're not leaving at once to find warehouse space in New York, you're not quitting your job and you're not abandoning your wife, kids, and home-cooked food. What you are abandoning now and for a long time to come is the idea that in order to be taken seriously one has to paint paintings at least the size of the garage door. Among so many students I know who start this way, never do I see so much paint over so much surface say so little.

There are some reasons. First, unless you plan to paint the garage door and lie flat on your stomach for the lower passages, there's no place, short of knocking out walls and erecting scaffolding, to do a painting that size in your house or apartment.

The second good reason is evident in the question: what do you do with a painting that big? I know. You think it will be grabbed up by the museum and will be part of this vastly heralded show everybody's waiting for. You've got to paint big for a museum, right? And once they see these gigantic pictures you're planning, will anyone in their right mind deny the talent behind them?

The third good reason is that it's going to take you two or three hundred bad paintings to make your first good one and unless you started as a toddler, you're not going to live long enough to paint a couple hundred bad paintings that size.

The best good reason is that you want to be successful and that means selling your work. People live in houses, they don't live in museums. They buy relatively small paintings as a rule. It's a rare collector who would be willing to

overwhelm a wall with a single painting, even if they had the wall and liked the painting.

Take a close look at the size of some of those monumental paintings you like that are reproduced in your art books. If you haven't seen the original, you may be shocked to discover that monumental content has little to do with dimension. It's the idea and the application of it that fills the room. In fact, the painting may be no bigger than the art book.

So you won't need the whole house, you'll need a room and my guess is that if you give up your visions of cathedral ceilings, a towering wall of art books, softly filtered north light and a Great Dane asleep in the middle of a polished oak floor, you've already got a studio, even if it takes some rearrangement or the ousting of a kid or two — at least from one room to another.

Expect some arguments. When you get them, tell about the East.

I lived in Korea for a time. Since the Korean peninsula is pretty small and the population large, Koreans have come to look at space differently than we in the West. They measure it in what is called a *pyong*.

To understand a *pyong*, you have to know that it's a lot less than an acre, which is what Americans measure things in. When you buy a house in America you want a yard and garden with it. You'll want acreage. You want space for your kids to play and some room to store the old refrigerator. You'll want to know how far you'll be from your neighbors, who you're certain not to like much. You'll want to find the lot line so you can get working on the fence between you.

You don't need fences when you talk in *pyongs*. *Pyong* is a word Westerners come to understand as closet space. It's roughly the square of two paces one way, two paces another. Americans don't consider anything less than where a washing machine will fit as space at all. And you can't get an American machine in anything less than a two-car garage.

For Americans a *pyong* is where you store Christmas decorations. For a Korean who has lived, slept, cooked and

reared a pack of children in something less than storage space, the measurement has meaning.

If you told them there is no space for a studio in your Western house or apartment, they'd begin counting rooms and the noses of people who lived there. If there were less than twenty-five noses — mom, dad, kids, uncles, aunts, grandparents, cousins and assorted friends — and there were more than four rooms counting the bathroom, you'd have a studio for one room and could rent out another.

So put a kid in the living room, shove a bed to the wall, put the sewing machine in the kitchen and the guest bed in the attic, or if you can stand up there, use the attic, or what's left of the two-car garage.

But every budding artist you know of has a loft in Manhattan, London or Paris, with a nubile young groupy hanging on his arm, and here you are in a converted nursery smelling of latent diaper rash with the baby outside bellowing and the vacuum cleaner on.

So hang up some travel posters: the Eiffel Tower, Hyde Park. Get the place smelling like a Paris metro. Put some music on, Gershwin if you've got it. Turn it up. Dance a little, like Gene Kelly. That's what music's for.

If the walls are anything but white, make them so. If sun comes through the windows, cover them with something thick and white. Everyone likes a window but if the light through it isn't neutral, do without it. If the house next door is painted red, you'll get a lot of reflected red. And watch greenery.

I painted once for a month in the porch of a house set next to a spring fed creek in the middle of the Anza Borego desert. The profusion of green shrubs and bushes and trees and vines nearly swallowed the house. It was alive with this green. The world around my screened porch, my cage, was charged with everything that crawled, danced, sang, chirped, and croaked once the sun dropped low and you could smell the evening coming.

It was idyllic. I had to throw away the paintings I did there. All the paintings were over-warm and over-wrought, compensating for nature's cool, green oasis.

41

Now hang the studio light. Get that kitchen table, or, if there's resistance, another like it. Paint one side of the glass you bought with gesso and when it's dry lay the glass on the table. Fill the pots with water, squeeze out a generous palette and begin.

Before I leave this, I've got to get back and do better for the landlord. Remember him? These guys are not over-fond of artists. And he saw you with an easel. It's his place you're renting. And he's got your deposit.

So, if a part of what you do is hurl paint at your canvas from a considerable distance, prepare for that. Put plywood on the floor, keep the door shut, and plan to repaint the room when you move. If he threatens eviction, show him these last paragraphs. If that doesn't work, show him the title of the book. Tell him you'll mention him in your will.

Chapter VI

Living A Divided Life

So you've begun painting again. Though you're squeezing it in between a life-drawing class and what you do for a living, you're painting. And the zest for life begins to kick in.

You've haunted the libraries and book stores, perfecting the art of standing lock-kneed for hours while reading books you can't afford. You've learned how to keep your place when jostled in a crowd. And when the store's nearly empty, you've learned to keep your composure when the owner stands behind you and you hear him breathing.

You've come to stalk museums and stand long enough before a painting to rouse suspicion from the guards. You are no longer handed literature at the front desk inviting you to become a "Friend" or "Associate."

You've seen that the works in galleries don't stand up to your own. And with each new show you check in to see if things have changed.

You're working under the lights at night. And when you lose yourself to it, it gets to be a lot later sooner than you expected. At your paying job you're less than the dynamo you once tried to be. Now, when you rally behind the

boss sometimes for days at a time, there's something less sincere about it; your contributions in staff meetings fall off and you've noticed he carts less of his bright ideas before you than he did. So lately you've been relieved of making the appropriate sounds of approval.

His favored employee — someone else now — takes you, quite unexpectedly, to lunch. There are some questions about how things are at home — the wife, the kids. Though this comes amid other chatter, there's a pointedness to it that's uncomfortable, as if he really wants to know. When you accept the second drink you're offered and he declines, there's a meaningful pause before the chatter resumes.

In the restroom, after lunch, you throw water on your face and see where you missed a spot shaving. The late nights and early mornings have made you less attentive about the way you look. And when you stand back to brush the wrinkles out of your suit, they resist it the way suits which haven't seen a cleaner in recent memory tend to do. You straighten your tie and wonder whether the stain on it is a matter of lighting. The mirror again discloses a disheveled guy, now with two drinks in him. You recall how your wife has been urging you toward a barber for weeks. Judging from the guy looking back at you, she surrendered her concern some time back.

Though you hadn't mentioned it at lunch, the wife is a part of it. The sad fact is that home has not been a bedrock of stability. She has been taken to exhaling elaborate sighs. She's asleep most nights when you leave the studio.

The kids have learned not to interrupt you in the studio, or when you're reading or engaged in thought. They do this by not talking at all and merely looking up when you enter a room. They've taken to shrugs or grimaces where answers about their day used to be.

All of it moves you deeper into the monastery, the seductive world which only other artists know, where life is vision, beauty, truth, color. This world is governed by the next painting, the one that will say it; the one that will say it in a way that's never been said. You're consumed by it, and

the drive to achieve it leaves no room to discuss charge cards and mortgages and house repair jobs and garbage that needs to go out and the stuff at the office. You're into immortality. What care you of this temporal life, of the secular concerns of garbage and wives and Master Card and earning a living? Bless those unanswered bills, for they know not what they say. Or ask. Or, more recently, demand as life comes down around you.

The disease is well-documented in the history we know about. What we don't know are the countless souls who fell victim to this disease and went untreated. Their life's work rolled, rotting and forgotten in the corner of a cellar on moving day.

"What about this stuff?"

"What stuff?"

"You're father's stuff. The roll of those dreadful paintings."

"I don't know. They aren't so bad. You think they're dreadful?"

"Well, your brother wouldn't have them."

"True. But he's got a small house. Anyway we've got — I don't know — a responsibility, don't we?"

"Suit yourself. But you're the one's been talking about essentials, culling what we don't need. We need a heavy roll like this?"

"Well, OK. But don't dump it. Leave it. Leave it where it is. Let them, the . . . the new owners look at it."

The disease is called monomania and if left untreated you and your marriage and your work will die from it. It is not a bad way to go, but you will die just the same. You will die believing in your purity and dedication and you will come to die alone and in poverty with an I-told-you-so smirk.

You will die making angels in the snow, succumbing to the cold and to sleep. Your paintings will die with you.

There will be no rescue. You will not be discovered. They will not take an axe to your studio door to wrest you

45

from your work and carry your paintings and your pure, but nearly lifeless, body to the Tate for the opening of your retrospective. You will die and your paintings with you for there is too much negative and middling stuff around, and your work, however good, will be buried in it. Everybody's mother paints, everybody's.

What I've come to tell you is this: you're the manager of your art life. At this point, nobody else will apply — not your wife, kid or best friend, however they may praise what you're doing. Since there are no managers in monastaries you'll be able to climb down from the abbey to take a look at what you're doing, leaving the trappings of your pure life behind, at least for the time it takes you to make some practical decisions.

Uppermost among these decisions is to continue painting. And you're not going to do that if your life is dragging around your knees, the wife and kid gone, with bill collectors pounding at the door, and that best friend unavailable to phone calls. Those who might otherwise buy an inexpensive painting look into your eyes and see desperation where confidence should be, and they'll tell you they'll get back to you.

Before you climb back to the abbey understand that you are responsible for your own success. To achieve it you've got to paint in the monastery and succeed in the marketplace. Since that means being in both places at different times, you'll have to commute. And for a while you're going to keep your place in society — that includes your job. The best job to make the transition from the work-a-day guy to a self-sustaining artist is the one you hold. Keep it.

Go slow. Make evolution, not war. Get your suit cleaned and pressed. You're not ready to abandon it yet. You get paid. You owe a day's work. Give it and come home. Those around you presumably love you. Return it. Take out the garbage. Then go paint.

For a while you're going to play the part of a work-a-day pigeon, so heed well **Pigeon Factor 57:**

> If you're going to be taken for a pigeon, you better act like one. Pigeons do this very well.

Be focused in what you do, but don't let it get away from you. Divide your life in a way that will work for you. That's your first concession to reality. It may hurt, but you'll get over it.

I knew a guy who went to heaven. He did it every year. He did it by managing a divided life. He was the coffee man in a hot-springs resort between Los Angeles and Las Vegas. It was a big, full-board resort with starched waiters and a tiled pool. It catered to those coming from or going to the casinos, a halfway house for gamblers. They could taper off with card games, snooker, and golf. If you weren't into this, you could dance to a local orchestra or sit around on outdoor chairs.

I was in college and worked summers and holidays as a lifeguard, a fiction I maintained by looking attentive and ready to spring into the pool at a moment's notice. Having me there tended to mitigate against lawsuits. Those who worked at the resort, lived there. We ate three meals a day just off the main dining room. Nobody ever complained about the food.

The coffee man's job allowed him plenty of time to read and, judging from the size of him, to eat. When he'd finish a book, he'd pass it along to me. He'd bring it down to the pool at night when the guests had gone, and we'd sit around the darkened pool sipping Bulldog Ale. That's how I came to know how he'd gone to heaven.

As you might guess, it doesn't take a heavy reader to make enough coffee to keep the resort's urns perking. Just as long as he kept it coming hot and thick, night and day, nobody would care if he graduated from Harvard, which, as it turns out, he did. He said he was a lawyer, but he didn't like law, so he quit and did a lot of other things he grew to like less. Then he found the resort about ten years back got to making coffee and got to participating in his idea of heaven, which I learned was to gamble and live the life of a high roller.

He did this by rolling low. I'll explain.

Like all gamblers, he's done his share of losing over the

years. And like all gamblers I've met, he had a system which he wanted to talk about. All the ones I'd previously heard would turn out to be just another way of losing. But the coffee man's system was different. He intended to lose going in.

After nine months of making coffee, reading and, as I say, eating pretty well, he'd take his savings on a Greyhound bus to Las Vegas. He'd check into one of the best hotel-casinos. For a long term, steady gambler the rates were next to nil, because the hotel intends to survive on what he and others like him lose. A plush hotel room, free drinks, hor d'oeuvres, and slinky young ladies carrying sandwiches were geared to keep the steady gamblers at the table where they played and paid for the services and a whole lot more.

The coffee man stayed there late afternoons and most nights. The system he had worked out was how to lose slowly. He stayed with one game — I think it was Keno — and win or lose he'd maintain the system. Never get greedy. Never despair. He could stretch his life of luxury out for months, while gradually going broke. He said you had to keep at it like a job.

He'd put in a long day eating sandwiches, drinking, talking to the girls, and losing a little. Remember, this guy loved the life of a gambler a lot more than he liked to gamble. At the end of the day he'd go upstairs, soak in a hot tub, sip a brandy, do some reading, and sleep eight hours in satin sheets. It took discipline, he said. You couldn't let things slide. If you took a day or two off, they might up the rent or slow up on the drinks. If his luck ran out, he'd go back to making coffee in as little as two months. His record was six months in heaven.

The divided life may not yet be bringing you heaven. But it's a lot better than the alternative.

Chapter VII

Mystics and Mirrors

*T*he next time you meet an artist who is impressed with *himself, you owe it to him to tell him this: A painting has little to do with the man holding the brush. If he's any good at all, he's but an instrument through which those who have proceeded him and are now long dead speak.*

You won't find a whole lot of this kind of talk in your stand-up How-To books, but since my aim is to set you on the hallelujah road to fame and riches you're going to have to understand that you're not working altogether alone. Fact is, you've got company.

What I'm saying is that the talent to which you're forever referring, believing it sets you apart from others and gives you a license to steal may not belong to you, and what's worse, it may not belong to you for long.

I contend that you don't own this gift and if what you're doing is worth looking at, you're only drawing it on account. There are a host of checks and balances to see that it's not squandered. Your account is open so long as what you do is honest, the intentions sincere, the work truthful, and that it's done with an absence of ego.

This is not too popular among a lot of artists I know. Most, as you might guess, are not all that big on humility. So when you put anything between their work and the praise they plan to get for it, you're likely to run into trouble. Just as you're likely to stir up some ire on the issue of truthfulness.

Taking the last first, I owe a definition of truth in painting. That's not easy. Painting is fiction, as you know, and is a product of a lot of manipulation, deceptions, tricks, and sleights of hand. None of these makes a painting a lie. Rather, these skills had better be a part of the artist's baggage, for he, like the writer of fiction and the age-old conjurer, must make his work convincing. The ancient shaman, ministering to his ailing chief, had better not spend a lot of time rummaging through his deerskin bag of potions and dead frogs searching for a cure. He better know. And if he doesn't, he better pretend he does if he intends to walk out of the lean-to with working body parts. As any doctor will tell you, there's no lie involved here, just good medicine — defensive medicine, in this case.

So what is a lie? A painting created for the sole purpose of sale, recognition, or propaganda. (That's "sole" as in only.) Sometimes things get mixed up and a painting survives a painter's worst intentions.

I like money and this book is designed to make you as much as you need or want. Recognition is a by-product of success, and since one reinforces the other I'm going to show you how we can move recognition along a little faster.

But if what exclusively drives you to paint that picture on the easel is pound sterling, dollars, yen, and/or what that picture will do for your reputation as an artist, it'll be a lie and it will be written all over it. You've seen 'em. I've seen 'em.

From the most saccharine tourist-town art to the most flagrant sensation of art-as-happening, these distant cousins share the lie: one for the money, two for the show.

"Ah-hah!" you say. So what about portraiture? What self-respecting artist would do this for anything other than money, given that he can't find honest work?

50

Not many. But the exceptions are notable and marvelous, not a few masterpieces among them. What is overcome in these good pictures and in these great ones is the vanity of the sitter. His demands are shelved on behalf of honesty. What emerges are revealing glimpses of what a portrait must contain: the character of the sitter as filtered through the artist, even when both characters are vain. I'm thinking of Velásquez, Goya, Rembrandt, Gauguin, Van Gogh, Cassatt, Sargent (occasionally), Picasso among a long list of greats.

What makes it art also makes it hard for the portrait painter to collect his fee. You'll see a lot of good portraits listed in the artist's collection. That means what you think it means: the artist couldn't unload it.

Not many sitters — again, with some notable exceptions — are strong enough to take honesty. So can we blame the painter when his well is dry, for some judicious work on the matron's wrinkles, a sable brush mellowing of some chalky skin? Of course we cannot. But it doesn't make the painting less of a lie. It's pasted all over the super-sweet countenance and the stultifying smile of what might otherwise be an agreeable sitter. It hangs above the fireplace, this thing, and says to every guest with eyes, "Look at me. I'm a lie."

As to those of the leading edge who are leading us off it with their thirst for recognition, for what, if not their notoriety, are they brewing their tedious schemes? When they deign to use the painted surface, the lie they unfurl speaks volumes about the painter and his intentions, and of course his cherished ego.

While we're speaking of dishonesty, at the other end of the spectrum is another group which needs attention and since they're public figures, they can handle it. These are the celebrities who belatedly discover that they were also artists all along. Though there are one or two fine exceptions, most all of them came to art once they learned their name could sell it. Just as others sell sausages, designer underwear and weight loss programs, these folks set in with the appropriate pomposity to be entrepreneurial artists, maybe the worst kind. Ironically, most of them are comedians and actors, oc-

cupations painfully apparent from their work. One is an aged singer with a well-chronicled history of art bashing, who has shamelessly published a book of his own drivel.

So let's get to the truth in art.

Whatever truth art reveals it ought to be universal, the beauty enduring, because if it's art, it's going to be with us for a while, not just for its historical position as a low-water mark in a decaying civilization.

Politically charged art or art based on socially correct thinking, if it meets its intentions, is not art at all, but illustration. Unless it is also art — as in much of Daumier's fine work — it won't outlive the political idea or the fashionable social one it serves to illustrate.

The best of Diego Rivera is in his murals and they were politically charged as Rockefeller belatedly found out after commissioning some walls at his New York center. But they were far more than that, something Rockefeller — for all his apparent interest in art — sacrificed for political expediency. Today, Rivera's politics seem naïve, but his work — the real truth — stands strong.

There are a lot of temporary truths in fashionable thinking; what is morally, sociologically, and politically correct. If you chase these, you're chasing the topical. What you get is propaganda, not art.

Though now is the time of sexual politics, art has no comment. It doesn't give a damn if it's a man or woman standing behind the brush. The feminist who demands a distinction at once demeans her constituency and art.

Rembrandt's carcass of bloody beef speaks to us as only truth and beauty can: silently. It doesn't need to muster a vote on it. The work is not subject to polls. There's nothing democratic about it; it does not need to reach a plurality of believers.

It is because it is.

Despite record numbers pushing strollers through museums on Sundays, art is not for everyone the way Super Bowls and Test Matches are. Sadly.

It's that artist, alone, who must wrench the beauty out

of that plate of ripening carp. When he succeeds and it stands as a truth, he won't be invited to discuss it on late night TV.

So why all this straight-arrow stuff: truth, beauty and sneaking up on money? Because of spooks, that's why.

I defy any artist to deny he hasn't felt the touch of long dead artists, hasn't felt the breath of a spirit at his shoulder, hasn't had the chain of "happy accidents" stretch to infinity. We're not talking salt over the shoulder, walking around ladders, and such. We're talking ghosts, spirits, and boogie men. You want to sleep nights? Then listen up. To the artist, the mystical is pretty familiar territory — a lot of what you call historical precedence.

A long time after the beginning man chased beasts with sharpened sticks, and the skilled and lucky came back with meat which was cooked in the fire in front of the cave. The equally skilled and unlucky came back carrying only the stick. It became known that a few were lucky most of the time. Since everybody was more or less equally hungry, they were, it could be said, equally motivated. Likewise they were fleet of foot, agile, because arguments and family squabbles often eliminated those who were not.

When the same lucky hunters brought back their killings day after day, luck became a frequent subject for campfire discussions. The berry picker was naturally excluded from these conversations. He was fat and lame and was kept around as a source of humor, and because he was pretty good at his job. It was resolved one night that those with luck in hunting would teach luck to those who didn't have any. They were asked to get their sticks and demonstrate, which they did with great zeal and authority, posturing and jumping up and down in the firelight. There was a little more acting than there needed to be, but on the whole it was pretty impressive, though with all the shouting and yelling, it didn't seem the best way to catch an animal unaware.

The following day, when those without luck again returned empty handed, they demanded of those with luck a

demonstration in the field, for they said only in the field could anything practical be learned about this luck.

So those without luck followed their teachers into the field to see how the lucky ones killed the animals. The teachers, with great stealth, spears raised, began their approach to the grazing animals. The students followed, scuffing along, chatting among themselves, tripping over dead branches, coughing, and such.

Not surprisingly the animals ran before the lucky ones could reach them. It was suggested that they show their skills on an animal that was already dead and not likely to run away. So the next time an animal was killed, instead of eating it straight away, they put it in the grass. The hunters did their elaborate routine, but it was no better than the demonstration at the fire. It didn't have the ring of truth.

They tied the dead animal to a tree as if it were grazing, and that was better, though it seemed a waste of good meat. And before those without luck could get the hang of what those with luck were teaching, the animal got to smelling bad.

So they had another meeting. All agreed that what they needed was something that looked like an animal but didn't get to smell like one. Nobody had any ideas so they turned to the berry picker, who, until asked questions, was necessarily silent. In addition to being funny to look at, the berry picker was known for his strange ideas, for his habit of smearing his ample body with berry juice at the end of the day and not bathing in the river as much as was the custom.

He told those assembled that he had an idea, and if he could take the following day off, he'd show them. They granted him that. It was late berry season by then and everyone was sick of them anyway.

Finally, when the lucky and unlucky got back to the cave before dark the next day they found their fat plucker painting on the cave wall just inside. He was painting in berry juice and mud, and the image had a pretty fair likeness to one of the animals they regularly hunted. When he stepped downwind, the others thought it smelled all right.

So they tried it out, the teachers with the common folk

looking on. Again, there was a lot of jumping around, pointing at the painting and stabbing their sticks in the air. But like before, they got tired and stopped. The drawing didn't move. Even when the berry picker touched it up with some sienna and umber, it didn't have any feeling of life to it.

That night when they sat around the fire at the entrance to the cave, they discussed the funniest way they could dispatch the berry picker once the season was over. The subject of the grisly humor sat just outside the edge of the firelight praying for an unusually long season. He was given no meat, since that would be a waste.

The fire keeper saw it first. He had gathered an armful of dry wood from the recesses of the cave and was on his way to replenish the fire when he passed the painting. It moved a little. First to the right, then abruptly to the left. He called to the others. Together they watched the painting dance in the flickering firelight.

It was exactly what they wanted. A moving animal that didn't stink. The berry picker was duly honored, if from a distance. He told them he had planned the whole thing and that the movement by firelight — though subordinately a matter of spirits and other mystical things — was something he, the berry picker, could fully control. He offered to explain if they'd pass him some meat.

Thus began, in the embodiment of one fat berry picker, the first artist and the first shaman. As it turned out, he was not the first liar. There was a still longer precedent for that.

Consider **Pigeon Factor 58:**

> Though there's little conclusive evidence that pigeons believe in ghosts, the studies are limited.

But you're not a pigeon and as an artist it's likely you will understand these matters of spirit, just as it is likely that those who aren't won't. In the East the subject is easier to broach. Their eyes don't glaze over. They don't smile, shake their heads, and scuff the toe of their shoes in the sand. They know the spirit and pay homage to it each day they pick up a brush or feed a mountain kiln to fire their smoke-

green celadon pots. There's a ritualism which speaks to them. I have not met an Eastern artist, Japanese, Korean, or Chinese who would say or do anything to discredit the spirit they believe stands behind them when they paint.

QUESTION. Wait a minute. Let's hold it there.
ANSWER. What do you mean?

Q. I mean come on. We're gettin' in over the boots here. You say you got it divided: artists and the world. Them that believe, them that don't. You're talkin' ghosts here, right?

A. All right, yeah. You could say I'm talkin' ghosts. But give me a chance to explain. I'm not talkin' bedsheets.

Q. That would be an improvement.

A. I'm just telling you how it works. As an artist, you know, you're working along and the painting's doing just fine and you're getting to feel pretty good about yourself. You handled that passage just the way it ought to be handled. You got some color working one against the other. You're getting the thing said, you know, and you don't feel you're all that bad as an artist.

Stepping back, squinting a little, you get it that you're not bad at all — pretty clever, really. You're full of compliments for yourself, for doing such a hell of a painting and you put down your brushes for the day. You go get a drink and sit in front of your painting. Now the painting is brilliant.

The next day you look. It's not the same painting. It's a joke. A parody of what you were doing the day before. The color leaping out, attacking you. The whole painting is obvious, clumsy, garish. It is not the painting you left when you went to bed last night.

Q. You're saying what? Some spook got it, he didn't like what you were doing, drifted in during the night and re-painted? Who's this guy? This guy's maybe Van Gogh in a nightshirt? Your grandfather, maybe, didn't buy a picture from brother Theo? Come on.

A. OK, here's another. You're going along with a painting; you got some idea and you're moving along with it and

your brush leaks, you know? You got some color running and you flick at it with a cloth but the cloth's got some color and all of it smears across a passage you'd been laboring over. You're mad. You sit down. Then you take another look at it. And when you look at what's happened, you see something different, a different way to approach it, maybe a change in the subject matter or in the color or application. Anyway, it's a solution. You use the accident and build around it. And maybe this mistake becomes the focus of the painting.

Q. Oh, sure. This is this guy you were telling me about, standing behind you with bad breath. He did this? He made the color run and all this other stuff? This is what you're saying. Right?

A. I'm not saying it's a "he." I don't know what *it* is. But it *is* an answer to a problem, and that answer teaches you something, same as if you had somebody behind you telling you what to do.

Q. This guy get paid, this teacher?

A. Get off it. I'm saying this: sometimes you paint over your head. And it goes on, throughout the painting and when you look at it in the end, you see how great it is, but this time you know how little you had to do with it. Everytime you see that painting, or reproductions of it, you know it is only nominally yours. You know that you can't paint that well.

Q. So, what do you do? You leave milk and cookies around at night? Hang a stocking?

A. OK, let's drop it.

Q. You get Lautrec dropping in, you gotta do better than milk. Anything less than a quart of gin and this guy'll really get after your paintings.

A. Look. You asked me about this thing. I'm telling you. You don't like the answer. Ask somebody else.

Q. You guys, you know, you're all alike. You ask a question, you get deep mystic, whacko stuff. You're making a living, same's anybody else, right? So I make a living too. I'm

57

making six figures pushing computers. Do I talk to you about spooks at night?

A. OK, let's forget it.

Q. I mean come on with this stuff. What do you take me for?

Maybe he's right and "mystical" is too strong. But I have a story I'm wanting to tell you about, and I'm guessing something along these lines nudged you into art. I'm wondering if we all have stories like this.

It's early morning in Paris. The barbershop has opened. Two chairs are already filled, and there's a third behind which an idle barber waits. I'm at a kiosk just in front of the shop pretending to look at the magazines. I'm toying with the possibility of occupying the remaining chair. I'm wanting the luxury of a straight-edged shave, though I'd shaved not more than an hour before.

It's Sunday with the sun low, spilling darks and lights and long shadows, the traffic behind me still a soft purr. I'm weighing the cost of this shave I don't need with the francs in my wallet. I'm weighing it against needing lunch later and having a few beers before driving back to Orleans and the army.

I'm standing there thumbing through a *Paris Match* considering whether I'm the only young man in the city without a girl to talk to or stay in bed with. I'm in front of the barbers' with the sun rising and I'm thinking about being a writer.

I was up early that morning, and after croissants and coffee, I took a Metro to here, to where I hadn't been — which is one thing you can do if you're without a girl in Paris to talk to and take to breakfast and walk hand in hand with. What you can do is go to places and walk new streets, streets you're a stranger to.

I turned from the kiosk. I remember turning and I remember seeing it as a low building across several lanes of traffic, the sun lying on the ragged edge of the rooftops. I could remember reading the sign on it that announced it as a museum. I crossed directly in front of the building, slow-

ing, almost stopping, as a car passed just in front of me. It was the Jeu de Paume and the door was open.

Inside it was dark with lights on the paintings and with the glass cases illuminated, and I had all the time in the world. They were Impressionist paintings and in the cases were some of the things from the studios of long dead artists: a crusty pallet, dusty bottles, paint-caked rags folded neatly, colors in crushed, odd-looking tubes.

At the far end of the darkened hall, a Turner was showing, a shipwreck in a churning sea, but it was the evanescent sky that was the painting, washed in warms and yellows and wets. There was another painting between that and the Renoir. But I can't see it. I don't remember it, because of what the Renoir did.

It was *Jeun Fis aux Piano* and I knew what this man knew. As though I were this man, I knew it. For the painting was lit from the gold and russetts and underlying greens of the girls' hair. From there it spilled across the outstretched pale arm of the one at the keyboard.

I was not an artist, and while I had seen many paintings, this was the first time I knew. It was the first time I knew the man who painted a picture as he knew himself. And it came to me in the hair of the blonde girl in the painting. And it came, this knowing, strong enough to make me want to weep.

Among other paintings, there was a Van Gogh, which was lit with thick, oleaginous strokes laid wet on a still wet canvas. The power and the pain somehow fused. Beside it in the case sat his brushes, worn like run-down heels.

I walked out then, into the sunlight, for I had seen in those paintings all the paintings in the world. And I met all those who painted them.

I walked back through the traffic. This time not slowing, not stopping. I walked as though there were no horns or complaining brakes. I walked to the pavement under the arcades and, after that, walked for miles.

Much later, lost and looking for a Metro, it occurred to me: there had been nobody in the museum. No one taking tickets, no one viewing paintings, no guards, no attendants, no one.

The schedule I found weeks later in Orleans when I was planning another trip to Paris and to the Jeu de Paume was undoubtedly wrong. For it said that the museum did not open until one o'clock on Sundays. You couldn't go Mondays; it was closed. But you could go in the mornings other days, because it opened at ten. The only thing you couldn't do, the schedule said, was to go to the museum on Sunday mornings.

Q. You expect me to believe this? They left the place open for you? So a guy can walk off with a Turner on Sunday mornings? Wha'd'ya tellin' me here?

A. Look. Don't worry about it. Take it as a story if you want.

Q. Old man Renoir singled you out, right. I mean, come on with this stuff.

A. I told you, forget it. Don't lose sleep. Forget the story if it bothers you.

Q. Whacko stuff. You know? Really whacko.

A. OK, let me tell you another story.

The spiritual leader's reputation preceeded him. Though young and uncommonly good looking for his trade, he had gathered a large following among the rich and famous in the boomtown mentality of Korea in the 1980s.

He had heard about me, an artist and teacher who had lived in his country for years. I had my first successful international show in Japan, had accumulated many friends there and in Korea, and was writing a column, "The Outsider," for the major English language daily out of Seoul. I was free to write most anything that gave the reader an insight into what foreigners thought about Korean life. I could aspire to being a sort of Toqueville of the East.

A mutual friend had told me about this spiritual leader and how he was set on meeting me after reading a translation of a column of mine which appeared in the *Korean Times*.

It went like this:

I was walking on one of the lighted, lively streets of

60

Nomdaemoon the other night and passed a darkened window. I saw myself there and the reflection was startling.

I'd gone to this vast market to find a present for a German friend, something Korean, a fluted vase, anything. As always I got caught up in the rhythm of the place, the pulsating chants of the merchants as they worked the crowd, the candles, the lights, the faces, the colors and how the smell of one part differed from another.

I was not walking, really, but being carried along, being jostled, tugged, pulled, carried in the current of the crowd. Seeing everything and nothing. Losing myself to the faces, images, and sounds.

So when I saw myself in the window it took a moment to recognize the image there. When it occurred to me that I was not looking at a strange man in the crowd, but at me, I was taken aback. I was not a part of the crowd as I believed, but someone separate. I saw me as those around must see me.

I had forgotten I was not Korean.

The man I saw peering at me from the reflection of the window for those few seconds was clearly a Westerner, an American, maybe, with all the good and bad that comes with that. There he was, his looming face above the crowd, dishevelled hair, long straight nose, moustache, his height giving him a disadvantaged, awkward look.

The first thing that struck me is that he was alone. He was not talking or laughing or calling to someone or shouting or walking arm in arm with another as others around him were.

His big, awkward face was like a moon and it was perched above the murky images of those who surrounded him. Looking serious and somehow comical.

I saw him as Koreans might.

I saw the humour in him, the great, clumsy good-naturedness of a man bent on being an appropriate guest in a country so strange and different from his own. In him I saw the reason children smile and greet him with "*Ajosi!,*" a sort of "Hey, uncle," as he walks through his neighbourhood or buys potato chips in one of the child-clogged shops near his home. "*Ajosi,*" they shout, "*Ajosi,*" as he passes, lugging his plastic sack of potato chips and

OB beers. He smiles and waves and says his part out of the phrase book, *"Anyong haseo,"* believing it to be too formal a greeting for children but not knowing anything more appropriate.

It was I in the window, this hulking, comical mute who children call *Ajosi.*

I saw in the man in the window that night other men like him who years ago came here to fight a war they didn't fully understand in a place they didn't understand at all, but who came nonetheless and fought and died, some of them, or returned to tell of a new world they discovered.

I saw my brother in this man.

Also I saw the threat this man in the window poses, the suspicion that he can, by some invisible power, absorb Korea and its life and replace it with culture, standards and values identical to his own. I saw him as a sinister Pied Piper to those young enough or foolish enough to believe in hard rock and discos and T-shirts with Western slogans, and to those who wanted to emulate his casual, careless ways.

When a young man fails to relinquish his seat to the old man who boards the crowded bus, the ill manners are the fault of the man in the window and what he has brought.

And I saw opportunity in what was reflected there. If I could get this man to speak to me, I could learn his language. If I could befriend him, I could learn still more, though never enough to understand him nor he me.

And there was the unexpected in the darkened window, fear that this ponderous man would abruptly turn and ask me a question about directions or where he could buy a vase or what one does with the glazed head of a pig, and do it in a language I had only studied in books which I carried in a back-pack on my way to middle school, books that talked about places I had never seen, strange seashores and people who were addressed Mr. and Mrs. Something. Books and teachers who tried to twist my mouth and tongue to make impossible sounds.

But also I was curious about this man, so unlike me.

I'd like to know about his family and Sunday barbeques and suburban homes and freeways and divorces and what it's like to grow up independently, without an endless string of friends, family and associates, and how it is to drive his Dad's car with his girlfriend sitting close and the radio on as though he owned the world.

And I'd like to know why he's here, the man in the darkened window. And what he thinks about, so quiet — comical, really — walking along.

The spiritual leader had called this friend of mine from his home town in Kiungju. He told her that it was the right time for him to meet me, that he would come to Seoul by train, some six hours away, when she had arranged it. He told her that it was important and that he would start the trip in the morning.

When she pointed out that neither he nor I could speak the other's language and that I had absolutely no interest in spiritual leaders, he would have none of it. He would come to Seoul the following day. If she was not to help, he would stay in a hotel room until she did. "He will meet me," he said.

The day we met was a hot August one. She introduced us in the hotel coffee shop. He was dressed in the traditional *Moh-Shi*, a ramie suit, with shirt and pants looking like starched and pressed mosquito netting. It was clothing you rarely saw these days and then only on old men in the countryside.

His hair was black, cut precisely; beneath it was a boyish smile. He did not look like a *doh-sah*, a spiritual leader. Those I had seen were grey haired, expansive men with inward-turning saturnine eyes. They were old and privileged enough to wear a beard. This one was clean shaven. You could almost smell the talc.

He sat down, took out a pocket mirror, and looked at himself. He looked at himself for a long time, then at his coffee, then at me. He smiled, then drank his coffee. When he was finished, he looked at his mirror and again at me.

Curiously, it was hard to return the look. It was hard to

63

meet his gaze. Our friend was carrying the conversation, translating some of what was returned to her, but mostly engaging him with questions about the travail of his trip, or so I gathered.

He may also have had some trouble looking at me, for both of us used our friend as cover, as a distraction to covertly size the other up. He would often refer to his mirror.

As these things so often go, there was a lot of talk and little translation, though I was the subject of it. I knew from the frequent glances and the respectful references to *joh-sa-neme*, the teacher. It was nearly like not being there.

When they stopped talking once, I thought it was so that I'd get a translation. She asked me if they could see my right hand. When I extended it across the table, it was received with the suppressed excitement of discovering a previously undocumented Gainsborough in a garage sale. A lot of furtive whispering and solemn confirmations were exchanged. *Do-sah* leaned back and looked at himself in the mirror. My friend was clearly in shock.

When I got my hand back, I looked at it. It looked pretty much as it had for the past forty-odd years.

Though there was a lot more talk after that, I didn't learn about the hand and what brought on the Gainsborough reaction until later. I learned it after *doh-sah* had gone.

He had described my hand to her before I showed it to them. He had told her what she would see, the way one of the creases in my palm would run straight across the width of my hand as though it were drawn with a ruler and then at exactly what point and in what way it would intersect another.

Since then, though I've not taken a survey, the lines in the palm of my hand have in no way conformed to any other I've seen.

The news he had left with my friend before all of us parted was that he was to be my spiritual guide, whether I thought I needed such a thing or not. Since he had spent his life doing what he wanted to do, there was no denying him. And, apparently, he didn't need my permission.

He's been as good as his word. We call each other brothers. He's been at my side at opening receptions, I, at his in his historic town when we climbed the mountain to stand before his great stone Buddha. Though his words to me and mine to him are limited, neither of us is afraid of silence.

I've learned of his life of poverty, how he taught himself to read and write the ancient scripts, and the mysterious events that brought him to it. I've learned how he could meditate through a full winter day and night atop his mountain, and how his faith had, he said, transcended the cold. And I learned about the mirror and why my column about the reflection in the darkened window in the market brought me to his attention.

It was not vanity that made him consult the mirror throughout his visit. He had me understand that the mirror kept his spiritualism in check. It permitted him to see himself as others saw him. It gave him the reassurance that he had not drifted into the other world from which he could no longer communicate. He made me believe that he straddled both worlds, and the second one was so seductive that, if he were not anchored by his image to the first, he may cross to it and never return.

He likened his mission to my own, and to yours as an artist: to occupy the middle distance, to be best able to teach one world about another.

It was from him I learned of the shaman and the artist, what was meant by the image in the darkened window that night in Nomdaemoon, and the function of the mirror in art. It was in the context of his other world that I understood the importance of the critical eye.

I had been using the mirror in my studio, almost from the beginning, to offset a crippling and embarrassing deficiency: the inability to see straight. Literally.

Everything I paint or draw falls dramatically to the left, like having one short leg. Despite my knowing about this failing and making compensation for it, everything — I mean all of it — will lean to windward, and it's no light breeze.

So, by habit, I build my paintings around the mirror I've come to anchor across from my easel wherever I am.

It's a pair of fresh eyes and a built up shoe. I catch the lean while the painting is but framework and, lest it creep back in, check it every time I turn to wash a brush.

I hadn't thought of the second imperative for the mirror until I began to understand *doh-sah*'s mission and the parallel his mission has to my own and yours. I had quite inadvertantly begun to use the mirror as a bridge to span two worlds.

Chapter VIII

The Critical Eye

As I've urged you, most art schools, departments and the teachers in them ought to be avoided, though, if you have succumbed to the popular belief that they would do you some good, rest assured that the damage they inflict is generally not permanent and can be overcome.

If the school had a library and directed you there, your education wasn't a dead loss. There is information in a host of good books which you need to read if you haven't. From the color wheel forward you begin the long apprenticeship with that most arduous of taskmasters, the critical eye.

Let it be your own. Let it be intelligent and studied. Let it be skeptical, unsympathetic, demanding. Let it never be content with what it sees. Never.

If you've got an eye like that — or can develop one — you're half way home. But if you haven't done a lot of this, let me warn you about some of the problems you will encounter in developing a critical eye so that you can protect yourself from the twin evils: triumph and despair.

I told you of my days teaching sculpture in Mexico. Regularly, the student would begin with a portrait study of a

model, a life-size bust in clay, from which he would learn, among other things, how to cast it into permanent material. The course was open to sculptors and painters alike and to those who had come to learn about art for the first time. From this last group a pattern would emerge.

The student who was a businessman out of Chicago told me that he was not sure he had the eyes right. He told me this in a tone that made it sound like he was quite sure they were perfect.

He called me over to his modeling stand and stepped back from his work in clay. He was a balding, heavy-set man who had been a good-natured novice until then. Now his eyes, dark beneath a thicket of brows, defied me to find anything wrong with the masterpiece before us.

He was on a two-week vacation and had maybe twenty hours on this, his first, sculpture. It was not as bad as they get.

"I don't know, the left eye, maybe. What do you think?" He was clearly having second thoughts, his voice tremulous as though he were restoring a clay study for the head of *David*. I had heard that he owned three apartment buildings on the Outer Drive and had bought and sold a baseball team.

He was in the bloom of his first creation and didn't understand the trick of the eyes. He had been too close to his work and didn't know how his eyes could lie to him. Since it was better than most first efforts, I wanted to help him. I wanted to show him now rather than have him learn later, as I was sure he would, that it was a mistake.

He wanted me only to tell him that the sculpture was wonderful. Instead, after I had turned the piece slowly on the stand, I asked for his modeling tool. I cleared the dry clay from the curved edge with my thumbnail and positioned it above the left ear, then drew a line in the clay that ran through the careful modeling of the eyes to the top of the right ear. It revealed the positioning error.

When he protested, I told him that I could not show him any other way, that I could not, in honesty, tell him it was a matter of one thing and have him change that. He told me he couldn't understand why I couldn't just tell him to change one thing.

I explained that everything was built from the beginning and ended in the end, and if anything was left wrong along the way, all of it was wrong.

He said he wasn't arguing, but couldn't he have adjusted the thing that was wrong; wouldn't that have been easier than having to do the whole damn thing again from scratch? When his voice rose, other students around us turned to listen.

I told him it would be easier, but that would not make it right, that he would end up with a portrait with something wrong about the eyes.

I knew he would argue some more, but in the end he would repair the damage and after another five hours or so he would have a better piece. It would still not be as good as he believed and when he'd cast it and could no longer see it, in his mind it would improve some more. When he would chip it out the next day with a mallet and chisel, the piece would emerge. It would be a disappointment. He would not believe it was the same piece he had cast and had been enthusiastic about. He would wonder if there had been a mix-up and if he had chipped out someone else's.

In the clay, after he had repaired the damage inflicted upon it, it looked so much better than it did in the plaster. He did not know that the long hours working on it had mesmerized him, had made him think the piece was somehow important.

But he would finish just the same. His two week vacation was running out with nothing to show to his wife. Under running water he would sand the roughness from the plaster. He would repair the airholes and the parts of the face damaged by the chisel. And with all the work it would seem better and he would want to put some concoction of patina on it and mount it on a piece of sanded mesquite. The concentrated hours of work on it would again make him believe it was something it was not. But he would remember how he had been tricked. He had not used his eyes before and did not know the tricks, yet he was learning.

It would make him uncertain. Sometimes when he

69

looked at his work, he'd see it was good and worth preserving. At other times it would look like something the former owner of a baseball team would make. But he would take it home on the plane, not trusting it to go in his luggage, he would carry it wrapped up in his lap.

At home he would show it to his wife and when she exclaimed it's greatness he would display it on the mantle. He would stop and study it sometimes in passing. When his friends visited he would joke about it, about a businessman trying to be a sculptor in two weeks. But he would watch his friends when he joked. He would try to read their faces. After a while, he would put it in the attic.

The eye is like that. It will fool you for a long time before you are able to take stock in what it tells you. But if you question its authority, it will fool you less.

For some reason, it takes to extremes, the critical eye, either total praise or darkest vilification. It's why so many artists in history sought cheer or solace by draining whiskey bottles.

Believe neither extreme. Work with it. Leave a piece for a time. Come back to it. Use a mirror. See it as others must, for if you are an artist, you are a communicator. A painting is an optical exchange between the one who paints it and the one who looks at it. One set of eyes to another. It's the purest communication and needs no words to sully it.

If a painter finds he needs words to elaborate on what he's done, he's violating an unspoken agreement. At best, he's redundant. At worst, he's a journalist practicing the wrong craft.

A painting ought to stand on its own. It should not do everything for the spectator, nor should the spectator do everything for the painting. The painting should encourage what should be the best relationship between them, a collaboration.

But if there's nothing in it for the spectator, he oughtn't to feel bad about it, he oughtn't to think it his fault for not understanding, provided he has made a reasonable effort to

do so. The painting fails to communicate. The lines are down. It may be strong in form and content. It may be bold or striking. It may be drenched in the artist's emotion. But unless it speaks — and gets listened to — it ain't art.

It needs to speak to more than the artist's roommate and three other guys. Four guys do not a universal truth make.

What I'm hesitating to tell you is this: this failure to communicate is why most contemporary painting fails as art, fails as painting, fails as entertainment, fails as contemporary thought.

I realize that's blasphemous and I hasten to support my contention before the *Le Club* gets to mounting their assault, before they find a moderator for their round table, before they assemble their critics and curators, and before they facilitate debate with participators and get media experts and art historians and professors of aesthetics talking about establishing symposia with meaningful dialogue.

But the fact remains: most contemporary art isn't art.

And I say this fully cognizant of **Pigeon Factor 59:**

A pigeon who roosts with his back to the wind is going to get his feathers rumpled.

I know I'm not going to win a popularity contest, but I'm saying this stuff, this art, is not made to be looked at, and it's not made to be seen. And I'm going to tell you why.

It's Picasso's fault, that's why.

Don't leave me. Stick around for the rest of it. They won't take the book back now anyway.

Let me get to the Picasso problem second. First, let me tell you why most contemporary art is not seen, felt, or understood and is therefore disqualified as art.

It's ugly, that's why.

But worse, it's unrestrained ugliness. It's a second-year drama student emoting the bloody hand scene of *MacBeth*. It's the scream of Edvard Munch without his focus. It is, most of it, expressionism gone berserk — riotous colors, dark purple thinking.

We get emotion in the wrong place. We get it in the painter instead of where it belongs: in what he paints. We

71

get the pizazz. We get the heavy, heavy content. We get un-bridled freedom, and usually we get written instructions.

If you still have any doubts about how the painter feels about his work, look around. In his publicity material there'll be his photo. It's designed to counteract your first and lasting impression of his work: that he's putting you on, that this guy's got to be kidding. One look at his photo — his glowering mug — and you'll know that if this thing he does is a joke, he didn't get it.

We get all this misplaced emotion from artists because they haven't been schooled in the discipline of their trade. And thanks to art teachers from grade one up, they haven't learned there *is* a discipline to their trade.

"Mr. Wilcox, I'm sorry to take your time on this. I fully understand that as grade school principal you have many duties. As you say, I am a qualified first grade teacher. I'm therefore responsible for the behavior of my students in the classroom. And I know Christmas is approaching. And you're right. Children are inclined to get a little wild at this time of the year. But please. This is the third time Robbie has burned down the class tree."

"Miss Reed, I understand. Robbie has been a challenge for all of us. But we can't put everyone in the art class. He'll just have to wait his turn."

There are those who will tell you that the do-your-own-thing, art as therapy is, after all, expressionism.

If you like expressionism as I do, look at one of the best exponents of it, Kokoschka. But don't imagine for a moment that his apparent free-swinging brush and seemingly arbitrary coloration are nothing but stylistic accidents and that the freedom they convey was not plotted, purposeful, even calculating. My guess is that they are exactly that, and that behind his freedom was a thorough understanding of color and line and the knowledge, intuitive or otherwise, that conveying emotion is different from experiencing it (different, like not the same).

Van Gogh, confined to an asylum at the height of his lunacy, produced his best and most restrained paintings.

And it's that *restraint* that charges those canvases with their power, beauty, and emotion.

Take another discipline — fiction. How does Chehkov bring us to tears? By unrestrained exhibitionism? By flinging words at the paper? By telling us how we should feel? No. He calculates — in the most restrictive sense of the word — how to make us, the reader, feel the emotion he intends to convey through the interplay of his characters. He doesn't tell us, he shows us. His prose is not the prolonged shriek of a high school girl at a rock concert.

If you're just getting into painting and you were focusing on venting your frustrations whole cloth thereby achieving instant and permanent fame, let me save you some time. There are already too many pigeons sitting cheek to jowl on that same ledge.

Unless you have a Ph.D. in macroegotistics, it won't work. I tried it. I, too, was an angry young man set on burning the world in my wake: sensitive, impatient, unstudied, petulant — the whole profile.

When I was learning to paint, I loaded brushes with paint and slashed at the canvas. I troweled on great globs of paint with a palette knife the size of my splayed hand. I used sponges and the sides of cardboard. I put paintings under running water. I threw sand at them then scraped. I smeared it all with the side of my fist. I did it all with a lot of emotion. Emotion, then, was what I was best at. Then I'd get mad and do it all over again. I'd walk away from that canvas drenched in sweat. I had put everything I had into that painting. Thank God nothing came back.

So save yourself, some paint, and some canvas. And save us from what you'd produce. Anyway, you'd be loading in at the close of the cycle. The avant-garde as we've known it is wearing a frayed hat, its babble failing to win the audience it once claimed. It's a piece of history, their icons in place, the high and low watermarks of a half-century of unrestrained emoting. It's where we've been.

And it's true, there were some giants among the midgets. They were chroniclers of the times, painters who told how it was. But what was, isn't any longer. The time when we

were all students of our own navels is history. It will become known as the periods when art and society turned in on itself, like abscessed toenails.

But these are new times with new possibilities and new painters. And you're among them. Anyway, God knows, the least we can do is to give our poor critics a break. They've been falling all over themselves trying to come up with new ways to explain the same old stuff.

I listened to a priceless pair on BBC World Service the other day discussing the opening of an exhibit in London. In radio you get it all in words. In this case you didn't need the pictures.

The subject was a geometric artist of the '80s with a show of her last ten years. Critics, we'll call Richard and Sarah, lost the draw and got to attend. Their job, which they apparently took seriously, was to express the inexpressible, to find words that would stir to life paintings where the brush had so clearly failed.

They approached the work like Rorschach tests.

I believe it was Sarah who started off:

"I'm confronted with calm ranks of vertical stripes which, well, disturb the eye. There's a conflict between the colors. The work carries titles like *Burnished Sky, Dark Light,* and *New Day.* And I'm standing before the painting *New Day.* What do you think it means, Richard?"

"Well, Sarah, there are greens, sun-shiny oranges and yellows, shocking pink. And light flickers between them like between trees or branches."

"Yes, the title does mean something doesn't it?" poses Sarah. "Vertical shafts, with space — a lot of space, really. Surprising amount of space there. An awful lot of white really . . ." Sarah, trailing off, is rescued by Richard.

"As I see it there are two ways of looking at it: they're either dead color panels or abstract versions of landscape."

"Yes, Richard, I think you're right. I prefer the former. How would you view it?"

There's a beat or two of silence. Richard is clearly pressed. Finally, taking the safe side he opts for both. There's a piano interlude as they move on. There seems to be a lot

74

of piano between paintings and one wonders if it isn't to disguise some bickering between the two. At last, it's Sarah again:

"You mentioned romance. Isn't it more that she is frightened of romanticism . . . perhaps?"

The piano interlude is back. Now, there is little doubt about the argument. But they've regrouped and the piano fades. It's Richard and I've missed some of it.

". . . shafts of color, diagonal lines. You're right, Sarah, really wide spaces. Vertical shafts of color. Not particularly bright. Don't you think they charge one another with energy?" The question hangs uncomfortably.

A little more music and this time they come back in agreement, their little spat resolved. Both now express confidence that the artist will eventually take her place in the landscape tradition of the English.

More piano and out.

So, let's get back to the guy who in large part got us into this mess: the little Spaniard out of Málaga, Spain, whose genius shaped the way we'd look at art for more than sixty-five years.

Almost from the time he left that city in 1891 to his death in 1973, Picasso was at work in his studio changing the way we looked at the world. His brazen leaps, his parries, his ripostes attached his name to a host of styles and schools and experiments, from cubism through pop, op, minimal and beyond, his name and image engraved on them as his own, even when they were not.

It was not only his astonishing insight which was to change the way we saw ourselves, as an artist of his stature could hardly fail to do, but it was his parapetatic nature that was to do the real damage. As an artist he was a consumer. He engulfed and in that firey belly digested more media, more schools, more ideas than any artist before or since. He ate the best part and spit out the seeds. And he did it so astonishingly often and fast, that we were bewildered, blinded by his lightning facility. With good reason we were sure of the power of the man and were convinced he could best communicate our times. He took on the mantle that he

very well may have intended to wear from the outset. Simultaneously, he became the man, the myth, and the legend for the twentieth century. He took on all comers — and there were many good and great ones — and he won, hands down.

Sadly, he also became the pacemaker. Our heart beat in time to his, and his was in a constant state of fibrillation. It was tough to keep up.

As its principal exponent Picasso moved art through its paces, taking it all, drawing, painting, sculpture, ceramics and, yes, performance. He dazzled us. Before we could marvel long, he had moved on. He never looked back, so neither did we. The times were best for that. With Western industrialism ascending and a post-war East on the mend, these were boom years. The world was Dawson City and Picasso staked claim on the richest vein. Contemplation was out, consumption in. Yesterday's "ism" was a day old, as out of fashion as running boards, rumble seats, and last year's Packard. Art was seen as progressive which, of course, it was not.

Picasso came to his death at full tilt, producing something in his studio, it is said, even on that day. The world of art was panting at his heels. His output was enormous, in part because he never threw anything out, and he didn't coast to a finish.

Even as the genius fell, he left the world with the fire stoked and the engine on a straight track down hill as we continued at the pace he'd set. We were swept through a blur of boundary-breaking clap-trap into and out of the '80s.

Until now.

Now, when reality dawns on that line of pigeons on the sill, stirring against the warming of a new day on the same old roost, shifting against the rising stench beneath them. It's been fifty years or better. There's some fluttering and fuss. They're ripe for a change. Even pigeons breathe.

Pigeon Factor 60 says it better:

> It doesn't take a great talent in reading spoors to know where a pigeon has been. The question is why it took him so long to leave.

I angered a James Street dealer once not long ago in

London. I have always tried to see as much of what's going on in art as I can by seeing as many galleries as I have time for wherever in the world I happen to be. In the interest of time, I've long ago given up pretences and conversational niceties. I'm a painter, not a buyer. I don't want to get anybody's hopes up.

It was a single room and held maybe thirty florescent canvases, all painted with the subtlety of plastic beach chairs. I walked in a few paces, did a 360°, and was on my way out when the dealer stopped me. He was a big, bald-headed man carved from the same tree as the huge desk he occupied, the top of which was as clear and burnished as his pate.

"Surely you can't be through," he said, less a challenge than threat. It must have been a slow day.

"Thank you," I said. I was almost to the door.

"Certainly you could not possibly have seen all these paintings. Clearly you have not studied them. And I should have liked to invite you into the back where I have others." It *was* a bad day.

"I don't think so," I said, "but thank you." He had a hard business and I didn't want to make it harder. But he wanted more.

"Tell me," he said, "how you can leave without seeing these paintings?"

I mumbled something, excused myself and left. It took me three blocks to compose an answer:

"Sir, I've seen your paintings before. I've seen the ones in the back. I've even seen the ones your painter hasn't yet painted. I've seen all too much of them.

"As to my studying them: I've considered these paintings a hell of a lot longer than the painter of them considered me."

It was brilliant. But it was whispered into a brisk head wind on a cold November day. For the next couple of blocks I edited it, making it stronger still.

It would have been devastating.

Chapter IX

How to Make it Look Like You Know What You're Doing

The student will not believe this, as I did not. But if he's serious, he'll come to it as I did. It will take maybe two or three hundred paintings before he begins to understand the nature of paint and how it works on the human eye. But as long as these are burned or buried, who's going to know he didn't understand it all along?

After your pyre, when all of it is ashes, you get to turn to matters of art. You're a painter now. And we're looking ahead. We're talking your next twenty paintings, numbered 300–320.

Make each of them your best. Make them one at a time. Cut a vein. Bleed a little. But stay with us. Don't drift to never-neverland. Use the mirror behind you. Stay conscious. Be cool. Anchor yourself to the middle distance, the no-man's land between the two worlds. You're an artist; you have up-dated passports to both worlds. Don't get lost in either.

These paintings are your stake, your ante in the game of success. They're going to speak for you. They're going to make you. They will form the basis of your credibility as an artist, the foundation for your fame.

And though you will sell them, they'll haunt you.

They'll be with you forever. You don't want to cringe when somewhere down the road you see a reproduction of one. You don't want to have to make excuses for it. You'll have to live with all of them.

This is where you finally get to show everybody that you really know what you're doing.

Since we've been changing the world in these pages, why don't we change it all. I don't know about you, but I'm sick of the sterotypic artist. I don't want to look like him, act like him, or be like him. I've had enough of the B-movie image, the SoHo hype. I don't tell everybody this, but I'm still into booze.

Look. I'm like anyone else. I wear old clothes in the studio too. But I don't wear them all the time. I don't sleep in them. And I don't wear them to dinner, unless it's spaghetti and I'm eating alone. Is it written somewhere that we have to shamble around in worn leather sandals, painted Levi's, and a sweat shirt that would rout a herd of camels from the last water hole? Is there not another way?

I was walking down Tokyo's fashionable Ginza some years back. Walking with me was the director of half-a-dozen world-class galleries. He wanted to show me his newest acquisition. He was wearing black khaki pants, a ragged wool sweater, gym shoes and a beret. I was in a three piece suit. When I pointed out the irony, he shrugged it off. I should have let it alone. Still, how was I to know how things would turn out. Years later, he'd have been overdressed to meet a seated president of the United States.

Maybe everybody wants to look like an artist. Let's let them. While we get to looking like something else. Ponder, briefly, **Pigeon Factor 61:**

> It may not seem that the inordinate amount of time a pigeon spends grooming, fluffing, and preening is justified. But you're not another pigeon.

Please understand, I'm not much of a dresser, but when I show up for the occasional TV interview — maybe the worst format for an artist — the program director gets nervous.

He shakes hands warily. Shielding his eyes against the light, he checks to see if I might be representing someone else in the studio. Making the best of what he's got, he starts in:

"We thought we'd begin with some establishing shots of your paintings. And I'll introduce you and talk a little about each if you can give me something, you know, some ideas. Then I'll ask some questions. We'll chat. You know, we'll sit over on those stools and just sort of have a casual conversation. I'm talkin' casual. Just an interviewer having, you know, a loose, laid back discussion, just talking along . . ."

"Did you want me to take off my suitcoat?"

"God, yes. And can we get rid of the tie?"

Of course it doesn't matter what you wear if you paint good. But who is the guy that decided we have to wear a uniform? I already wore a uniform, without much distinction.

Why do we have to look like a street pusher? And what is this obligatory pose we've got to come up with when we get our picture taken, the one leaning against a brick wall of graffiti? Do we all need to look like the jacket of a one-man heavy metal band?

I know about image. But let's get a new one. Let's leave Bohemia to those who want to pick up what's left of the last fifty or sixty years, those who can't imagine there's another way.

And while we're talking about the Left Bank as history, the Monmartre fantasy, Bohemia as life style, let's talk about another myth: That artists need artists.

You know how it goes. It's in all the movies. Where artists are forever hanging out, hitting up or coming down, forever holding late night conversations in street cafes with models hanging around.

And they're talking heavy stuff and what they're going to do after Mom sends money. They're discussing how it's going to be once they begin to paint the thing they've been talking about for three reels and never seem to get to because of the sub-plots, car chases and the nude scenes.

Who's going to spend ten dollars at the box office watching some guy paint? The big scene is where he steps back on a tube of raw umber. Right?

80

Like anything else, the doing of something isn't all that sensational. So what is slightly better is to get a whole lot of guys sitting around talking about it. That's known as touching base. Getting a feel for what's happening. Readying yourself for what comes around. It's also called drinking.

Not only is no one painting — a hangover is a sure cure for art — if you take the time to track those comprising your art group you'll find that few if any intend to paint. What they intend to do is talk about it 'til Mom's check comes through. Talking's a lot easier, and you can do it and drink at the same time.

But you're forgetting the advantages of networking, the sociologists among us will argue. I hadn't forgotten. Networking is freak-speak for exchanging information. It holds a lot of currency for those who agree with its premise, i.e., there's a wealth of secret information on any subject that is made available only when three or more people get together and order a beer. But it is only available to those three and anyone who joins them, provided the new guy picks up the next round.

It's also believed that there is an exchange of techniques among artists who meet and network. You have as much chance of getting new technical information from a fellow artist as you have of pushing the Mona Lisa out of the Louvre in a shopping cart. Like movie acting and choosing the million dollar lottery ticket, there's a lot of competition for any kind of success in art. Chances are dim at best for one of these guys to reveal anything more technical than opening a tube of cadmium red. **Pigeon Factor 61:**

> A pigeon forever faces a chronic shortage of something to eat. When something appears don't expect a fellow pigeon to make an announcement.

It's much the same for clubs and associations, with the added disadvantage of not being able to drink at meetings. I made the mistake once of co-founding and presiding over a chapter of a long-established professional art association in the cultural backwater of San Diego, California. I had read

the by-laws which favored putting artists on an economic footing in keeping with his contribution to society and believed, as it said, that it could be accomplished with numbers.

As I belatedly learned, there were two sticky parts to the idea. First, we were to draw our credibility from our status as professionals. If one were to maintain a strict definition of the word, i.e., anyone who earned his living exclusively from what he produced as an artist, there might be two people on the West Coast and six nationally who qualified — not exactly the Teamsters. So, the second sticky part came when we bent our rules a little, as every chapter did, until we had a constituency of a hundred housewives, me, and four guys who came each month in order to get away from the kids.

Two things became apparent from the first meetings: I wasn't a politician and nobody liked me. They raised objections to everything I suggested, then spent the evening objecting to what anyone else suggested. There was a lot of noise, internal grumbling. I feared a coup.

When it got late and after each of the members had a chance to express a view, however unrelated to the topic on the floor, and, in the process, establish him or herself as the only artist qualified to speak as one, they decided to approach the city's museum of Fine Art.

Rather, they decided I approach the city's museum. The problem then, as I presume it is now, was the entrance fee charged to an artist who seeks to exhibit. The theoretical question also remains: why should an artist pay to be juried in order to win a place in a show when the chief benefit accrued was publicity for the juror and his taste in art?

It made sense to me. And, since they were no longer talking about an overthrow, I agreed. I took the problem right to the museum director's secretary. She was on vacation so I told her temporary replacement.

In time word came back that he'd be fundraising for the next six months and would get right back to me thereafter if I put my request in writing and left an address.

I took it to a newspaper friend. He wrote a story accurately voicing my objections to the museum's policy and said

that I was speaking on behalf of this resolute power group. When the story appeared, I got a dozen calls inviting me to quietly stand down as first president, that the group hadn't intended to anger the museum, that I didn't tell them I was going to the newspaper, and that it was my fault their chances of exhibiting in the only important venue in San Diego was probably lost. When I countered with the argument of an unjustified entrance fee, they told me it was a small price to pay for the privilege of showing.

I took a seat near the back in the next meeting. The new president was greeted and they moved on. Neither she, nor anyone in the hall, made reference to me. I left before the cookies and punch. How temporary power is.

What I want to tell you is that you're on your own as an artist, the best and only way to be. You don't need committees, clubs, friends, or associates. And when you finish this, you won't even need Mom.

Your place is in the studio, though for a while you'll need to support the habit. It's a good time for testing.

Earlier I told you I would describe what good painting and bad painting was. I lied. But I did make some remarks which you can read if you like or skip if you're hungry and want to get on to the money part.

I'll put 'em down. You decide.

- A painting is a problem with too many solutions and not nearly enough rules. But however the painting is solved, it must derive from, or seem to derive from, the first brush stroke. That stroke and every one following it must lead to the last. In the end it must seem that the artist knew what he was doing from the beginning, though he probably did not. This is only one of a host of deceptions the artist as conjurer uses to make a painting convincing.

- You cannot squeeze the lushness of cadmium orange from a tube without understanding Van Gogh and the lunacy that drove him to eat it.

- Style is not what you think it is. It is not something

83

added to a painting in order for it to be distinctive. Style is something others may recognize. It's nothing more than what the artist calls painting.

- A painter's life is populated with ideas, color he has seen and places he has been, and hope, hope that his next canvas will reflect a small part of how he feels about it all.

- An artist ought to live before he paints and the canvas he produces ought to stand as a testament to what he's seen.

- Never paint sitting down. Stand in front of your canvas with legs apart, brush in hand, as though you were addressing something of great importance. When things are going smoothly, sit down. Try to recall the last time things went smoothly. Then stand up and find out where you went wrong.

- Unless you have been taken hostage and are compelled to do so, never read books that tell you how to paint trees, barns, and furry animals.

- A good painting will speak to you if you care to listen, but don't be embarrassed if the language is intimate: a whispered exchange between the one who paints it and the one who sees it.

- There's a lifetime of reasons for not painting. Don't spend yours that way.

- I've never met a man who wasn't an artist or a writer or would be if he had time.

- Believe only those who praise your paintings for they have the taste and good sense to understand. Believe them even if they're lying.

- I don't often paint what I see, though that's as good a method as any. Most of my paintings contain instead what I imagine or what I'm reminded of. Sometimes I let the ground — a wash of maybe sienna and cobalt — suggest something. A reclining figure here, a landscape

84

there. I paint these things until they take on a feeling of the thing if it did exist. When it does, I quit.

- I don't like theories or paperwork. I don't like to be told what I'm looking at. I don't like titles that describe how deep and sensitive the artist is and how I should feel about what he has done. An artist who begins with a painting ought to end with it. All talk about it is rot.

- No amount of paint will make a bad drawing — or bad idea — good.

- Remember the feeling you got when you closed a good book, when it carried you the distance and you felt alive for making it a part of you? And not wanting to put it down for a while, you looked at the cover again as though you were seeing the book and the name of the one who created it for the first time? That's how paintings are, or can be.

- I remember when we used to apply the word "uplifting" to the arts. I'm old. Maybe that's the problem.

- In art as in literature ugliness rendered with compassion is beauty.

- If you look at enough paintings long enough, you will learn to see. The condition is irreversible.

- If you stand quietly before a Monet, you can hear the colors sing, like wind in a distant tree.

- Paul Cézanne, generally accepted as the first modern painter, was very nearly the last.

- I don't understand the physiology of this, but you can't look at paintings for more than twenty minutes at a stretch. Beyond that the colors seem to leak, spilling from one painting to another, as though the eye was absorbing more than it could carry. It is best when visiting a museum to conserve those minutes. Plan a strategy for your stay. Go directly to what is important and interesting. Study only that. You can safely by-pass the rooms containing most of what has gone on in art for the past fifty years.

- It doesn't make a damn what you paint. How you paint does.

- Has anyone ever understood the editorial matter published in the contemporary art magazines? Has any one ever met anyone who writes this stuff? Just checking.

- The young artist will not believe as they do in the East that a painting is burnished with hardships and accumulated years, but he will.

- When viewing a painting, don't be afraid to get close enough to smell the varnish, for only then can you see the magic the artist employed to make the work convincing. It is not fashionable to do this. If you are in a museum, those who see you do this will scoff at your ignorance. Try to ignore them.

- Direct this to your collector: Judge a painting by how it makes you feel. Before buying it ask yourself whether you want to feel that way every time you look at it.

- Don't paint large pictures unless you are married to a carpenter, own shares in a frame company, and are paid by the square inch.

- I lean toward intuitive painting. I'm not smart and when I think too much my mind hurts.

- Most of the Impressionists — even those who sold us on the merits of plein-air paintings — did not paint much out of doors. They had good reason. Like celibacy, it's better in theory than practice.

- Do you remember evenings on the lake and how the sun bled through the pines and the sound the loons made? That's what painting is like.

PART II

MONEY

Commercial success has nothing to do with art. It has to do with commercial success, though it provides the artist with the means to continue. When I was young I trucked along some sculptures and some slides of sculptures to show an old man who was to become my first painting teacher. I told him I didn't want to be an artist. I only wanted to sell some sculptures. He looked first at the sculptures, then at the slides. He took a long time.

"Do I have some talent?" I ventured. He was putting the slides back into the protective sleeve. He waited to speak until he was finished.

"I don't know," he said quietly.

"Well," I fumbled, "What I mean is will they sell?"

"Of course," he said. "All you need is someone to buy them."

Chapter X

Waiting For Guggenheim

N ow that you're an artist, I've got to tell you about this play I sketched out. I cleverly gave it the chapter's title.

Scene opens. A man sits on a packing crate marked "paintings." (I didn't say the play was subtle.) He's dressed in paint-spattered clothes, he's twisting a beret nervously. He faces a closed door, street noises beyond. He maintains his perch through ACT I and II. In ACT III (for those who return from intermission) the man shows increasing signs of agitation. Big finish now. Man gets up from the crate and exits through the door. Magnified sound of door closing. Lights extinguish, but not before we see he's left his beret on the crate. (Enormous applause.)

OK. It could be stronger. But the point is made: They ain't gonna come. You ain't gonna be rescued. There is no divine intervention. You want to be an artist, you're going to have to make it on your own. That's it. That's the beginning, middle, and the end of the thing. A Guggenheim girl will not appear in your loft, as though in a dream, toting a contract and a fifty thousand dollar purchase agreement. It'll be

the landlady for the rent, and she won't take paintings. You want to be discovered?

You have as much chance of being discovered as Columbus has of being voted honorary tribal chief of the American Indian nations. They won't find you in Schwab's Drug Store sipping a cherry coke. There *is* no Hollywood. Not the one you're thinking of anyway. You may get some action on the Sunset Strip, but they won't be asking you for a resumé.

I know how you got this idea fixed in your head. It's all a part of survival. If only you can keep on painting, your day will come. Right? It has to, just has to.

"God, that's a climb. When the legs go, it's all over. I used to take stairs pretty good. Thirty years back. Had the police beat, Bronx. You talk stairs. Nobody ever has news on the first floor. Rule. Gotta go to the sixth. And City Hall? Damn elevators are always busted. Commissioner's on the eighth, right? Jesus. But these. You make this climb every day? Gets the blood up, though. Wind goes right through you out there, day like this. These lofts aren't much for keeping the cold out. Hear that wind? No, no. Don't turn around. You paint. I'll talk. Think I got the wrong place anyway. Damn numbers. Stand around down there and try to figure it out, you gonna get knifed. Mugged if you're lucky, dead if you're not.

"I'm on the arts page now. Believe that? Ten years back. Slow day on cops and robbers. We're between mass murders. Editor-in-Chief calls me in. 'Hey,' he says, 'Wa'd'ya know from abstract art?' I tell him my uncle used to have a frame shop on Eighth Avenue. He tells me to go see the cultural editor. I meet this guy. He's on the phone workin' on a salami-on-rye and he's takin' notes. Cultural, right? This guy doesn't know to zip up his fly.

"Anyway, he tells me, I write good, and I can quit climbing stairs. Cover museums, not morgues. And how am I at think pieces?

"He had me there for a moment. 'You mean on art?' I say. He had hung up the phone but was still into the salami sandwich. He had spilled a little mustard on his pants and was working it into the weave with his left hand.

"Wait a minute. Mind if I sit here? Hell of a climb. But don't worry. You work. Like chess, right? Planning the next move. Waiting. Thinking. Make or break a painting like that. Nice color. You got a nice piece going.

"So, workin' in the mustard, a little pickle juice on the chin, he asks me if I own a tie and can I take pictures. I tell him I used to and I don't. He says, good. Tells me to check out a camera and learn how to point it. Ten years back, right? I'm still luggin' the same camera. Tell you about Journalism? Then he tells me to go buy a tie and cover an opening that night.

"Wow, hear that. You can feel these old buildings move. Look, heater like that don't put out therms it oughta. Big room like this. All the heat's up there somewhere, keepin' the bats warm.

"So, I tell him, sure, you know, I'll borrow a tie, but I don't know from art. He says that never stopped anybody from writing about it.

"Tells me when I show up at a reception, first thing I do is find a guy with gym shoes. He'll be the artist. Take a picture of him and if he don't smell too bad put somebody who looks rich in the frame with him. Maybe it will be an advertiser, who knows? Write down all the titles of the art stuff. You'll need that, he tells me, for verisimilitude. It's for when you write your piece, he says. And it tells the chief somebody showed up for this gala and wasn't makin' it all up.

"He warns me, 'Whatever you do, don't talk to the artist. Whatever it is, don't ask. He won't know.' This cultural editor tells me to find the gallery owner or director. He'll be the one with the silk tie, blue blazer, and titanium white teeth. Ask him, he says. He'll have all the hype ready and a tearsheet from one of the other rags. He tells me to damn near copy that, cause the guy who wrote it got it from somebody else who didn't understand it either.

"So, I go to my first show, right? And it's wall to wall candy wrappers. Maybe ten huge canvases all pasted up with these wrappers. A pile of it is on the floor with a group looking down. Everybody's nodding sagely.

"Listen. You sure that heater's stoked? You gotta move around some, you know. Don't take my advice, but

I'd stand up from time to time. Get the sugar coursin'. All right. Don't listen to me. You got your way. I got mine, right? You got a nice feel for color. Damn nice piece. You ought to look at it from back here.

"So, there I am with the wrappers, Mars, Hersheys, Almond Joy, Baby Ruths, whatever. And sure as hell the artist has got black gym shoes, his khakis cut high enough to show a nice pair of argyle socks. And it's pretty obvious from the size of this guy why he's into wrappers and not the bars. This guy's a Sumo and when he asks me my newspaper, I tell him. I had him lined up with three old ladies with fur pieces and I'm about to squeeze off the second shot, when these three dears are all over me. I don't want to pay for the company camera, so I'm holding this thing away with one hand, fending off the blows from the ladies with the other. I mean these gals were really nailing me. If I fall, I'm dead. He's behind them, this Sumo, yelling, working them into a frenzy.

"I worked my way to the door, got it open somehow, got it between me and the ladies, shut it and ran. A few blocks later I was getting my breath, checking the rip on my coat. The owner comes up, breathing hard. He tells me he's sorry. Says his openings usually go smoother and attributed most of it to high blood sugar. Tells me the other part of it was the guy I replaced. Wrote a review on Sumo's last show. Of all things, the guy raised the question of art. He said he knew I'd be smarter than that, which I became, then and there.

"Until that night I hadn't been touched, and I had twenty years interviewing murder-one suspects, rapists, the lot. Been on drug busts, covered gang fights. Nothin' like those old ladies.

"But, look. I'm takin' your time. I'm supposed to be doing a story on an up-and-comin' Pollock. His studio's around here. But I got a better idea. Suppose I do a story on you, what you're workin' on. Get a picture of that, some of the other stuff you've got against the wall there. I think we can do a Sunday spread. Maybe four or five paintings, use a double truck, full color. You could use the help, right? And I'm not into climbin' more stairs. What do you say?

"Jesus, it's cold in here. Get up and stamp some life into you before you freeze to death sittin' there. Hear me? You sleepin'?"

I think you get what I'm coming to. If the only thing you do is paint good and you think waiting is going to get you where you want to go, you got another think ahead of you.

Waiting is going to make you old, maybe dead. The trendy set is not going to knock on your studio door. They're not looking for you. They want drawing power — the show-biz factor. If you're a paraplegic Romanian carting thirty years of protest paintings you've done with your teeth while locked in a cellar in Cluj, they can work with you. They're up to their ears with Aussi aborigines, Bornean headhunters, and bearded hermits from Tierra del Fuego.

They're looking for ideas. Something chic. They want message, environment, if you've got it. But you need to package it: a radical and unsightly way to convey your lasting sympathy for whales, South American rainforests, sea otters, the endangered American woman or authentic fish and chips.

Even the contrarians have lost steam. Paintings and other art works designed to support the fragility of the shopping mall against the ravages of encroaching forests and fishing streams aren't carrying the weight they once did.

If you paint good pictures, your membership application to the *Le Club* may not get past the secretary. You can appeal to government, all right, but unless your grant request is on university stationery, don't get your hopes up.

Anyway, if what you do is good, whether you paint objectively or not, you'll probably be damned with the label "accessible." Why should the government support artists whose work is accessible to others? These can find their way in the marketplace, for the work is good and can be recognized as such, they reason. They'd much prefer to support the contemporary museums and have them get blamed for their exhibits. If pressed — and they don't want to be burned with the French Academy business again — they'll seek out the worst in individual art, for if it's bad enough, it must be because nobody understands it.

It's clear. Bad work needs support so those producing it can continue. That way we'll have a reminder of what government is doing for the arts.

Naturally, with all the junk around, people will ask questions, taxpayers and such. Government wisely set up a network of art committees and art councils at local and national levels so that it would have a whole lot of qualified people between it and the bad work that gets supported. These would be people it could call to testify should the wisdom of their selection be challenged by public outcry. They turned, of course, to the academic community, museum associates and established artists to sit as jurors, since what they don't want are a bunch of purple-haired neo-freaks and Harley bikers sitting before public inquiries. That would not appear to be a prudent way to dispense the diminishing largesse.

They got the academic crowd right off, for only pedagogues have the time or inclination for this kind of exercise. Since the museum folks felt obligated to government, they sent in some names of loyal supporters. The problem was finding some established artists, for no one who took art seriously would be caught dead on such a committee. Eventually they found a few whose career was fast fading and who could benefit from per diem expenses and a free lunch. Any seats remaining were filled by forgotten movie stars.

With the oath taken, the mandate of government behind them, they stand ready to discharge their public trust by selecting from the towering pile of applications before them, this year's batch of freaks and bikers.

If you rightly want to know where you come in, government will provide you with an understanding letter. It will tell you how the trickle-down theory works. For visual art the bulk of taxpayers' money goes to underwriting contemporary museums, associations and universities and, indirectly, you are the beneficiary. Don't believe it.

Trickle-down is another name for being pissed on.

Reader, when you bought this book, we both know you

had your suspicions. But you paid your price and you got to here. I want to return the favor by telling you how you can save your time and far more than this book's cover price: stay away from government, learned art councils, stipulated and restrictive funding, and any academician when he is acting or speaking on behalf of contemporary art.

Stay away. Even when he smokes a pipe, stay away.

Instead, go sell your work. And forget about all you've heard about the four-letter word "commercialism," selling out to bucks. Selling does not necessarily mean prostitution. But I'll guarantee one thing: You'll be turning tricks in thirty-six positions for the government loot, and they're not going to drop it on your bed, turn out the lights, and leave the room.

You won't keep your virginity with the triumvirate: the museum, the university and the leading-edge gallery. They're working their side of the street.

You don't need to sell-out to sell your work. And I'm going to show you how it's done. It ain't easy, but I'll take you through it as painlessly as I can. If you take my advice, you'll find, as I have, a world-wide freedom the government crowd and the freaks-for-lunch bunch can only dream of. Take me seriously on this. I have a way for you to make it in art.

Q. Wha'd'ya trying to give a guy here? I mean, what's with this?

A. What?

Q. What, he says. Ya hear that? Guy says he's the Virgin Mary for nine chapters. Eternal truth and beauty. Remember that line? Get's this far, tell us how to cash in. Go for the lolly. He's going to show us how, right? This guy's gonna have us painting love messages on sea gulls for the Brighton Beach crowd. The marketplace, he says. Galleries closing, dealers busted, auction houses wringing out blood from a stale biscuit. You tell me about this market of yours. You tell me that.

A. It's out there. And I'll show you how to find it.

Q. It's out there, he says. You read newspapers. How

many people are buying art these days? I'm not talking tour-ist-town dregs. Art, you know? Your truth and beauty. How many people are buying good stuff?

A. A slim part of one percent of the world's population. They buy the "good stuff," as you say, and they'll pay the price.

Q. What's this "slim part of one percent?" Four people?

A. All the buyers you'll ever need, all anybody will ever need. I don't need a survey to tell you this: there are far more buyers — by the hundreds — than there is good art being painted by painters today. Stuff that's worth buying. You got buyers with every interest at every price level. They're looking for living painters who can produce some-thing worth hanging on the wall. If you know how to paint, they're looking for you. You have buyers to spare.

Q. You gonna play "trust me" again? I'm gonna take your word?

A. You bought the book. Give me a chance to show you. You're any good, you're gonna sell. I guarantee it.

Q. Sure.
A. You don't believe me?

Q. No.
A. You gonna dump the book?

Q. Maybe.
A. You spent two days in a mountain cabin, fought your wife and landlord, burned 300 paintings and you're gonna quit. I'm about to tell you how you're going to get successful and you're giving up.

Q. Don't take it so hard. I said maybe.
A. Just maybe, huh?

Q. Wa'd'ya want? One of your guarantees?

Before we get to the good part, let's get rid of any re-sidual ideas you have of making it big by somebody's be-nevolent accident. Let's make sure those diamonds in the

sky you've been dreaming about are seen for what they are: the makings for acid rain.

Here's the bad news all at once:

That newspaper is not going to give you fame. It's not going to do your story. Whatever your story might be, it, like almost all stories on art, won't be read. And newspapers make their money by getting advertisers to believe the things in it are read. Readers of newspapers are presumed to have money to buy things, like the advertiser's product. But advertisers, since they're spending their own money, are pretty smart. They want their ad in a position to be read. They want it on the sports page. They want it at the bottom of the same page that has a lot of action shots and pictures of drunks jammed together each hoisting an index finger for the cameraman.

They don't want it on the cultural page beneath a two-column unleaded essay on why negative space played an important early role in establishing your pictorial priorities, thus contributing to the seemingly irregularities of composition in the six paintings on view behind the teller's cage at the downtown branch of First National Infidelity today through Saturday.

The art magazines, while better focused, are equally uncommitted to publishing your poignant essay or anything else which will help you establish yourself publicly. Even when you include a package of your newest slides with the submission, they will be inclined to turn you down. They will reject you because they haven't heard of you. They will do this on behalf of their readers who likewise haven't heard of you. You're not in the loop. Since these magazines are mostly slick and national, advertisers spend a lot of money for an ad. They will not advertise in a magazine whose editors don't understand who's in the loop. Since there are only five living artists in it, it's hard to fake it.

They'll send you a form letter and, though the staff of three occupies the same small office, they will lose your slides. They will steam off your return stamps from your self-addressed envelope. Since they lost the slides, what's the point. Times are tough for magazines too.

96

And you won't make it on television. Though it's certainly more egalitarian and, I hesitate to say here, accessible, it has nothing in common with Fine Art. *It* is out of the loop. If you spent thirty minutes a day for a week on sixty channels offering to give away the oil original of Monet's *Impressions Sunrise* to the first person who could correctly identify the school of art which borrowed its name from the title, you'd get three calls, all from nursing homes, asking for reruns of "Dallas."

And you'll not make it by winning places in juried shows, because even if your work is accepted, it will be demeaned by all the other trash that hangs on the walls with it or sits on the floor before it. Even the blue ribbon will set your work apart for a kind of ridicule.

Entries in art fairs, listings in *Who's Who,* or leaping stark naked from municipal skyscrapers won't attract the attention you think these ideas merit.

And the mega-gallery you heard about, the one with branches in fourteen countries and three principalities. They won't take you on. Sorry. I know this comes as a disappointment because you staked your almost certain rise to fame on it. You remember: This is where Daddy Warbucks found you out and bought you cheap. He had you to dinner, bought you a cigar, and had you sign a contract binding everything you ever painted and everything you will paint for the next five years in exchange for living expenses, a loft, and supplies. You'd sign because all you want to do is paint, right?

But he didn't call. And when you sought him out, you found he hadn't taken on a new painter for forty years and he'd been "consolidated." He now conducts business in one gallery, a single room you had difficulty finding, in Charleston, South Carolina, across from the Pic and Save.

Chapter XI

The Supreme Authority

As the last chapter will attest, there's a lot of bad news associated with the art business and it all seems to come at the worst time: after you learn to paint. It comes after all your wall space is taken and when you begin reusing stretchers and stacking the raw paintings under the bed. As that stack and the dust balls around it grow, doubt casts a darkening shadow across the sun-dappled image you've carried around with you, the rolling green farm and studio with dogs and goats and a happy wife and a mail box at the edge of the road, pregnant with offers, ideas, pleas, and checks made out to you.

It first comes late at night, awake for no reason, lying along side your wife looking at where the ceiling would be if you opened your eyes. It starts that way and grows. You're a little less sanguine about paintings you've been finishing, though you've applied the critical eye and they stood up to it, more or less.

And that breakthrough painting you've proudly mounted above the sofa has lost some of its luster since you put it there. Words you used to describe it after you painted it now seem hollow, but not all the time. Sometimes it still

lights from within, one color vibrating against another. But more often, lately, it's just a painting above a battered sofa. When you pass by it you're inclined to avert your eyes, lest you have to consider it still another time.

A lot of the uncertainty comes from the bad news. It's hard to sustain optimism when all the avenues seem closed and with all the things that need to be paid for and the money running out, and all the time you spend in the studio. (Squandered time, maybe.) Your wife's mouth is set in a straight, thin line more and more these days.

It is foolish, really. Spending all this time on paintings that were received as they were by that successful artist friend you had over one night for dinner not long back. He was less than expansive. Even after his second and subsequent gins, he talked only of his own work, which you've always admired. But he talked as though he were the only artist in the room. He talked like that, even in the face of the work he could see on the walls.

Nevertheless, the wife enjoyed the evening, glowed even, as she laughed at all the right spots during his long and tangled monologue. She drank more than was her custom.

It is foolish, really. Spending all this time on paintings. If those days haven't come to you, they will. They will come to you one day and then periodically, they will come again. It is the nature of the beast and it drives the weaker — and sometimes these are the better among us — to lunacy. At best, these times will drive you near the edge or seem to. At worst, you will cave in. You will quit.

There can be no declaration more brazen, more arrogant than the claim a man makes that his work is art and ought to be viewed as such. And his is the still greater conceit which causes him to stand by it in the face of withering criticism and rejection, or apathy.

Whatever you resolve, there are times you're going to look around for confirmation. Times you're going to want to call on an authority. Find out if what you do is any good or whether you had better pack it in.

What you need is a supreme being to sit in judgment of your work. So's you'll know.

99

You'll talk to other artists and if you're smart you'll learn the mistake in that, for they're hell bent on defending their own work against all comers. They need all the steam they can muster, and they know, as no others you will ask, what it is to proclaim or disclaim another's work while themselves standing on rubbery ice. Do they know your work is any good? Maybe, they do. And they might even tell you — but reluctantly. They'd prefer you just quietly went away.

So should you turn to that dealer, that gallery owner you faintly know? Chances are thin he'll be trading in what you do. If he's successful, which few are, he'll be best at telling you how good he is at selling what he had. He will tell you this even if he's unsuccessful. What he won't and can't tell you is what he thinks of your chances of success as a painter or whether what you do is any good. He won't and can't because he doesn't know.

You'll find he's not alone. You'll find that there are a whole lot of others that don't know as well: that learned museum director, the curator of contemporary paintings, the art critic who seems to know everything else. Even he will not know the value of your work. Nor will all those who talk about their love and understanding of paintings.

Even rich people won't know whether your work is any good. Nor will that aunt of yours who once worked for an interior designer in Columbus, Ohio, and was thereafter widely hailed as the person in the family with the last word in things artistic. She can't tell you, though she may try.

Nobody can give you the definitive word on whether what you do in those hours in front of a canvas is to create art or consume time better spent doing something sensible. But there's someone who can do much more than tell you your work is impressive and important or otherwise fill your deflated balloon. I'm talking about the guy who's going to put money on it. The guy who's going to walk your painting out of the studio. This is the one guy, through his actions, who can tell you whether you're foolish or not. He's the supreme authority. He's the buyer. In some polite circles he's called a collector. You can call him freedom.

He is the ultimate critic. He's your road to a creative life, to doing what you want to do — to travel, to fame. When he spends his money on your work he will have done so carefully, but thereafter he will become your best salesman. It is natural for him to be so since he did the research on you and on the painting before he made a buying decision. He's not going to show the painting as a mistaken purchase. He's going to say nice things about you and he's going to encourage others to buy your work. You can trust him.

He's on your side. He's going to work for you this way: he's going to encourage people because he knows that the more people who buy your work, the more valuable that work becomes. As prices rise, his investment appreciates. He wins, since he likes to buy smart, and you win, since you need food, a place to stay, and walk-around money.

If you sell enough paintings, you can leave "Bottom Line," and you can begin full-time work on what you do best. You don't need government endowments, grant and loan programs, foundations, or other thinly disguised charities. You won't need those make-do jobs, nor will you need to teach the Saturday morning flower painting class to the ladies. But if you enjoy teaching and want to continue, you can start by dumping the artificial flowers. Give them some fresh flowers to work with. You can afford it now that you're making sales.

You can also quit selling those dreadful Christmas cards you painted. Stop hanging your work in clothesline sales, or leaning paintings against trees in art-in-the-park events. You don't have to spend your rainless weekends watching walk-bys ignore your work.

You can give up your position traveling the shopping mall circuit. Unlike the glass-blower, you're not much entertainment anyway. What you do is paint and watching a painter work is as much fun as watching a turtle eat lettuce. As you've come to notice, nobody at the mall wants to spend more than three dollars with frame included.

You can finally quit your job for the furniture chain. I heard a story in Mexico from another expatriot artist who

was giving me a ride to a party at a bull ranch outside San Luis Potosi. He was a painter of huge and violent landscapes and drove the remains of perhaps the only Deucheveaux extant in Mexico. The rusted body was held in place by ropes and struts and electrical cords that crisscrossed the interior. The floorboards beneath my feet had gone and you could watch the blurred roadway beneath you. Riding in it was like taxiing across a plowed field in a Piper Cub.

It got worse when we left the paved road for a dirt one. A rock painted with the distance to our destination was not encouraging. The car had immediately filled with dust.

"Under your seat," he said. "There's a painting."

Fumbling around I was able to slide out a small stretched canvas that had lain face down. It was coated in dust and grease, which with the dust that filled the car's interior made seeing the painting impossible.

"There's a rag under there somewhere. You won't damage it. Take my word," he said.

It was a slick portrait of a tousled-haired boy with huge opalescent eyes. At the corner of one, a brilliantly high-lighted tear was working its way onto a puffy cheek. The boy appeared to be either grinning or sitting on something that hurt.

"It's called *The Street Urchin,*" he said.

"Jesus," I told him.

"Now lay it over the abyss at your feet," he replied.

The dust in the interior slowed and began to settle. I could begin to identify my friend again, the red beard, the hooded eyes. He told me the name of the artist.

"Does mostly clowns now," he said.

I told him it seemed like a natural transition.

"Out of L.A.," he said. "Sold encyclopedias, roof coating, and typewriter repair courses. Got into selling correspondence art. Turned in his suit for a beard and a Levi's jacket and was doing fine. You know the pitch: why work when you can become world renowned in weeks.

"Anyway, he got to painting in his garage. Turning out things like that at your feet. Formula stuff for furniture chains. Ever see how they work?"

"No."

"I'd watch him sometimes. Line up maybe thirty canvases. Mix up a batch of umber, a little ultra-marine and lay in all the hair on each. Come back with the ochre and pick up the highlights. Lay in the flesh tone, middle value. Come back with the highs and then the lows, thirty noses, thirty smiles, sixty billiard-sized eyeballs. Hang on."

It was a cattle crossing and we took it without slowing. We left the ground and nosed in on the other side, pitching sod over the windshield as the rear end slammed down behind us. He had not decreased pressure on the accelerator.

"He'd get maybe five bucks a pop. That's $150 for an hour's work once a week. He was happy enough and the chain got sixty bucks framed. Since the frame is guilded plastic, they were doing all right too. Once they asked if he could do little girls. The next batch he made the hair longer.

"It all went wrong one day in Laguna. He was passing a gallery and sure as hell there's one of his God-awful urchins. They had it in the window. And there was another signature.

"For him, this was too much. Like picking a grave robber's pocket. He went in and an old woman with a tidy bun of gray hobbles out of the back looking for all the world like she could win a Norman Rockwell contest.

"She serves herb tea and pitches him. She tells him that the perfectly marvelous painting he has inquired about was done by a well-known Burmese painter who had suffered swamp fever and went blind, but not before he had finished this, his last painting.

"She told him she was surprised he hadn't heard the name since he was up there with the best and coveted by art authorities everywhere. It all accounts for the price of $1,200 which included shipping, or if he wanted he could take it with him.

"So, when he took the story back to the furniture chain, they readily agreed they had not been wholly forthcoming with him, though they cautioned him to reread his contract before taking legal action. To show they had concern for him as an artist they offered to double his price if he would do something other than urchins. They already had plenty."

"Hence the clowns," I concluded. "I wondered who was doing all those damn clowns."

"The clowns didn't come right away," he said. "He sort of grew into those. He's the guy who does the bug-eyed little boy holding hands with the bug-eyed little girl. And the cocker spaniel."

"The one with the tear?" I ventured.

"That's the one."

So, once you find the buyers for your work, you can turn honest. You won't need these jobs anymore. You can turn in your Levi's jacket. But before I tell you how you're going to find all the buyers you'll need, let me dispose of your last best hope: the art gallery.

There are two kinds of galleries: ones that will take your work, and ones that won't. The ones that will, you don't need. The ones who don't, don't need you, yet.

Let's look at these in order.

The large majority of the galleries in the world are owned and operated by those who have just enough retirement money to remodel a store in pale pastels and sit for a full calendar year staring at the twenty paintings consigned to them by foolish artists like you and me. At the end of that year, and without warning, they will close and take their inventory to Reno where it will decorate their double-wide trailer home which won't have a phone.

And you're stuck contemplating **Pigeon Factor 62:**

Pigeons and artists are not known for making intelligent decisions.

Most of the dealers in art are otherwise well-intentioned housewives who are facing the calamity of a retired husband home all day. They've chosen their new occupation for several good reasons: they want to get out of the house and leave the television to the old man, they want someplace to go where they can dress nice and go to receptions, and since all they want to do is take forty percent of what they sell, they don't want to put a lot of money into it.

104

There are several faulty reasons as well: They believe it will be stimulating to meet and do business with the community's artists, that people walking by will notice the pastel interior and the paintings and seeing her in matching skirt and blouse will come in and buy some art, and that all of it will lead to a clandestine romance whose intimacies she can share with her friends without risking her husband's monthly retirement check.

It's a particularly fitting occupation. All her life she has had a great thirst for things artistic. Everyone says she has an eye for color. All her friends know that she had recklessly bought the desertscape, the Taiwanese original that hangs in her home, without first checking the color of her couch against it. But the acid-green cactus matches up perfectly.

Since she came to the Fine Arts naturally, it seemed a waste to study. Though, frankly, she was secretly relieved to learn that the painters whose work she had accepted after long and careful deliberation didn't know much about art either. She feared, unnecessarily as it turned out, that she would be caught up in conversations about art history.

By the middle of the year she had attained an air of confidence. She wouldn't have time to look at the work new artists brought in. She could dispatch three years of labor in a studio with a disdainful flip of the hand. In the third quarter of her career she would only look at slides and biographies at her convenience.

One of her disappointments came early and lingered. Nobody bought paintings. For a while she hosted monthly shows for one of her gallery artists. Later she did group shows. She knew it was important to make a strong impression on the community with these shows and spent days before the opening worrying about arrangements and getting her hair done. But she was known for her facility as a first-rate hostess and at each reception those on her mailing list came. They ate the cookies and drained the vodka punch. When she'd meet them on the streets — even days later — they told her what great fun it had been. She believe they had enjoyed themselves, but she hadn't sold any paintings.

After the little flurry of activity opening night, things were pretty quiet for the balance of the month. Fact is, almost nobody came into the gallery but the mailman and the cute young fellow who wanted her to take out an ad in the local paper. The day the ad appeared even the mailman didn't show, though in fairness it may have been a postal holiday.

In the final quarter of her life in the art business, she took to being slightly more open to the few customers who happened through the door. She no longer honed and painted her nails or pretended to be busy on the phone. She no longer waited for the customers to make a selection and write out a check.

She began to greet them and she used her God-given talent as a hostess to engage them in conversation about herself and what brought her to be an art gallery owner and other problems she had. Sometimes she offered coffee.

She still hadn't sold a painting when she packed up for Reno with the only thing going: her husband. He had heard the TV reception was better in desert air.

That leaves the better established galleries who have made it abundantly clear that they limit their work to handling artists far, far more important than the likes of you. I'm going to show you how you will make them change their mind, how you'll make it real easy for them to make a decision in your favor. It's called business. They're in it. You're in it. They want sales as badly as you do, and you'll be their rising star.

Though these are professional galleries and have, presumably, been in place for more than twelve months, you're not going to be much happier with the management here than you were with the hostess with the great eye for color.

For sure, they will be busier. Because if they've been around, they have chosen a much more expensive venue where people generally walk by. That means that they are able to get out of their cars in an area of town that poses no imminent threat of cross-fire from gang warfare. There are probably other galleries around as well.

When a potential client comes through the door, they may engage him in conversation. They may even appropriately ask their customer about the art that interests them. They'll stand ready to take him into the inner "closing" room with the work in question. They will mount it on a felt-draped easel, key-light it, and make him coffee.

By doing that, this kind of gallery will make more sales than the first, which isn't difficult. What they won't do is make as many sales as you expected of them. One of their problems stems from what is axiomatic in the business: nobody needs to buy art and those who want to, do not need to buy it now.

When times are bad and discretionary income is scarce, owners of these galleries are compelled to sit around and wait until times get better, and then wait until they've been better for a while. Since they have to pay premium rent during the good and bad times, many of these gallery owners go out of business when things are slow, just like our lady with the green couch. This is but one of a host of disappointments you'll find doing business with the professional private gallery.

The attention they give you will necessarily be divided among artists they've contracted. Some galleries have so many artists you'll be lucky your paintings get hung on the walls long enough for anyone to see them.

It is also probable — and understandable — that the sales staff, working at least partly on commission, will devote most attention to the artist who has already achieved some sales and who they've already studied.

Since your art is — as it must be — different from those artists who have established themselves with the gallery, its staid clients may be less than enthusiastic about new work. It will take time to convince them and others familiar with the gallery of the merits of your work when they are expecting to see what they've always seen. Even though you were accepted because your work was not unrelated to the other gallery artists, there will be resistence.

Every gallery tries to market to a thin slice of the art pie.

They're doing business with a stable of artists whose work reflects that slice, for they have accumulated, or hope to, a client list interested *only* in that kind of work. An owner won't know or care what's going on in the gallery across the street, and he's going to make sure that anything you show him pretty well stacks up to what he's got on the walls. And since he's got a lot of it already on his walls — and not on his client's — who needs more? Or so they reason.

It's this myopia and resistance to change that reflects the bigger problem for the private gallery. It is suffering from terminal anachronism. They got left behind in a changing world.

There are not all that many places to do business anymore. With a few notable and very expensive exceptions, cities don't work as they did. What used to be a center for commerce is now office space and car parks.

Attempts at downtown revitalization have faltered badly. It was only a means of staving off the inevitable anyway. In most parts of all cities, people wisely don't window shop anymore. They don't stroll in and out of stores as they did. If they value their lives, they will get in their cars, lock the doors, and head out to the shopping complexes for their needs and wants.

There, in the slab and glass fortresses that are as architecturally appealing as a penal farm, they can gambol in relative safety amidst the muzac and other shoppers. It is not out of keeping with the feel of these places that armed security guards patrol the perimeters, much like they walk the wall at Leavenworth.

It's mass commerce on a hideous scale. It is the last place in the world to display art or anything more serious than Leroy Nieman prints or custom car parts. You will not buy anything there which has not already been bought by fifteen thousand others.

Apart from the prime districts such as London, New York and Paris in the West and Tokyo, Taiwan and Hong Kong in the East, there are few places for galleries to go. And in these ever-constricting districts, rent is measured in

inches and calculated in thousands. Looking to the future is facing Bleak Street.

While the world recession has decimated dealers numbers, it's more than that. This time the losses are structural, not cyclical. The flush of the eighties is a history unlikely to repeat itself for awhile. While those fast-money times kept many galleries afloat, there was a more fundamental malaise. The bankruptcies you're seeing now have been long in coming.

I'm not much at economics, but if you talk to the owners or directors of top galleries, they'll tell you. They'll recite the same agony: rent, high and rising. This and insurance costs and day-to-day expenses plus low sales are forcing big galleries to lay off, to consolidate. It's forcing the less resilient to close their doors.

It's the same story everywhere. The price to do business is up, sales down. The gallery scene in New York is typical. SoHo's returning to the ghost town it once was. Madison Avenue is boarded up. Uptown, midtown, downtown, whatever school, whatever price level, they're turning out the lights and going home. For St. Germaine, Bond Street, the Ginza it's pretty much the same.

Those who will survive and prosper are those who are willing to face change, those who will abandon their comfortable lair and go out hunting. The spider and the fly principle is outdated: It costs too much to build a web these days and the flies are getting smart.

Success will come to those who will chuck their high priced real estate and all the trappings, rent a second floor office, and go find what they're all looking for — the worldwide buyer.

Nobody, but nobody, is in a better position to do that than you or an agent representing you. But we'll get to all that.

Before we leave the galleries as your road to Oz, I've got another time saver for you in case you've been thinking about making the tragic mistake of opening your own gallery. I made the mistake for you.

109

I'll run through the logic with you, as I unwisely did years ago. It'll sound pretty good. Don't, don't believe it.

If you have your own gallery, you'll run it, right? And since you want to paint all day anyway, how about a studio in the back? And how about a cheerful little bell on the door to tell you when somebody comes in to give you money for the paintings you've got on your wall? You could run art classes. How's that for an idea? Why you could run your business on what you earned on the classes and put the bags of money in painting sales right into the bank.

You would know all about the art you'd sell because it's your own. And people who buy like to meet the artist they're buying from — as everyone can tell you — and there you'll be, clomping out at the sound of the bell, brush in fist, adjusting your smock, with a big lopsided grin. Like a Bavarian wood carver you'll come. You'll come with big hello's, ready to tell them the marvels of your work and to regale them with art stories. A big, good-natured, funny guy waiting on people and wrapping paintings. And you'll look discreetly away as they write out their check.

Your wife can help, of course. She can keep the books and be there at long lunch breaks and when you need to go to the bank to put the money in. And maybe, you just might, this great, good-natured Bavarian, offer space for your artist friends and maybe have monthly shows. What the hell. Spread the wealth.

And you'll think of a nice name, something a little bit tricky, and you'll get yourself a big sign and put the name on it. Though I stopped short of using a name that began with "Ye Olde," I used enough foreign language in mine to make it sufficiently incomprehensible. It was called Las Artes and I had it carved in wood in the Bavarian tradition. With a little help I got the sign hoisted and mounted just off the roof above the door. But I never did feel it was anchored securely. It was pretty ominous, really. I worried the right wind could send the thing crashing down on a customer innocently walking in the door — slick as a guillotine. I worried for the six months I was in business. I needn't have. There weren't any customers.

110

The problem I had in opening a gallery is the one you'll have if you insist on proving the logic. You'll find, as I did, that you can't afford it. I don't care if you're the Sultan of Brunei, you can't afford it, unless you're into charity. And if you are, give to the Boy Scouts. Make a direct contribution. It'll save you the trouble of a sign.

Here is the tag end of it: You do not yet command the prices to afford the space in the part of town where a buyer of art is likely to stroll. And when your prices will allow it, you won't want to.

But if you get all wrapped up in enthusiasm for this as I did, having convinced the wife and all, you're not going to want to give up when you find out the prices they want for the spaces a buyer is likely to find. Instead you're going to look into other parts of town. Then a little bit out of town. And if God is against you, you're going to chance on something.

God delivered me a plumbing shop in Pacific Beach, California. They were a couple of nice guys, these plumbers. Landlord introduced me. They were heading up to bigger, better quarters, packing their equipment, wrenches, inventory of pipe and tubing, and such. Their business there had been pretty good, they said, though they couldn't tell me much about the art prospects. One of the partners volunteered a cousin of his who did watercolors of sheepdogs. He told me she might show some of her work if I gave her a call. If I put her on salary, she'd answer the phone, sweep up, that sort of thing. Mention his name, he said.

The neighborhood wasn't that bad and you could talk yourself into the qualities that may take a little uncovering. All right, it wasn't all that prosperous, but you could walk to the cleaners and two electrical supply companies. And it faced a well traveled road on which one could get from La Jolla, a prosperous city a few miles to the north, to my front door without too much effort. With an ad in that city's newspaper, I could reach all the art buyers who could still find their glasses. As long as the sign held, I was in.

I did most of the remodeling, such as it was, myself. It

111

took almost a month before we felt ready to handle the crowds that would arrive once the doors were swung open. Not many people stopped by in those weeks, but we owed it to the fact that most were waiting for the gala opening. Anyway, we were busy getting ready. The week of the event we advertised in three newspapers.

We stuffed flyers under the windshield wipers of all the cars in the parking lots of the three nearby supermarkets. We took it in shifts, as cars would come and go. In a single day we managed to alienate maybe fifteen hundred people.

The flyer was my idea. It would have been better if it had been thought through. You needed to think of those who upon loading a week's groceries into the trunk of their car and taking a seat behind the wheel, were not all that pleased to see our good news flapping in the breeze on their windshields.

It took getting out of the car to find what son-of-a-bitch left it there. At least that's what I heard from the two dozen or so who called me later that day.

We spent most of the opening looking out the windows to see if people were having trouble finding a place to park.

Finally, at the close of the day, with the good-natured wood carver and his wife still on duty behind a full punch bowl, the cheerful bell sounded for the first time, and an elderly man and his wife made their way in. The man waved off the punch as he had the greeting. He wanted to talk to the owner. I gave him the lopsided grin and pointed at myself, chest high, with the glass ladle. I could see he was angry, but I was afraid to ask him if he did his food shopping nearby.

"They tell you anything on the phone," he explained. To the jangle of more bells the wife brought in a dog which had taken to scratching fiercely at the door. It was some mix of Labrador. The wife pointed to a spot on the floor at her feet and commanded it to sit. It moved off to a corner, circled twice, and slumped down against a free standing sculpture and fell asleep.

The old man told me he was against phones and wanted to say what we had to say face to face.

"Do you charge from your door or mine? And I ain't going to pay from yours." He was clearly firm on the matter.

I told him I didn't understand. His suspicion deepened.

"What are you giving me," he said.

I think the old man wanted to fight. His wife mediated.

"He's been on the phone all morning, and he just won't pay from your door. He says, how does he know where your fellow will drive to. Says it ain't right, and we ain't gonna pay. Says he doesn't care if we ever flush the toilet again," he continued.

I finally got them settled down. The wife accepted some punch, the dog, some water. I explained how the plumbing shop was now an art gallery, but the old man kept shaking his head. The wife worked on him some and he looked around, but he wouldn't give in that easily. After a while, she took him and the dog out. I had given her the new address of my plumbing friends. Outside he glanced through the window at me. He was having none of it.

The only other visitor on opening day was the plumber's cousin. She came with a box of polaroids she'd taken with her flash attachment. It was hard to tell about her paintings. Mostly what you got was a lot of white light bouncing back from the glass that covered them, though I didn't doubt she'd be all right sweeping up.

By the process of elimination I think you've come to understand that you won't be saved by divine intervention or even by a member of the Guggenheim family. Neither will you be saved by appearances in prestigious journals. You've learned that galleries aren't going to help you the way you thought they would, that most of them are closed and many of those which aren't, should be.

I've advised you against shopping malls, outdoor parks, banks, and I doubt you'll get your price by hanging your work in restaurants, though, traveling around, I wonder why so many do.

"Wait, wait!" She held her hand up to stop me. She was concentrating on the cash register, reading the buttons. She

113

looked to be thirteen, though that was impossible, and had a pencil stuck in the bun of her hair. It was the professional touch of a waitress on her first day.

"Don't wanna get confused," she told me. She was trying to read her own receipt. "You had the breakfast special. Was that with or without pancakes?"

"Without," I said.

"The regular special?" She looked at me accusingly. She had been up since maybe 5:00 A.M. It showed. She pushed some buttons, then read some more. "One regular, one continental, two coffees," she announced.

"No, just the regular special. It comes with coffee," I said.

"It doesn't say that here," she told me. "But, OK," she shrugged off the loss.

The drawer opened. She spent a long time with the change.

"Now, what do you want?"

"I was asking about that picture, the watercolor over there. The card in the corner of the frame says it's seventy-five dollars. Is that right?"

"The pitcher where?"

"The one over by the cigarette machine. I was wondering if the price was right. It says to go ask at the counter."

She consulted a list. "What's the name of the pitcher?"

"I didn't get the name. It's right over there."

There was an audible sigh. "We got the two. I don't know which one you're talking about."

"It's the one where the sun is going down behind some snowclad mountains. There's a lake in the front."

"The one with the ducks or the fisherman."

"Ducks," I said.

She turned and yelled something into the smoky hole that was the kitchen. She picked up a coffee pot and left. A sweaty face emerged at the hole just above and to the left of the homemade pie tray.

"What pitcher?" the face said.

I went through it again.

"That's Charlie's pitcher, for Christ sake!" he shouted through to me. He was incredulous. Some of the regulars on the stool nearby began an agitated conversation.

"I wanted to know if seventy-five dollars was the right price."

"For Charlie's stuff? Come on. It say that? Tell you what. I got eggs frying. You let me get hold of him on the phone. He ain't up now anyway. I told him he could hang a couple pitchers around, but I never told him he could put a price like that on 'em. I got ten years in this place. We don't overcharge anybody. Policy. Come back this afternoon. I'll see you get it for five. Who's this guy think he is, anyway, a Goddamned artist?"

Chapter XII

Face It — It's A Business

I'm sorry. It came to me as bad news too. I was in a funk for months when I came to the realization that if I was going to make it as an artist I had to take seriously what I had been telling the Internal Revenue Service for years: that I was a self-employed businessman. It's a wretched way to describe an artist, but it has the makings of accuracy.

What it means is that your job isn't over once you paint the picture. It ought to be, but it isn't. You've got to manage it all from start to finish because nobody's got the investment in your life that you do. The world is comprised of you and all the others, and as far as you're concerned they're on vacation.

Not only are you going to make the product, you're going to build the factory and buy the supplies. You're going to take an accounting of it, see to it it's photographed, cataloged, publicized, sold. And then you're going to see to it that the money's collected and reported in a way your accountant can figure it out. You're going to be the one to decide if anyone has been cheating you along the way. You'll be planning your future, the new directions to take, new ideas to sell.

116

It's depressing.

I grew up with a Dickensian understanding of business: the high stool, dim light, unstoked fire, and eating underdone potatoes for lunch.

It turned out to be pretty accurate. But understanding how it works, the forces behind it and how you can use them, makes it reasonably tolerable. And knowing there's no other way — short of putting your life into the hands of incompetents — gives it the kind of weighty inevitability of a Victorian novel. You know what's going to happen to the virginous heroine. It's a question of how soon and by whom.

I'm suggesting soon. However poignant the ironies — you probably were drawn to art to escape business — the sooner you couple with business and stop marching around with your skirt hoisted above your ankles, the faster you're going to find freedom.

You've got, or you're working on, the twenty best paintings you've ever done in your life. And you believe in them, in your talent, and in your future. You've got your (I hate this word as much as you do, but let's play the business game) product. Describing it that way helps us put our brushes away, shed our smock, descend from the scaffolding, and deal with the world for a while, as it is, not as how we want it.

I'm asking you to divide your life again. You've been working for a living and painting. For a short while, I'm going to ask you to do a third thing. I'm going to ask you to climb on that high stool and pull that eyeshade low. You're in business. You're running your own company. And anyone successful in doing that will tell you what part of it takes the highest priority. It's called sales. And beginning today you've got two things to sell: you and — get used to it — your product.

A couple of things are in your favor.

First, it's a nice, clean business. You paint the pictures; you sell them. You're not manufacturing brain scanners. Nor are you making a movie with a cast of thousands. You own the inventory; you've got the copyright. It isn't neces-

sary to sell many, and you don't need a fleet of trucks to carry them around. All you need do is set a reasonable value on them and exchange them for hard cash, nothing to it.

The second thing you have going for you is the inherent avarice of the collector. If you're any good, he's going to want your paintings worse than you're going to want the money that will result from a sale of them. The collector is a breed apart from the casual buyer of things. Once he sees what he likes, he's going to have it. Unless you know how to protect yourself, he's going to walk right through you to get it. And he's going to come out the other side without the faintest twinge of guilt. He's no doubt a successful man.

While you'll necessarily do business with him, for he's the guy who's come to put money in your pocket, take care, and take heed of **Pigeon Factor 63:**

> If you believe everyone who offers to feed you is doing it out of kindness, and you're a pigeon, you're headed for a squab dinner.

Maybe the collector came up the hard way, maybe he didn't, but he got where he is by operating under his own moral standards. And chances are his standards aren't ones you share. He calls these standards reality. Or he calls them just plain business. Either way, if you're going to work with him, you better understand him.

But, remember, your relationship with him will be a business one. You want him on your side and, once there, it'll be in his interest to help you. Don't expect charity. He didn't get where he is by giving money away. Don't expect to be his friend. Expect to do business with him. Don't let it all go his way. He's not a bad guy, this collector of yours, but when he pulls his green eyeshade down, you better not blink.

I met my first one at four. He may have been a year younger. I was building an extensive highway system in the damp sand of a play area in some park in some city where for some reason I had been dumped for a couple of hours.

It had to be a part of somebody's plan for I had access

118

to three or four of my toy cars which would otherwise be scattered around my back yard where I left them. Though they weren't a set as such, each was maybe four to six inches long and comprised of enough cast metal to give them the heft a toy car needs.

With a small chunk of wood I was ploughing a side road off the main highway when I noticed the two splayed shoes fixed in the sand a few inches from me. Both were brown. One set firmly on my hairpin curve, the other directly over where my underpass was. They were pointed in my direction.

My eyes traveled up an expanse of faded blue overalls, past an orange shirt to a placid blond face with hair that matched the shirt. As far as I could tell the boy had no eyebrows or lashes. You could see clean through his blue eyes to the base of his skull, but he didn't move them off me, nor did he make any conciliatory gestures.

Instead, he squatted down where he stood, eyes still on me, reached for and seized my fire-engine red Mercury coupe which I had parked in the construction site of what would be an artificial lake once I had attended to the secondary roads.

I rocked back on my heels, but had too many things to say at once and they wouldn't get in line to come out. It was the deliberate way this chunky kid had seized the car. There was nothing furtive about it. He wrapped his freckled fist around it as though daring me to contest it. He wouldn't take his eyes from mine. If anything, they narrowed.

I rose to my height, considerably more than his. He rose too, the car still enclosed beneath the dimples where knuckles should have been. I reached for his shoulder. He shrugged it off, facing me, the eyes not changing expression.

I looked for help. There was a blur of people on the periphery, maids pushing carriages, old men reading newspapers. But nobody moved to claim ownership to this beefy, red-headed kid who didn't know the rules, or didn't care to follow them if he did. It was anarchy and my government wasn't around.

The resolute way he handled himself made me pause.

Eye to eye, I reviewed the facts. It was clearly my fire-engine-red coupe he held in his pudgy fist. It was my expressway he was standing on. I was older. I was bigger. And all of this ought to have been apparent, even to a little kid like him.

It meant a fight. I was sure of that. But since I hadn't been in any, I didn't know how to begin. Before I worked out a course of action, he turned and started footing it across the sand, one step at a time as though he had all day. I followed him step for step.

I considered the options: grabbing him, tackling him, pulling him down. Anyone could see I was justified. I touched him on the shoulder tentatively. Maybe we could work something out. He jerked his shoulder without looking back.

He continued out of the sand pile past the maids, the old men, past a group setting up a picnic at the edge of a stand of trees. I waited at the edge of the sand to determine what grown-up would own up to this kid.

He kept walking across the park. I yelled. He didn't turn. This kid was going to walk for miles. I started after him, but remembering my other cars in the sand behind me, stopped. I didn't want them nicked as well. I looked around. Nobody else was appalled. They pretended not to see this barbarous act. It was happening in broad daylight. In a perfectly respectful park. Nobody wanted to get involved.

When my mother came later she asked me why I wasn't playing. I couldn't tell her. When she asked me whether one of my cars was missing, I shook my head. When she asked me what was wrong, I told her there was nothing. I didn't know then that I'd met my first collector. I did know I met someone I was going to remember for a long time to come.

It cost me a car and some self-esteem. But it taught me to appreciate how little one can hope to deflect a willful collector when he is seized by the desire to possess something beautiful.

Naturally there are limits. The buyer is not compelled to walk away with your paintings at any price, but it helps if

you understand that the collector wants with a capital "W." What triggers that want is a unique bank of nerve synapses that engage him at the aesthetic level. He's not buying skivvies or even that diamond brooch that contains in its design the intrinsic value of the gem. He's not buying real estate or stocks and bonds. Though he'll expect or hope for an investment potential, it is not the motivator.

Remembering my Mercury coupe and the little boy who seized it will help you to understand perhaps the most important principle in conducting your successful painting business: You do not SELL paintings, you PRESENT them.

I did not sell my coupe. I did not have to tell the little collector that it was a solid piece of cast steel, that the paint was baked enamel or that it represented one of the newest, sleekest aerodynamic designs in toy automotive history. (Who knows? It may have.) Had I tried to sell him, he'd have turned on his heel and toddled off.

That good piece of news is going to save your life. When you act upon it, you're going to start being successful. Simultaneously, you're going to quit feeling bad for all those times you took it upon yourself to try to sell your work. Instead of it resulting in permanent injury to your psyche and enough accumulated embarrassment to cause you to shudder even years later when you think about it, you will be allowed to forgive yourself.

For you're an artist. As one, you were granted by divine powers, your choice of dieties, or any number of spirits, a facility to paint and communicate at one of the deepest levels.

The degree to which you effectively do this is an inverse relationship to your ability to join the business community as a salesman.

I'm sure you're no stranger to the phenomenon. As you assume the sales mode, your eyes sink back a quarter inch into your skull, your eyelashes conjoin like copulating caterpillars, your tongue swells like a regulation Voit football, your neck recedes into your shoulders, and your ears color. When you lean forward to smile your reassurance, children retreat behind their parents and dogs snarl. It's why **Pigeon Factor 64** ought to make some sense to you:

You can't get a pigeon to look, act or sing like a canary,
even if you clean him up and paint him yellow.

God gives. He takes away. The good news is that you
won't need what he took. So you can put away your great,
good-natured, apple-cheeked Bavarian wood carver smile,
the one that gets caught on your eye tooth every time you
mention money. You won't need it.

Your paintings don't need to be sold. They need to be
bought. You, or somebody, needs to be there to sign the
receipt, shake hands and count the money.

That leaves you with but a single job: finding the buyer.
While it puts you in the same search as everyone else in busi-
ness — from the corner Mom and Pop store to the mighty
Mitsubishi — you got one thing going for you. While you
need buyers, you don't need many.

And as you find them and allow them to buy, your
prices are going to rise, you're going to need fewer of them
every year. And since you'll be better known then, the few
you'll need are going to have a lot easier time, because they
are going to be seeking you out. It won't be long before
you'll have to defend your paintings against demand. But
first things first.

For now, we're looking for some start-up buyers. As
you've no doubt surmised, they're looking for the good
paintings you're about to show them. So let's quit fumbling
with the hooks and buttons and get this thing consumated.

First, let's find out what a buyer looks like.

Chapter XIII

What a Buyer Is

I 've got to come clean about something with you before I get on with telling you how you can recognize a buyer and how you're going to allow him to make a success out of you. I told you that you didn't have to do any selling, that any selling you did would reduce the number of buyers. And I'll stand by that. I'll stand by how I told you to be a presenter. Because you and I know that as a salesperson you'll have as much success as Yassar Arafat pushing Tupperware at the back door of the Tour d'Argent.

What I wanted to clean up is this: People are not going to be writing you checks and calling you on the phone. You've got to work for sales. You've got to search them out. To find them it's going to take a lot of time from your studio and a lot of work that you're not going to be keen on doing. Some of the work is going to look suspiciously like selling: you will have to canvass the market, develop a potential client list, target your most likely prospects, prepare a telephone pitch, make cold calls, suggest a time and place for a presentation and get referrals.

It all has the ring of a help wanted ad for a vacuum cleaner salesman, the one that offers you big bucks to set appoint-

ments by phone, as though everyone was sitting around knee-deep in a dirty carpet waiting for the phone to ring.

I'm sorry. It's bad. But it's not as bad as it seems. The people you'll be asking for appointments are going to be interested in looking at art. And you'll make the request and the experience as nonthreatening as you know how. Because I'll teach you. You bought the book. I still owe.

But let me make a humble suggestion as one who knows your proclivities, who suspects you may have the telephone personality of a taxi dispatcher and in your zeal to improve it you're going to come off sounding like an Albanian goat merchant on his first day at the free-market fair.

My suggestion is that you find an agent to help you with some or all these matters. The idea is that if you can put someone smart between you and the person who is going to buy your paintings, someone who can speak for your work, you're going to feel better and, more important, the buyer's going to feel better. Having a happy buyer is tantamount to a sale.

Remember that piece of false logic we used to talk ourselves into opening our own gallery? The one that says buyers like to meet the artist? The truth of it is they don't much. Those who do would rather meet him *after* they bought the painting. Potential clients are human. They don't like making sad announcements. They don't like to tell an artist that the work doesn't appeal to them, that it is downright bad, or that they like it, but not enough to buy it, or that they like it, but at a lower price.

They'd rather talk freely with another businessman, someone who did not make it so painfully obvious that the art in question belongs to him. They'd rather do business with a middleman, someone they can tell to push off. Everyone's heard of artistic sensitivities. Nobody needs to have on his conscience an artist given to opening a vein and bleeding all over the conference table.

Great, so where do you get this agent so that you can turn this book over to him and get on with the job of putting paint on that picture in the studio? They're not in the phone

book (those that are should be avoided), but they're around. I'll show you how you can find them, train them, and use them to make you get rich. But for now, you need to know that this is still another something you can't afford.

You can't afford an agent now because he lives on money as much as you do and hiring him now would make two of you without money. That's a condition that does not portend prosperity.

So, who would like to do some or all of this work over a sustained period of time, get paid nothing for it, while maintaining a stake in your future as an artist? Not Mom. She has a stake in Dad's future: how she's going to get him to push himself away from the dinner table.

Friends will become decidedly testy. Relatives will remain so.

I'll give you a hint. Remember when you bought the easel and all the stuff and had a talk with your wife about the decision you made after two days in the mountain cabin?

Let's go see if she's still around. And if it's a husband you talked to before your decision to paint twenty of your best paintings, let's find out what he's been doing lately.

If they haven't left you, take a close look. You could be facing your first picture dealer trainee. And the price is right. Tell her — or him — that it's pretty easy and won't take all that much time. Tell your trainee you will set the goals and the rules, and that since you're the painter-manager you'll explain everything step-by-step. Even if your new dealer has never done any such thing before, if she is capable of picking up a phone, walking into an office and holding up a painting while at the same time enunciating sums of money, she will be of great service. Remember, I'm not asking for a salesperson. If you get that out of your head, you won't pass bad news along to your first employee.

How will you know what to tell your trainee? Finish this book and let her read it. Or hide it and explain it. She'll think you're mildly smart. Mostly tell her how you'll both be successful, how she can share a vital role in making all those hours in the studio come to fruition in recognition, money,

and travel. Tell her there won't be much heavy lifting. And if she can't take you as a manager? See if she wants to do the painting.

You're not married? Get married. Or ask a live-in, a special friend. What if nobody will marry you and you haven't got a friend? *You're* going to be the picture dealer. Go take a shower, shave, comb your hair. Look in a mirror. Practice saying sums of money without blinking or chewing the inside of your cheek. See if you can smile at the same time. If your upper lip gets damp with sweat, practice some more.

If you do not disassociate yourself from your work you will convey your anxiety to the collector, and he will grow restive. Face yourself down on this. Relax. Allow him to be comfortable even if he knows you're the artist. If he doesn't know, don't tell him.

Either way — with someone representing you or if you're representing yourself — get the artist out from the middle of it so that both you and your client can concentrate on the matter at hand: selecting a painting he'll want to pay you money for. Just as there is no earthly reasons for your wife or husband to immediately lay claim to a marital status when talking to a prospective client, neither must you, the artist, own up. If it makes you feel any better, this does not make you a liar. You or your agent is representing a very talented artist. Period.

I trust you are better at this sort of thing than I was. For some reason — and I fear it's endemic among artists — I felt that for someone to know something about me, he had to know everything. There had to be a cause and effect relationship dating back to the crib. I felt I needed to answer questions before they arose. And then give my own answers to them. Thus forestalling any doubt about anything.

"This painting? You want to know the price of this painting? It's not one of my best. It's something I never was pleased with. I couldn't quite get the feel of this passage here. Happens to me sometimes. Unable to really get down to what I want in a way I want to say it. But price? Well, a guy sets his prices, you know, on value. Sure, size, period, they're

all important, but the end of it is: what it's worth. And you put that in a dollar figure. And I don't know what it would be in this case. I mean how much, since — you know — as I was saying, neither me or the wife much likes the damn thing. So, here. Take it."

As you might guess, this blinding honesty was a major factor in the perpetual poverty of my early years. It's taken me longer than most to learn that the person asking the question is most likely wanting an answer to it. He probably is not working for the C.I.A. or surreptitiously taping an unauthorized biography, and he no doubt believes I am what I say I am without my depreciating it with all sorts of jive and nonsense.

I once tried to teach my dog not to make such a row when someone came to the door. I could, if I stood over him in a threatening way, succeed in getting him to throttle the bark to a barely audible, but repeated, burp. Each time it would escape him, he would look up at me, his eyes rolling in white.

I've had slightly more success than my dog in learning to shut up. But like him, I get my spasms, too. It's hard to stifle ruinous behavior.

So what I'm saying is that if you don't make it too hard for yourself, don't over dramatize the business of exchanging paintings for money, you or your agent, will do pretty well. It's a snap once you find a buyer.

To locate a buyer, I've kindly provided you with an admittedly subjective profile. So you will recognize one when you see him, here are some things buyers are:

• **People who like to look at paintings** and who gain something from the process. These people understand that paintings speak and they can't get enough of what they have to say. They gain from paintings as one is enriched by music, a good book, a play. At last, when they walk away from studying a good painting, they leave with more than they brought to it. They will have a memory for the good paintings they've seen. More, they will be haunted by them.

I had a friend in Antalya, Turkey, who sold carpets this

way. He had learned it from the women on the looms in the windblown villages of Anatolia where they worked on them knot by knot. They advised him never to sell carpets. Rather he should arrange to have his customer spend some time alone with one he's taken a liking to. Hand woven carpets, they told him, are like young girls. They will know how to make a lasting impression so that if your customer walks away one day, he will come back the next.

• **People who have money to buy paintings.** There are many people who like paintings but must content themselves with liking them in museums, galleries, and other people's homes and looking at or buying reproductions of them. Some of these people will be artists, some students, some the chronically broke. They will want to meet you and spend time with you. They will monopolise you at your receptions, if you let them. They will test your charitability.

Don't feel obligated. You owe it to yourself as an artist to focus on the one thing that will allow you to continue to be one: earning a living. If they like your work, tell them you will help them in the only way you can: you will produce more of it. Let them find a buyer for you.

• **People who like to own things they like to look at,** hence the collector. John Fowles, in his novel by that name, paced out the distance between collecting as a hobby and as an obsession and found the positions proximate. But whatever the psychology, you can rest assured that the collector is always at least one painting away from completing his collection.

• **People who like to display things they own and have a place to do so,** often called a house, sometimes called an office. This seems obvious, but by qualifying them this way you'll recognize the buyer from those who want to spend your time weaving tales of affluence and love of culture.

• **People who want to be understood and admired for the things they own and collect over the years.** Collectors can be artists in much the same way you are. They use their collection to communicate to others something about them-

selves and something about the art that comprises what they gathered that goes beyond individual work. Put a Jasper Johns together with Goya and you have something neither artist can say alone.

• **People who are probably, though not necessarily, well-educated** in what used to be called, liberal, classical or well-rounded studies, even if these studies are only a part of an otherwise technical or scientific education. If you are placed at dinner next to a doctor, engineer or baker, and you can't move the conversation beyond medical advances, computer imaging or the taste advantages of sesame seeds, your hostess has not done you any favors.

• **People whose parents valued and/or collected paintings** and otherwise respected the arts. Culture is catching. Children look at art because they've caught their parents doing it. Not only do children stand to inherit the collection of work accumulated by their parents, but also their motivation for collecting.

• **People who are inclined to support other arts:** operas, classical concerts, museums, theaters. There are exceptions, but it is more likely you will find buyers with these interests, than with interest in cock-fighting, mud wrestling, or bowling.

• **People who like to read books** — though not necessarily this one — and have them around where they live. But don't be fooled by home libraries where books are bought by the shelf yard as decoration and acoustical screening for their television room.

• **People who understand that good paintings — even of relatively unknown artists — have a monetary value** beyond the frame and stretched canvas; they understand that most paintings of better-known artists have value and that all paintings of well-known artists, be they good or bad, have value, sometimes measured in millions.

• **People who are mostly middle-aged to elderly** with well established careers in which they are active or from

which they are comfortably retired or those who otherwise have money.

As an added convenience, let me tell you who are *not* buyers of your paintings:

• **Better than 99.9 percent of the world's population.** There are a lot of people out there: those having wars or planning them, those who are starving or worrying about next year's crop; great vast reaches of humanity who have better or worse things to do than to contemplate painting.

• **Anyone preoccupied with living or earning one.** You won't find many buyers in Chittagong, Addis Ababa or Minsk or those in employment lines in Watts, Pittsburg or Detroit, or in coal mining towns of Great Britain. You won't find many among the recently enfranchised Inuets of Northern Canada, or those tending cactus in the sparse deserts of Northern Mexico. You won't find them in a whole lot of Africa, nor are their numbers great in the rural outreaches of sprawling Eurasia or South and Central America.

• **You won't find your buyer among the vast, untapped legions who have not learned to see,** to use their eyes, to behold the color, form and beauty of the world around them.

• **They won't be among the not insignificant number of people, mostly men, whose misfortune it is to be clinically color blind.** (Curiously, having color vision is not an entrance requirement for any course of study in painting that I know of, despite the simplicity of the test.)

• **People will not buy who, with or without good reason, don't like your subject, your color, your style, your price, you, or your agent.**

• **People who tell you they like everything that you show them** will not buy.

Nor will:

— Those who tell you they just love art.
— Those who tell you their wife or husband does all the

art buying and this is said *after* you've made a presentation.

— Those who tell you they are rich.

— Other artists.

— Members of parent-teachers' associations.

— Politicians.

— Those who formerly did buy art but are now under indictment in a bank or stock swindle.

— Deposed rulers.

— Any man seen at any time to have simultaneously worn a gold neck chain and a pair of sun glasses on top of his head.

If you haven't met many of them before, you'll soon be able to distinguish between the buyer and the nonbuyer. You will become skilled at watching him as he looks at your paintings. It doesn't require a whole lot of aptitude. Simply, ask these questions:

Does he want to get to the business of looking at the paintings, or does he want to hear you talk about them?

When looking at your paintings is he seeing them or is he talking? The two acts are mutually exclusive.

In the course of looking at your work is he reminded of any relative who paints? This includes any son or daughter who has aspirations for attending art school.

How long does he spend with each painting or with each color reproduction? Speed readers don't buy.

Finally, if he passes those tests, try this one. Hand him the stretched painting he has expressed interest in. Ask him to take it closer to the natural light. Watch how he handles the painting. Tell him to lean it against a wall and step away from it. See how carefully he puts it down.

I do business with a gallery in Tokyo. Once a year or so I bring in a roll of paintings. Before I'm much out of the taxi, the owner and two assistants relieve me of my package. The three of them carry it in like a car bomb ready to detonate. Gently, they lay the roll on their felt table as though it were an accident victim with a spinal injury. It takes two men to carry each limp canvas to the inner room in which,

131

presumably behind a leaded vault, they keep their supply of unstable plutonium. Only when the last one has been put away do they come forward to greet me.

This is the same roll that flew with me as a carry on and traveled in storage above me amid wet raincoats, boxes of duty free liquor, compressed backpacks, and a small pile of attachè cases.

But I must leave the subject of the buyer with a word of caution. People don't fit in boxes. You're going to meet buyers who defy all the rules I set up to contain them.

For example, one who buys a painting for the first time had been a nonbuyer until then and no doubt matched the profile, until then. He may hang the single painting and revert to his old ways. Or that painting and his ownership of it may have profoundly changed his habits.

He fell in love once. He could fall in love again.

Chapter XIV

Siding Up To The Devil

Now that you know what buyers look like, let's find out where they're hiding.

Go directly to your nearest big city. Since most people live in their nearest big city, you probably won't have far to go. This is your laboratory for applying the principles you read or will read here. It is your launching pad for success and freedom. And, not the least of it, it's your bank.

Look around. This is the city you're going to start in, where they'll put your monument some day once they get it all carved out of granite and can find a site and everything. This is where you're going to sell those first twenty paintings. Unless you already live in the center of New York, London, Paris or Rome, you won't need to go there. Yet. These are big cities whose central art districts you'll need later. Your nearest big city has got all the buyers you'll need for a while. And you don't need plane fare to get there.

Start by reading the city's newspapers. Read the local news and the social pages. These are two sections designed to keep readers from too readily finding the sports pages.

Start a list of people who are going to have an opportunity to meet you. They will be the city's important people

and will have their names in the paper. There will be stories about what they're doing and how important they are, and there will be pictures of them in tuxedos and long dresses and what-not amid other couples similarly dressed. They will be looking at the camera while holding cocktail glasses, and they will be far enough away from the cameraman so we can take in the full length of the tuxes and so we can see how the long dresses hold up in the glare of a strobe light.

You'll have a fertile thirty days listing all the people who own companies, do good things and attend interesting events. After that you're going to get the same crowd coming back at you in the news and in the pictures. They'll still be holding their cocktail glasses, but they will have changed clothes and events. The write-up will be pretty much the same.

This means that the newspaper's list of important people is now not much longer than yours. Unless you enjoy reading this stuff, you can just check in every month or so to see if anybody's moved in. But before you quit buying the newspaper daily, check your list of names against those who appear in news stories on the first two or three pages. Cross off your list the names of those who are being indicted for various offenses. They will be too busy for a while.

You will note that when important people are being interviewed they seldom fail to mention that they are art collectors. Don't get your hopes up. It does not necessarily mean that they buy paintings or hang them on the walls or donate them to the local museum or do other things usually associated with the term. It may mean they have a Norman Rockwell print and a signed and numbered collection of commemorative coins featuring portraits of leading astronauts sculpted by Walter Cronkite.

It may also mean they collect good and valuable paintings.

Your list, though extensive, is by no means complete. If you're making a start with these twenty paintings — or a new start if you've tried before — your prices will not be so high as to prohibit most anyone from owning one. But I want to

134

prove a point to you. I want you to use this list of important people who appear in the paper and add to it a list of equally important people who do not appear. And we'll stay with that. We don't want these twenty works of yours to go to just anyone. We want your paintings to be seen after they're bought. We want to choose your buyers. We want to make sure they're good salespeople.

So how do you get this other list of important people, those who are disinclined toward publicity? You are going to talk to them, to show them your paintings, to trade one or more for the check they'll write you the day they decide.

You're going to talk to friends, family, people who know you, people you've met. You're going to ask them for *their* list of rich, influential people in the community. And since it's something people like to talk about, they will give you a list and tell you a great deal about those on it, including those among them who have expressed interest in Fine Art.

Asking your friends about those on the list you have already compiled will enable you to deftly combine the lists, but, since you want your paintings to go to those at the top, you'll need to qualify them further. A lot of people get on lists of rich and influential people when they are neither. They get on the list by convincing people like your friends that they are indeed important. They do this by driving expensive cars, dressing in the fashion, and talking a good deal to people who do not know or care to ask questions about how they came to be so important.

It's a question you'll not fail to ask your friends. If they can't tell you why it is these people are considered important, we'll assume the worst: that they gravitate to the better circles without being a card carrying member. They may be good people, but we'll ruthlessly strike them from our list.

The next question we'll ask our friends is to name someone they know who is likely to know one or two of those on your revised list.

It's the old arithmetic progression trick: you know somebody who knows somebody who knows Prince Charles, the Sultan of Brunei, or Michael Jackson's chauffeur. It's

one of those old tricks that work. Unless your friends live in a packing crate, they will know somebody who knows a somebody.

Now that you understand how it works, we're going to ask your friends a small favor, then ease off. We're going to ask each of them to call that somebody who knows an influential person on your list. Please note that we're going to leave the important person alone for now. We're going to ask your friend to talk to this middleman about anything at all, anything that will lead to a short, comfortable conversation. In the course of the conversation you will want your friend to mention two things: your name and the fact that you are an extremely talented painter.

That's it. Write the names of your friends' contacts next to the appropriate names on your list. Now relax. Go home and have a beer. Already you've got people working for you.

While they're working, let's talk about those people on the list. If you've done your homework properly, the one common denominator is that they're all rich. Important people are rich. Rich people are important.

Rich people get rich for a number of reasons that do not always reflect on their wisdom, but they stay rich because they've learned how to spend money wisely. Oddly, (or not so oddly) money is far more important to them than it is to you. You have your art. They have only their money and the means to make more through whatever business they control.

They're going to spend their money carefully — however rich they may be — because it represents who they are.

You've got to understand that. Then you've got to help them. You must help them feel good about buying your paintings. When you help them in that way they're going to be grateful. They're going to talk about you to their friends. They're going to show their new painting to anyone who comes into the house or office. Your going to sell them your painting; they're going to pay you money, and as a bonus they're going to offer you up to their circle of friends. You can't pay for publicity like that.

136

So what will bring him to having all this enthusiasm for the painting he will buy? What will bring him to hang it in a place of honor and talk about it?

- He wants to like it . . . a lot.
- He wants to believe the artist who painted it is a professional and credible figure in the arts who, by continuing in his occupation, may one day be better known than he is today. He doesn't want someone who will quit and buy a hamburger franchise in Billings, Montana.
- He wants to believe that the artist who painted it believes in it. He does not want to hear from you that there are other paintings you like more.
- He expects permanent materials are used and that the painting will endure for generations and that as the legacy is handed down within his family, each succeeding generation will acknowledge the wisdom and good taste of the long deceased relative who first bought it.
- He wants to believe others will like it . . . a lot.
- As a businessman he is cognizant of the laws of supply and demand. While he wants you to be around long enough to make a name for yourself, he also looks forward to your sad and untimely death shortly thereafter so that his work is contained in a relatively small, and necessarily finite, *oeuvre*. Once you're deep-sixed he expects big bucks from the painting, should he need to cash it in for a defense attorney, a divorce settlement, or for upgrading his girlfriend's car and apartment.

He will be sorely disappointed if you don't follow my advice here, if you up and die before establishing yourself. There are a lot of dead would-be's leaving behind a lot of paintings that will never be.

- He wants to believe the price you ask is fair and equivalent to what others have paid for your work like it.
- He wants to pay less than that price.

In short he will get enthusiastic if he likes the painting he buys and believes you as the artist carry enough credibility to warrant the price you ask. He wants to feel that the price he paid was a good investment. He wants to believe that you will be a famous artist someday.

137

Q. Oh, that's great, you know?

A. What's great. I thought you'd quit reading.

Q. I should have. Think you're gonna get anybody to believe this stuff? A guy tries to unload twenty paintings and you come at him with investment and credibility and generations of art lovers. Come on. This buyer of yours. He likes a painting or he don't. He ain't gonna buy if he don't. And the way things stand in the world lately, he ain't any more likely to buy if he does. You look at newspapers. They're talkin' art market? Well, there ain't any.

A. You been reading this book, or you been skipping around? I told you. The art market's there. The way you sell has changed. You gotta take it to the buyer.

Q. So what do you think he's lookin' for, an annual report, stock splits? We're talkin' paintings here. Guy does paintings, you know? Wants to know how he can sell them.

A. I'm gonna tell him how. I'm going to tell him how he can sell and make the buyer happy enough to get on the team.

Q. I heard you about the buyer. You already said that.

A. So you *have* been reading. I wanted to check.

Q. Leaves you with a pretty tough rest of the book. Right? You gotta get these paintings sold and more like them. Then you gotta make him famous. The big think piece, right? My guess you got nothin' but problems.

A. You gonna quit reading?

Q. You kiddin'? Wouldn't miss this for the world.

So, what you've got to get before you get to the buyer is a lot more credibility than you've got now. Presumably you have good paintings. That was your job. You told me they were your best, and I believed you. We've got to make them look as important as they are or as we both believe them to be.

We've got to make a presentation.

I'm not talking frames. I'm talking about a sales tool

138

which you're going to use now and for the rest of your natural brush-swinging life.

We're going to catalog those twenty masterpieces in the slickest, sweetest full-color publication your buyer has ever seen in or out of any gallery. It won't be far behind anything Christie's or Sotheby's can muster. It will contain twenty color plates, your history, your philosophy about art, and something about each painting.

You're not going to do the writing. You're not going to do the photography. You're not going to do the layout or choose the typeface. Everything in it is going to depend on skilled professional craftsmen. It's your first extensive piece of professional advertising and it's going to say to anyone who picks it up: "You're looking at the work of an important artist."

It's going to put the cart in front of the horse. Where it's got to be. You know — and I can guess — how long you've been trying to beat that tired nag into dragging it along behind her. It's what most artists do and it's why most artists fail and quit being artists.

Here's what this catalog is going to earn you:

- The near instant sale of paintings which appear on the front and back cover.
- The progressive sale of the rest.
- Recognition as a professional artist.
- Your first fully successful show in your nearest big city in one of the top galleries.
- The attendant publicity for having a sell-out show and having among your buyers the most important people in the community.
- A tool you'll use to sell other paintings all your life.

That's what it will earn you. And I'll tell you exactly how it will do that. What it will cost you including some frames is less than five thousand dollars.

That's not a misprint. It's going to cost you somewhere near five grand. If you want to do it cheaper, don't do it at all. I mean it. Don't bother.

You're not going to save on photography and have your color slides pretty close to being in focus considering you didn't have a tripod. You're not going to save on color separations by convincing your one-hour photo guy from Delhi to give it a whirl. You can get cheap stock but the color on it will look like a shopping sale. You can get it printed cheap and the registration between colors will make your stomach feel like you sailed around Cape Horn in a gondola.

Trust me. You want it good? Pay for it.

I can hear you. Believe me, I've been there. You've been reading this book pretty good and all of a sudden this guy's talking five thousand dollars. You're an artist, right? You bought this book so you can make some money and here he is telling you to cough up five g's. Teach me how to sell, you're saying. Who's got that kind of money? Teach me how to make it, then talk to me about spending it.

I hear you fine. Now you've got to hear me.

Supposing it rains tonight. Not a little, but a lot. And it's late and you're in bed with the lightning flashing against your closed eyes and you're trying your best to remember whether you left your car windows open and then trying not to think of that at all by counting the miles between lightning and the following thunder, and at once there's an ear splitting blast of illuminated energy that explodes within your skull and you find yourself standing in your skivvies at the side of your bed facing Lucifer at the end of it, his black robes, like clouds, swirling around him as the thunder in your ears recedes. He's grinning, of course, his face lit as though from below.

You've heard the Faustian proposition before. He's going to give you what you want. He will make you a rich and successful artist with people buying up your work and inviting you places and with your phone ringing. Money, fame, you know how it goes.

Your knees are banging in time to your teeth and over the chatter you manage to tell him you're not selling your soul. Never would you sell your soul. Hardly ever would you do such a thing. And if you were offered riches in exchange,

140

and money and fame as an artist, he's just going to have to wait for an answer. You'll just have to think about it — well, you'd be a fool not to think about a thing like that. If you did it — I'm saying *if* — it would be just this once.

But instead this embodiment of evil tells you that he's not looking for your eternal soul, that what he needs is some money to pay off the printer. He's going to make you rich and famous and it's only going to cost you five thousand.

Tell me what you're going to say. Tell me you won't find a way to raise the money.

If you're serious about the pledge you made to yourself during the weekend you spent alone, with the TV in the closet, then you're going to find a way to invest in yourself.

Though you're going to have a lot of catalogs extolling your paintings in the years to come, this will be the last one you'll ever buy, if you do it right, and don't cut corners, and use it as it can be used: to sell every one of your paintings before the door opens on your first, fully successful one-man show in your nearest big city.

It will be the last catalog you'll buy because future ones will be sponsored and all you'll suffer then is a company logo on the back page and the scent of flowers at the opening.

After you find the printer who can do this high quality work, he'll have some recommendations for who can do the layout, color separations, and slide photography. He may also suggest an ad man who can do the writing, but this is a recommendation we're not going to take.

Remember that newspaper you quit reading after you got your list of names? Go buy another one. This time look at some of the local stories, the ones with bylines, particularly features. And see if someone is writing art stuff, if so, see if he is willing to sign a name to it. See if you understand what he's writing because understandable writing is the hardest kind. If you do, call him. Take him to lunch.

Show him a rough layout of your catalog. Tell him what you'd like written: a biography, some comments — yours or his — on each of twenty paintings and a couple of pages of

141

philosophy, why you're a painter and how you came to paint the way you do. Tell him how much the catalog means to you and why you chose a working stiff over some effete ad man and offer him two hundred dollars and the lunch he's just eaten. Offer that amount if he'll see what he's written through publication.

He'll work for you on that. He'd probably do it for less, but we need him and the big city newspaper that employs him. We'll get both this way. We'll get paid back in publicity when we determine which lucky gallery is going to get your sold-out show.

Now get it all going: the writing, the photography, design and layout, all of it. Stay with it. Look at every stage. Check the colors in the slides, the separations and the printing against what you painted. Check and then check back. If it's not right, have them redo it. Argue with them. Show them the originals. If they carry insurance, leave your paintings with them. These guys have good eyes. They need something to work with.

Get the proofs back to your journalist. Show him what they're doing. Get his ideas.

You're going to be spending more time at the printers' office than the printers do, and as a result you're going to gain an enormous respect for the process of producing a painting: one, single, solitary man making all the aesthetic decisions. Unlike printing anything, it does not take a cast of twenty doing everything wrong.

Ah, but when they get it right and it comes off the presses in your colors, your labors are forgotten; the disputes and frustrations are history. You're looking at the work and words of an artist heading to the top.

Now we're going to have tea and finger sandwiches with the three powerhouses of culture in your nearest big city. You've heard of them by now. They're often pictured at fundraising events for charities having to do with the arts. They preside over balls and auctions and can be seen pictured with the museum director discussing membership drives. They got the theatre group to stage that Saturday ma-

142

tinee of *Rebecca of Sunnybrook Farm* so that the inner city kids could take a day off pushing. Since there were no injuries in the drive-by strafing, the event was deemed successful.

You'll note that these powerhouses are all women. If they're not on your list already, their husbands are. They are important to you. Don't be deceived by their numbers. Each of them commands a brigade of loyal volunteers, all lethal. If you're nice, they're going to help you. If you're not, you're dead.

The lesson is articulated in **Pigeon Factor 65:**

> It is unfair that large, healthy pigeons are dominant in matters of feeding and roosting. But it's not an issue a smaller pigeon should raise.

Now for the finger sandwiches.

Look. Don't blame me. I told you to recruit someone for this thing and you told me you didn't want to get married. So fess up. Pick up the phone. Tell Mrs. Powerhouse that you have been reading about her good work and you know of her interest in the arts and how important she is to the community. Tell her that you have an art project that will benefit the community and you'd like her advice. You can't talk about it on the phone because it's a visual presentation in the Fine Arts. You want to take her to lunch or tea. Failing that, and recognizing how busy she is, you are willing to meet her anywhere at her convenience.

If you're persuasive, you'll get lunch; if not, you'll get tea. If you come off like a thug, you'll get five minutes in the lobby during the next women's club meeting. Take any of it.

While you're waiting to meet her and the two like her, select your gallery. Make sure it's the best one. Make sure that the work they show is not wholly dissimiliar from your own. If you do abstract expressionism and they're into pseudo-Dutch realism, it's not going to work. Make sure that they're not planning to go out of business tomorrow morning.

When you take Mrs. Powerhouse to tea, choose a quiet restaurant but make sure you don't slurp your tea or make other unsuitable noises. Show her the catalog and the orig-

inal paintings of the front and back cover. Allow her to marvel at your work and the professionalism of your presentation. Then tell her about your art project.

Award her one of your catalogs and take the trouble to sign and date it. Do this just below some nice words you've composed about your delight in meeting her. Tea, a little of your time, and a catalog are small gestures, but they will get her attention.

While you have it, you want to tell her this:

You are planning to stage a one-man show in the gallery you selected and when you discuss the plan with the gallery owner you would like to use her name by way of recommendation. That's all. No, you do not want to sell her your paintings. You have twenty and they're reserved for the show.

She will be relieved. If she likes your paintings and is beholden in the smallest of ways for the tea and catalog, she will say yes. She will even agree to writing a few lines of praise of your work and signing her name to it, since you so cleverly thought to bring some nice stationery for that purpose.

By the time you get to the third powerhouse, you'll be the talk of the town. It'll cost you maybe a lunch and two teas.

There's a point here that ought to be stressed. It has to do with how artists think the world works and how the world really works. Artists do not like to spend money. They are mostly poor and don't have much of it. They are, after all, offering the world their talent, the greatest of gifts, so why do they also have to pay for lunch when everyone can plainly see they're having lunch with a rich person. The argument takes wings when put against the costs of photography, a catalog, the writing of the journalist. Why can't someone in business sponsor this? Look at all the endorsements our sports heroes accumulate. Think of how much more valuable art is than their athletic accomplishments.

It's an understandable argument. But it's not how the world works.

Business is interested in success. It isn't interested in making you successful. It doesn't care that your paintings are good. It's not going to sweep you up. It's not going to save your life.

It's like the bank lending you money if you can prove you don't need it. Business is not going to sponsor you as long as you need the money more than they want to give it to you.

The same goes with lunch. If you need someone to pay for your lunch, you won't be asked. When you have something to offer, you will. What I'm telling you is: pay for the catalog, pay for the lunch. If Mrs. Powerhouse gets out of a stretch limousine, pay for the lunch. You owe her. But she'll be kind enough, hopefully, to pay you back later in other ways.

Now that your base camp's in order, you're ready to make the gallery assault. Remember, we are not going to be satisfied with "getting in" a gallery. We want a one-man show. We want it early. And we want it done right (which means our way).

So call for an appointment. Gallery owners do not like artists to "drop by," lugging enormous photo albums while a pick-up truck of sample work double parks outside. Especially when all this comes in the midst of a sales presentation they're making to a long established client.

Your call is a human courtesy. It also establishes you as a professional. You will further their understanding of that as you move along. Remember, you'll need to overcome a bias that artists either know nothing about business or refuse to conform to established business practices.

You're going to surprise them. Provided they don't surprise you first with their own business gaucherie by telling you, for instance, that they're too busy to see you or that they're not looking at the work of new artists. If you get either of these comments in the space of a single call, your talking to a business that lacks both acumen and common courtesy. Hoist up your Levi's. You're going to have to wade through it.

Here's the drill. Any businessman unwilling to discuss a serious business proposal concerning the business he pur-

ports to be in, and he does this on the basis that he is too busy to consider it, is a fool. I didn't say foolish. I said a fool.

But don't tell him that. Tell him this, "You're busy, I'm busy. But since we're in different ends of the same business, let's see if we can both find five minutes together to discuss what is important to both of us: making money."

Everybody in the world is busy, or ought to be. To announce this condition to a telephone caller is to describe the obvious. Talking about it — instead of the business at hand — is consuming more precious time. "I'm too busy," evokes the image of a guy frantically tying his shoes all day.

The second off-putter — "we're not looking at new artists now" — is more serious. There's enough stupidity in this statement to warrant you deepsixing this gallery for another. But let's be charitable. Maybe the comment came after the fifteenth artist that week had just left after "dropping by" with three or four buddies toting enough works in colored butter to fill the Tate.

It is unreasonable not to look at new artists at some time, in some way. It is impossible to be successful in business without assuring yourself that what is on your wall is the best and most saleable of the work you could hang.

"But my name is Monet. Claude Monet."

"I'm sorry. We're not looking beyond our stable of artists at this time."

"But they thought I was dead. I've got some paintings nobody's seen. They're going —."

"I'm sorry. Have to cut this short. Terribly busy. What kind of paintings, Mr. Monet?"

"Well, you know that haystack series? I have —."

"Sorry. We don't take haystacks."

When you get your appointment, prepare to show your catalog, the color slides you used for it, half a dozen original stretched paintings, numbered and titled on the reverse, and your three powerhouse endorsements. Surprise the owner again: arrive on time. This, among many things, I learned from the Japanese, who in my mind, stand head and shoul-

146

ders above all or most other nationals in doing business. Since they are immediately interested in anything that has to do with making money, you'll get an appointment to talk to someone at the top in a Japanese company easily. Implicit in the offer is that you have five minutes to capture his interest, no more if you don't, all day if you do.

Since he's going to meet a whole lot of people between 10:00 A.M. and 11:30 P.M., his business day, he doesn't want you to be five minutes late. It's not only that he doesn't want you late, it's that he won't have it. You sought the appointment, both of you settled on the time. He's there. You're three minutes late. He's not there. You won't have a chance to explain about the subway crash, your heart attack, or that you started to his office by taxi at 4:00 A.M., but you hadn't known the Tokyo rush hour began an hour before.

Mean? Unforgiving? Yes, it is in a way. But he's got it figured this way. This was the first time you were to meet. He's sure you will have a perfectly valid reason for being late, even for as little as three minutes. But he's also convinced that you wouldn't need a valid reason if you thought the meeting important enough to start early. And there's a small to excellent chance that your valid reason is invented. At least it's a statistical possibility that he's starting a business relationship with a liar. Since there are a lot of people in Japan to do business with, he won't take the time or risk to find out if you're not a liar. You'll never see anything but his secretary and a cup of cold tea.

Aside from arriving on time and assuming the strength of your paintings, here's how you'll impress the gallery:

• You'll have made a professional "businesslike" presentation organized logically and thoughtfully.

• You'll have paid tribute to the owner and his gallery by changing from your studio attire to something more in keeping with the serious business you want to convey.

• You'll have walked him through the full color catalog of the twenty paintings you will be showing. The catalog — by far — is better than anything that the owner has produced for any of his existing artists and may be better than any-

thing he's seen to date. He will not want to show you his little mail-outs.

• You'll have him note that the catalog he so admires has a place you've reserved on the back cover especially for his gallery imprint.

• He'll know the three women who endorsed the idea of you showing with him. They are either clients of his or he wished they were. He will know that each of these women will command legions of others and that many of them will come once you solo.

• He'll note that you have gravely acknowledged the importance of his gallery when he made it clear that an artist could not possibly be scheduled for at least a calendar year, and that it is normal for him to schedule shows at least two to three years in advance.

• He'll take in how rapidly you will have countered with the fact that all you need is a Saturday, Sunday and four working days in season for your show and that you know as he does that schedules can be changed if the reasons are merited. You'll make him understand that, short of the time it will take to frame and get the catalog with invitations into the mail, you're ready now.

• You'll make it clear that you understand the difficulties he faces in selling the work of a new artist to his gallery. That's why you spent so much time, effort and money on a catalog and it's why you are willing to have these twenty paintings retail at an average of USD 500. You are committed to establishing a market through his gallery and you understand the sacrifices that entails.

• You'll tell him that you'll do the framing and have them wired for hanging. You'll remind him they're already cataloged by title and size.

• You'll accept his terms of a 40/60 split. (As a new artist you should be prepared to accept 50/50. But fight it.)

• You'll add your mailing list to his. (You'll get some help here from the powerhouses.)

• You'll expect him to pay invitation mailing, advertising, and reception cost. (But you'll stand ready to yield here as well.)

• You'll sign on to give him the same gallery cut for presales and aftersales for a prescribed period.

• Since you've invested so much in this project you will pursue sales actively in and out of the community. While you cannot and will not promise, you fully intend to sell those twenty paintings before he pours his first bowl of punch. Anything else will be a disappointment.

He may believe you. He's seen your presentation, and he's not stupid. He'll figure it out. There's always a week or more between scheduled shows, even if he didn't want to alter the timetable. He can plug you in to suit. He'll pay for one small ad and the nominal price of invitations. His big expense is mailing, but he'll be sending out a great piece of promotion for the gallery, your catalog. Add some vodka to the price of punch and he's got it all.

And if sales go well he'll earn three of four thousand from your work for the week. While endearing himself to Faith, Hope and Charity, the three powerhouses and their crowd of supporters.

You'll get your show. And then you'll have still another incentive to offer the buyer: a scheduled one-man show in the best gallery in your nearest big city.

Now you need to get back to the ladies, to hand deliver the invitation to your opening if it's ready, to give it verbally if it's not. And you'll want to bring some flowers. They'll be on your side from now on out. Everybody likes success and you've had your first taste of it, in part, thanks to them.

You'll want to meet them one at a time and when you do you'll be thoughtful enough to bring along the two or three paintings that they expressed most interest in when they first went through the catalog.

And you will kindly offer them a chance to buy them, under the proviso, of course, that the paintings will appear in the show, red dotted as sold. Beneath each, in elegant script, will be the discreet — but not too discreet — message: "From the collection of Mr. and Mrs. Powerhouse."

If any of them favor the paintings featured on the back or front cover of your catalog, be prepared to give them up

at one or two hundred dollars more than your average price. Naturally, you will frame the paintings they buy.

Mrs. Powerhouse is not going to miss a reception for which she has contributed her endorsement. And such an endorsement would be vacant unless she reinforced it with a purchase. And it is not an expensive ticket. You're a comer. Most everyone in the community by now has heard. Those who haven't will. You can bank on it. Your prices do not yet reflect your growing status. Mrs. Powerhouse and most everyone you talk to from here on out will know that if they buy now, they're getting you cheap.

You're going to sell three paintings to three ladies, and when you ask for referrals you're going to have some friends of theirs who are not going to want to say no.

In return for their help you will agree to speak to the ladies in their women's club, a talk based on the slides of your twenty paintings. Naturally, you'll have invitations to the exhibition for everyone who attends the meeting and a copy of the catalog for a nominal cost. You will suggest to whichever powerhouse has drawn the good fortune to introduce you, to be kind enough to add to her introduction that you will stay behind after your talk to discuss paintings sales with anyone who is interested. You will not fail to note in your remarks thanking her for the introduction that she is one of your collectors.

For now you'll need to make tracks back to your journalist to show him the finished catalog — and to sign a copy for him — and to tell him about your sales to the three well-known women and the endorsements they've given you. As opening day approaches, his newspaper will not be averse to doing a story on the upcoming exhibition, the reception for which is fast becoming a social event of some proportions.

He'll help you or put you at the desk of someone who will. He's on your side. You paid him money.

Now you'll need to take the checks (made out to you) and your accounting figures back to the gallery where you will divide up the presale loot thus far in accordance with your contract.

The owner will be in heaven. He'll also feel guilty enough to increase the size of the small ad he was going to run and do some other publicity work he hadn't thought to bother with. He's also going to feel some pressure to make some sales, if only to demonstrate that he's not going to have some two-bit artist outselling him in his own field.

Sorry. Hold off on your celebration. You're going to have to take your share of the proceeds thus far and put it into frames for twenty paintings. Easy come, easy go, right?

Now is the time — when you've got money coming in and going out — to consider the inevitable, that the end of the year lurks and with it the tax creeps. Fear not. The stuff you spend will come off the stuff you earn, for now anyway. But you must keep track of it. Write all of it on the kitchen wall and keep a big sack of receipts and pertinent paperwork hung on a nail near it. It's called double-entry accounting.

Chapter XV

Closing in On the Opening

With a show fast advancing, we've got all the makings for a sell-out: early sales with new collectors we can reference, good paintings, a good gallery, a sleek catalog to fire up our prospects, and the word getting around.

It matters a lot that you or your rep work hard now. You've got a short fuse for sales which nobody but you recognizes. You understand it because you've found this great how-to book that tells you everything, and which will make you famous and happy as a pig in rut.

Why you know about the short fuse is because I'm going to tell you: from the moment the first guest enters on opening night, it's all over. For all practical purposes your sales are going to come to a screeching halt. What you and most artists thought was just the beginning, ought to be viewed for what it more likely is — the end.

There's a reason: a lot of people don't like to buy paintings. They like to talk about buying paintings, especially when there are a whole lot of other people around to listen. So they go to receptions. They will tell their friends which painting they will buy in a voice that would carry across a

football field. They will tell the artist. They will tell the owner. Then they will make it clear to everyone that they will not buy this painting at a public opening. It is something they never do. Instead they will return another day when they can have a chat with the owner about this marvelous artist. In the same penetrating voice they will admonish those within the radius of a city block not to buy art in a crowd nor when the artist is present. That to do so would be uncivilized. And that anyone committing such an error would be unfeeling and would be revealing how little he appreciated artistic sensitivities. To the owner they will announce that they will return later that week. They will demand the owner take their name and telephone number. The latter is barked out like a drill instructor counting deep knee bends. For now, they tell the assembled audience, they will have just a few more of those little cakes and yet another glass of punch and be gone.

If you manage a sale or two at the opening, or in the days following, owe it to good luck and the groundwork you laid before the show.

Do not count on the gallery owner or sales staff to bring off any sales. They may, but don't count on it. As you've learned in an earlier chapter, most galleries have not yet learned to take the painting to the buyer.

If you walk into the show with no sales, the chances are excellent that you're going to end up driving home with twenty framed paintings. Trust me on this.

So, why use this gallery? Why use any gallery? Because people still think art is sold this way, that an artist without a gallery is not one. And since people like to gather at receptions before they go out to dinner or a show, the countdown to opening night gives them a reason to buy in advance.

It sets a time on the buying of art. And that's the one factor that selling needs. Since art doesn't usually have time constraints, we'll have to settle for this one. I learned the importance of a sales deadline a long time back.

I grew up in a suburb of Chicago selling golf balls. A couple of us from the neighborhood gang did it more regu-

larly than others, so that when we got to be ten or eleven we formed a partnership. No lawyers. No papers. Just threats about what one could do if the other were caught holding out.

There were two golf courses near where we lived, about a mile or so apart. We'd hunt in one and sell in another, an agreement we conceded to the first day when the owner told us how ruinous it would be to his clubhouse sales if two kids were to undercut him on the links. He bought us two cokes and invited us to hunt with impunity on his course and to ruin the sales of his competitor.

Again, no lawyers. But our company made a solid pledge. In those days we could be bought cheap.

On weekend mornings my partner and I would work his course pocketing anything in the roughs and in the corn-fields around it. We seldom took anything rolling.

In the afternoons we headed for the second course. Our golf balls scrubbed and shiny, we would wait in the bushes behind the seventh tee. We'd wait for a prosperous looking four-some to finish putting on the sixth green and were heading to the tee. Only then would we sprint from our cover towards them, five balls in each of our hands, all prearranged with the nicks and the smiles down or other-wise out of sight.

In the interest of expediency we were into group sales, a hand at a time, mostly five for a dollar. While we would permit a golfer to examine the balls, he couldn't do it long, for the risk was strong that we would be spotted by the greenskeeper or one of his men roving around in one of the course's pick-ups. They were sneaky devils and would also hide in bushes.

We had been caught and threatened so many times that each successive time made the embarrassment of still an-other broken promise more acute. Sometime we'd have to forfeit the balls we were carrying. Sometimes we'd get off with a lecture on trespassing. But, since there were a lot of things to do on a golf course other than to hunt down two kids, we often could go for hours without interruption.

What we began to notice during those chase-free hours was that sales went down. Golfers would take their time over their decision, perhaps working out that we'd covered a smile with a judiciously placed filling of mud, that it wasn't three Spaldings and a Wilson, but two Spaldings, a Dunlop and a crock. And they had more time to negotiate or, worse, threaten to turn us in themselves if we didn't hand the balls over.

We had a meeting on it. We decided we would sell like there was always a truck approaching. We practiced until we had it right. We became pretty fair actors:

"Take it or leave it," we'd tell our customer, pretending to see something over his shoulder. "A dollar. Take the five for a dollar. I gotta go. The truck. Give me the balls or a dollar. No time. I'm going . . ." That kind of thing. We found we could sell balls faster and for more money if you had the spectre of a truck to sell to.

Just as you can move things along if you sell to that up-coming reception. Think of it as an oncoming truck. It gives you something to work against. If a buyer wants to buy, it will get him off the dime, give him a reason to buy now, rather than when the ozone layer heals.

Let's get back to our master list of important people, those we've researched in the paper, and whom our friends knew once removed. Check back with your friends to make sure they made that call and mentioned your name and that you were a talented artist.

We're going to use these friends of a friend as middle-men to get us past the secretary and onto the phone with the important person. Good secretaries are paid to screen calls and it will be some advantage to use your friend's friend as a mutual friend when asking to talk to the important person.

It's a little tricky, but it will all come out in the wash when you freely explain if asked that you don't know his friend, good old Willie, directly, but you have a friend who does and who has talked to Willie about you as an artist. Something Willie's friend will verify if it comes up.

Once on the phone, direct your energy to getting off the phone and into his office for a presentation. He's very likely to give you the five minutes you request and once he does you can thereafter forget the limitation. If things go badly, he will remind you soon enough.

He's likely to give you some time for a number of reasons:

· He's curious. He doesn't get calls about Fine Art everyday.

· He either likes art or feels he ought to.

· He's achieved his important position in the world by doing what successful people do best, listening to others and learning from them. As an artist, or one who represents one, you have something to teach him about a subject he feels he should know more about. And he need not risk embarrassment to get that education by walking into a gallery, for example, and risking confrontation when that confrontation might reveal his ignorance. His is a win-lose world. He won't shrink from confrontation, but he wants to be prepared for battle. He likes to win.

· The office is *his* territory. He's got fifty neat ways to throw you out.

· You sound rational — to him, businesslike — on the phone. You do not sound like you pick your nose in public.

· He too has heard of the ladies who endorsed you and of the gallery who is holding the show.

· He may well owe his wife or someone close to him a gift. He prefers to shop in the office.

· He may have a way in which his company will benefit by his purchase of the entire collection or part of it. He's smart. He'll have ideas you haven't thought about. Your suggestions will get him thinking.

So you'll likely get in. You'll get your five minutes to show some paintings and make him understand what a good and valuable artist you are. You can't do it in five minutes? Catch his attention, you'll get an hour and maybe some sales.

Almost all of what you do is a matter of presentation. Art — it needs to be said again — is a visual experience. Ar-

156

range to have him see what you've got in a way that will best contribute to that experience. Guide him. Tell him what you've got, then show him the paintings you brought, one at a time.

When you've put that painting to be viewed under the best light you can muster, stand back and shut up. He will look at it for what seems to you to be an eternity. Don't rush him into another painting. Don't talk about it or the weather outside. Let him begin a love affair. He won't need you for that. But watch him. When you sense that he's getting restless, before his eyes glaze and when they move to where you've got the next painting facing away, draw his attention back by telling him something about the painting, where it was painted, what you like about it and why it is unusual. Every love affair can use a little help and the longer he sees the painting the longer he's going to remember it. Seeing, as you no doubt know, is distilled looking.

Then take the picture away and bring in the next. Handle the paintings in such a way as to convey the value you place in them, far and above the modest cash figure you're asking him to pay.

In New York some time ago a major mid-town collector of mine introduced me to a dealer who was to have strong international connections in and out of the city. We met in my collector's Madison Avenue offices and after two hours of discussion settled on an agreement for this woman to represent some work of mine, beginning with the five paintings I had brought for her to see, all stretched, but unframed.

After she signed some papers, I offered to help her carry the paintings to her car parked in a public garage across the street. She told me she was late for something and wished they would bring her car around soon. When the driver brought it out she opened the trunk, pushed some packages to one side, took my paintings and began to wedge them into the too small space. To work the five in, she put two face to face. She handled them like placemats. I stopped her from closing the trunk, handed her the paper she'd just signed, retrieved my paintings and bid her good day.

157

Rather, that's what I should have done. Instead, I rearranged the paintings so that they wouldn't be damaged and explained how paintings could not be stored face to face. It would take me four months to learn what I should have understood immediately: that any presentation she made of my work would do me more harm than good.

Whether my paintings would arrive at her gallery without damage was the lessor of my two concerns. She was a fashionably dressed, middle-aged and apparently a well-connected woman. She was well-spoken and expressed the singular zeal one needed to be successful in her business. She had an impressive list of other artists she represented.

My concern, which I should have acted on immediately, was how little she cared for painting. Judging by how she handled them, they were cargo. It would take some months to find out she would treat me and all her other artists the same.

Like many people these days, they find themselves in a job a little beneath their station in life. In some ways it's like the waitress who complains of the long hours handling food and hungry customers only to have to count money and make change.

If I hadn't come across so many would-be reps like her, I wouldn't mention it. But I do mention this so that you can avoid a costly mistake. These are people you want to avoid, if for no other reason than that they won't be successful, or not for long. Don't become a squab dinner.

They're going to want to team up against you. They will not serve your interests. They will serve their own and imagine, by doing so, they are serving the interest of their client.

If the rich are different, as Fitzgerald postulated, they're certainly no better, as his fiction takes pains to demonstrate. That's a lesson lost on our rep. It will lead to her downfall and yours if you're foolish enough not to recognize disaster when it knocks.

She'll want to play "rich together" with her client. She'll cart along your paintings to her appointment as though they were not at all the reason she had come. She'll show them

reluctantly and with a hint of distaste. When they meet resistance, she will hasten to support it, siding with her client against the lower form of life who produced what they're looking at. She will demean you, either consciously or not.

She will apologize for the quality of the work and the price asked for it. She will hope her client understands that she only took on this artist to help him. Helping people is what she likes to do most, she will say. Then she'll say that some artists will take advantage of that, "God knows, and you're left with trying to get this kind of work sold. You can't believe how some of these people live. Hand to mouth. Money today, gone tomorrow. Then who do they come to?" Well, she was sure he could see her position.

A charity drive is not what a client wants to hear about. While he may ante up for starving orphans in Bangladesh, he doesn't want to buy his art this way. He wants to believe the work is good and the artist important. He's not interested in the rep. except in her position as conduit to the artist. He wants to believe in the worth of the paintings. He wants to see they're handled carefully and that they are appreciated for their value.

Just as he commands position and money, the artist must be shown to have position and talent. There ought to be a match. The client needs art as much as the artist needs money, and the client has already given to the Red Cross.

Whether you're working the street yourself or have got that home-made rep. I talked about, here's some more advice on presentation:

• Arrive on time in clothes and with a hair style suitable to your mission so that he will not question your sanity or his own for inviting you. The business world is still a bit stiff about chartreuse when it comes to hair color and leather and chains when it comes to attire. Depending upon your gender, I would not arrive in a mini-skirt or with the zipper to your trousers undone. You are selling paintings.

• Be ready to answer questions about the artist, his history and his philosophy. It is why he has created what you're carrying. You are not selling lampshades.

• Don't waste time in trying to be the client's friend. He probably has plenty. Anyway, you want him to be a client. There's a difference.

• Wherever your presentation, in his office, hotel lobby, airport terminal, his home, your home, in a restaurant, or under a street lamp, conduct it as though it were your last meeting. It probably will be.

• Say nice things to his secretary. You may come again. But don't say anything important.

• Begin your presentation shortly after you've been invited into his office and have exchanged a few pleasantries. Don't wait until the conversation comes around to you and what you brought.

• Even if you are representing yourself as artist, the pronoun "I" should be used sparingly. If you are a rep. it ought to be abandoned altogether. This is a greater problem in some countries than others. In America people don't have conversations, they exchange autobiographies. What passes for talk is two simultaneous monologues. If you want to sell art, you'll have to forego this luxury.

• Carry all the paintings and material you're going to use for the presentation into the office with you. It may entail you leaving some things with the secretary and going down to the car to get others. It will be clumsy to carry these things. You will look better, much more sophisticated, if you make an entrance unburdened by the trappings of art. But you won't sell anything. Also your client can't help but note the trouble you've taken to show him the work. That's in your favor.

• Organize yourself. Have things ready to show the client. Carry stuff in a portfolio, an attaché case. Don't use shopping bags. Don't have your rep. root in her purse.

• Let him set the pace. Watch him. Try to read his nonverbal messages to you. But also listen to him. Sometimes he will put his expression in words. If he doesn't like something, don't try to convince him. Put the painting away and don't refer to it again.

• Tell him the paintings are for sale and at what price.

Curiously, artists do not like to talk about money. If you're one of these, you can begin now. It is not impolite. If you won't talk about it, you won't make any.

More curious still, many reps. don't want to talk about money. Instead they will report a presentation in these terms: "We hit it off very well. We just wanted to establish a working relationship. It's the first meeting, you know. We'll get to the money thing next time," or, "It was a social setting. It wouldn't be appropriate to discuss money," or, "Really, this is a friend of mine. She loves the work, but I don't feel comfortable about talking money." The list goes on.

It doesn't seem worth mentioning that you won't make a sale unless you come to terms about how much money will be exchanged. But I just did because I think it does.

• Start with group sales and settle, if need be, for the sale of one. Don't overlook the multiple sale. Particularly if you have demonstrated an investment potential, his company may buy it all. But be prepared to negotiate by giving him permission: "Those are the prices for individual works, but if you were to buy the collection or a group of paintings, I will work with you."

You want to hold out for your price? That's fine with me. But it must be worth something, in your time and effort, to be relieved of the necessity of setting further appointments to sell those twenty paintings. But don't give him a second figure. You've made an offer. Let him counter it. If you set a lower figure, you'll start there. He may be constrained by a budget. Ask him how much he can spend on art, then work out the number of paintings you will sell for that figure.

• Art will provide you access to exclusive board rooms and plush homes. Do not be overwhelmed. Don't fear your client. I can't count the number of artists and reps. I've talked to who stand in abject terror of being described as "pushy." There is no such thing. Your client knows there's no such thing, because if he doesn't want to buy, he won't, and he'll tell you in no uncertain terms.

You will not *make* anyone buy a painting he does not

want — short of leveling a weapon at his head. And then it's not called buying.

Until he tells you "no," take it as "maybe." Continue to supply him information. Continue to contact him. Continue to ask him if he's made a decision. You won't be pushy. Believe me, he will not be too timid to tell you to get lost. Trust him.

The converse of pushy is doing nothing. A whole lot of people will do that for you. They will do this in the interest of preserving their contacts who they believe never talk about money either. With a whole lot of people bent on doing nothing for you, you will grow hungry and die. Your lifeless body will serve to underscore **Pigeon Factor 64:**

There's nothing in the world deader than a dead pigeon.

• Remember you're a presenter, a guide. Let him tell you what he likes about your painting. Narrow his choices if he's going to buy one, expand them if he's going to buy more than one. He'll be direct with you. You be direct with him. He's a businessman. He's made a success of solid decisions made quickly. If he tells you he'd like to think it over, you're permitted to ask him why and for how long.

• If you believe in your art and where you're going as an artist, or your rep. does, you must know that you are doing your client a favor by offering him paintings. It should be clear that the prices won't hold at the current level. If you fully believe that fact and convey it to your client, when he buys your paintings he will thank you for helping him.

As a guide you'll need to respond to his comments:

• **"I'd like my wife to look at it."** Tell him you had understood that he was able to make a buying decision. If he stands on what he said, ask him if *he* favors buying the painting if his wife agrees. Ask him what he will tell his wife about the painting and this meeting. Ask him to set an appointment for you to meet his wife. You'll need this information to make an effective presentation to his wife. You are also giving him a chance to say he only meant that as an excuse to get you out of the office. And if he doesn't say he wants you out and you still fear that, ask him.

• **"I like it, but I have a lot of money problems for the next couple of months."** Judge his credit worthiness and whether you want to sell him the painting for a substantial down payment and the balance in three months. Explain that he will have to sign a sales contract and show it to him. It will contain a clause that establishes his forfeiture of the painting and all monies if he misses the payment. He, better than anyone, will understand why you need him to sign such a contract and why you cannot blindly trust people you don't know. He would apply the same caution to you.

• **"I like your work, but do you have any watermelons?"** You must talk to him about the secondary importance of subject matter and then ask him which of the paintings he's seen is closest to what he likes.

• **"I don't like anything I've seen."** Thank him for his candor and leave.

• **"I'd like to wait and buy it at your exhibition."** You tell him exhibitions are a bad time to buy paintings. If he likes it, tell him you will sell it to him now so that you can both enjoy the exhibition.

• **"I just don't know anything about art."** This is an open invitation to teach. Tell him you like his honesty. Tell him what art is and what you're doing. Ask him if he feels anything from any of the paintings, and if so, which one does he feel strongest about.

• **"I like these two, but I can't decide."** Sell him the pair.

• **"Which is the artist's favorite?"** They all are. Be a guide, not a leader. Allow him to make a creative choice. Both of you will be the happier for it.

• **"Can you do the same painting again?"** This may come after seeing something in the catalog which has already been sold. The answer, of course, is no. Even if you think you can approximate it in another painting, the answer remains. You're selling original paintings. If you don't want to lose your freedom before you really start to enjoy it, continue to paint only originals.

• **"Will the color or style conform to the room in**

163

which I'd like to hang it?" Tell him yes, not only because you want to sell the painting, but because it's true. Tell him how a painting occupies its own space and commands it own attention. Paintings don't conform to anything. They are. If he's really worried about color schemes and interior decoration, invite him to tear down his house and build it anew around your painting.

· **"I'd like to hang it at home to see what it looks like."** Of course he can — provided he will sign for it. Offer to hang it for him. Leave it a week or ten days. He'll get used to seeing it. When he takes it down, it will be like having a hole in the wall.

· **"I need the company advisor to look at it."** Tell him the painting he likes speaks to him, but it may or may not speak to a company advisor. Ask him why he wants the company advisor to like the painting if he already likes the painting. If you lose all these arguments, suffer the entrance of the company advisor. In some parts of the world, well-known artists are retained by companies in the mistaken belief that artists have a corner on aesthetic taste. (I plead guilty to allowing myself to be paid as an art consultant to the largest luxury hotel in Seoul. The only active role I took was to disclose my bank account number so that my monthly money could be sent directly there. I was told I had an office and secretary, but I think that was a rumor.)

· **"I like the painting, but it's too expensive."** You will have established a fair market value for your paintings when enough are sold at a consistent price. You'll need to explain how prices are not set arbitrarily. That you need to protect other collectors who bought at the prices you set. But if these prices are too expensive for him, tell him not to worry. Tell him you made a mistake in offering something he couldn't afford. A lot of people can't afford to buy nice things. You didn't realize his company didn't pay him very well or that it didn't have enough money to buy the paintings for him.

While we still have some of the paintings, resign your-

self to going full out in making presentations, talking to everyone you know about the show and to getting that catalog to anyone who may have an interest. Check regularly with the gallery owner. You can co-ordinate your efforts with his. You'll no doubt have some money to give him to sweeten his day. Check that he has plugged your show into all the public service spots in newspapers and radio. Make sure that for his part he has followed through with phone calls to his mailing list. What he hasn't done — which may be a lot — you offer to do.

You want to ask people if they've received the catalog and the invitation for the upcoming show. You are looking forward to meeting them at the opening. There are still some paintings that have not been bought and you didn't want them to come to the opening expecting to have the selection you can offer now. You're willing, of course, to show any of those in the catalog that interest them as long as they haven't been sold. And you'll come to their home. Or they can come to yours. Or you can meet somewhere, for an hour or so.

If you've never been to your church, synagogue, temple, mosque or house of prayer, go now. Talk to your minister, priest, rabbi, teacher, or holyman and tell him what you're doing. Talk to him in detail about your work. Talk through the paintings in the catalog with him. Invite him to the opening. Ask him if he knows who among his parishioners would like a catalog. Leave some with him.

Lastly, we want to do the neighborbood. We want a block party. These are the folks who watch you come and go on the way to work, who monitor the progress you're making turning your drab green lawn into more colorful weeds. We want to touch base with those who wave at you and those who don't. Since they've all had their eyes on you since the day you brought the easel in, let's give them something to say.

Remember those 300 paintings you burned? You didn't, did you. You sorted through them, maybe, threw out some, but you wanted to hang onto the rest. A kind of insur-

ance against your never doing anything better. Well, you have. You've got your twenty paintings for the opening. And the sales have brought an adrenaline rush of creativity. You've been painting hard and late. Best of all you've begun to appreciate your paintings, to see them for what they are and to see them as others see them. You understand their value. You know that they can be regarded as currency. That they can be considered as cash. If you see your paintings that way you will never — I mean never — give them away, unless it is your practice to give money away. To maintain the value of your "currency" you will not lend your name to anything that is not the best you can do.

But does thinking of your paintings as currency demean them? No. You know that they are far more than the measurement society currently places on them. But it's also good to know — since your link to society has always been a tenuous one at best — that anybody wants to measure your work at all.

So go back. Weed out the crocks. If you're really fond of some, OK. Keep those if you believe they are as good as your recent work. Take those which won't stand muster (a high percentage, I'd expect) and carry them curbside some fine Saturday morning before the show.

Burn them one at a time. Burn them on a pyre of warped and damaged stretchers. Get a good crackling blaze going. When your neighbors come to tell you that you don't have a fire permit, tell them what you're doing, that you're celebrating a turning point as an artist by burning your history. Tell them about the show. Give them a catalog. Set up a card table and sign the things. Invite them to the opening. Hold up each painting before throwing it to the blaze.

If someone asks you for one — since you're throwing them away anyway — refuse. Tell him what you owe to posterity. When the police come to ticket you, sign a catalog for them. Tell them what you're doing and invite them to the show. Ask them if they will turn on the siren for you. It's what police do best.

When the fire burns out, sweep up the ashes. Fold up your card table and head toward the house. Since you know

the eyes of the neighborhood are on your retreating figure, you can wave without having to turn around. Make it regal.

You've got to start getting used to being famous.

Similarly, you better learn how to conduct yourself at your opening, since this one marks the first of many. And there's no easy way. Nor is there any escape. While the gallery owner is host, you're stuck with being guest of honor. That means you'll be there early and you'll leave late. You'll thank everybody for coming and you will graciously acknowledge all the compliments. You will do this by smiling modestly and saying things like "thank you" and "I'm glad you like it" and "I would enjoy seeing your son's first art project."

Since others will dress for the occasion, or at least dress for where they're going afterwards, you'll want to consider the advantages in going as one of the bunch over something more flamboyant. I knew an artist who came as a rabbit. It was very funny. For five minutes it was funny. After three hours he was still a rabbit, deep in sober conversation, ears flapping as he nodded gravely to the group who had traveled 200 miles to meet him.

One of the reasons you arrive early is to get into your neutral corner. This will be a place you'll have arranged if you've had anything to do with hanging your show — and you better. It will be a corner free of your work. You want to put your back to that. You don't want to make people look over your shoulder and around you to see the work behind you. It will also cause anyone who normally would avoid you to come face to face with you when his intentions were only to see the painting you're in the way of. He's avoiding you because he's another artist taking stock or he isn't but doesn't like what you're doing. When he discovers he's face to face with you, he's liable to get aggressive. You'll meet a lot of people you'd rather not meet this way. There could be a scuffle. The punch bowl falls, breaking the instep of the matron about to write a check. The police arrive to quell the riot. They're the ones who ticketed you for the fire earlier that week. It could go like that. You're an artist. It's best to avoid problems. I'm going to give you **Pigeon Factor 65** so's

167

you'll remember that problems can gang upon you. Cut it out and paste it eye level on the bathroom mirror:

> Things happen to pigeons in large part because they're pigeons.

So get to your corner and stay there. You'll get introduced to a lot of people. Mostly they won't be hostile. They'll pretty much read the script for this kind of meeting and you'll reply in kind. After three hours, your face is going to feel like it's been painted in a thin coating of super glue. Try smiling through it. See if you can say "thank you" without splitting your lip.

Within the first thirty minutes you will be approached by a voluble woman with blue hair. She will be wearing an ample pantsuit of a plastic derivative that looks to be fire resistant. She will tell you and everyone within a three block radius how much she wanted to buy one of the paintings that has already been sold. She will tell you that she can't do without it. She will tell you and everyone else that she must ask you to sell it to her, that she will pay you cash here and now, and how she cannot believe you could let it go for so little money.

Don't refer her to a painting which hasn't been sold. I've tried it. Do this: Ask her to go point out the painting. She will dance over to it with some grace and little flair for the dramatic. Wave her back. Ask her to find it in the catalog. Look puzzled. Look concerned. Then relieved, tell her how happy you are to have her discover this mistake. The painting is indeed available and all she needs do is take her money to the gallery owner. Point him out.

You won't see her after that. I want to tell you about her because I think she goes to all the shows. I've met her in Buenos Aires, Ankara, San Jose, and London. And once on a second class bus to Puerto Viarta. At least I'm pretty sure it was her. She was wearing the same pantsuit.

Try to arrive sober and don't be tempted to drink the cheap champagne or the vile concoction they mix in the punch bowl. If you do, don't mix it with anything resem-

bling food that might be served. You don't want to be sick all over your shoes.

It won't help sales.

Congratulations. If you had a sellout and held at your prices, you did a little better than break even, which any businessman will tell you is not at all bad for the first venture.

Here's what it cost:

USD 3,500 Color separation and catalog printing cost
 1,000 Framing
 200 Photography
 100 Lunch and Teas
 50 Fine: Burning without a Permit
 20 Flowers
USD 5,070 Total

Here's what it earned:

500 x 20 paintings = 10,000
@ 40/60 you get = 6,000
USD **Balance = 930**

You're also left with:

1. A great first catalog that will help you sell paintings forever.
2. A continuing market, with the gallery anticipating your next sellout.
3. Photos and publicity tearsheets.
4. An education you won't get in Harvard.
5. And the credibility of an artist.

Q. Hold on. You kiddin' me? You tellin' me this guy worked six months organizing a show, paid for the catalog, bought lunch for three old ladies and a faded journalist, donated twenty paintings and paid — actually paid — this gallery slouch 40 percent?

A. That's how it works out.

Q. And your artist earns what — nine hundred bucks? That works out all right. It works out to about 80 cents an hour, less paintings. You're gonna get this guy rich, right? I don't think he can afford you.

A. You're right.

Q. What?
A. I said you're right. Let's have him give up.

Q. Wha'd'ya mean?
A. Let's have him open a frame shop. Look, I didn't say this would be easy. There's hard work, sacrifice. What I'm trying to do is set out a path. So's I can point the way. I can't walk it for him. I'm trying to cut a path through the god-damned wilderness.

Q. What is this you're making? A lumberjack? You got this guy buying his way into the business. He's paying for the lot and handing the dealer a pack to boot. It's like the wife of the chairman of General Motors. She rents a gallery so's she can stick up her wall hangings. And God help his man-agement Monday morning if she doesn't have a sellout. There'll be a board meeting on it.
A. He's not buying anything. He's selling his paintings. You don't read so good. I told you his stake in his future was twenty paintings. He hasn't laid out a nickel he hasn't gotten back.

Q. So, he's sweet on the gallery owner? This guy get's four grand for what? Opening the door? Turning on the light?
A. We're trading twenty paintings for credibility. He's had a one-man, sellout show in a pretty fair gallery. He's got himself a market in the city and he can use this gallery, or one like it if it closes. He's the fair-haired boy. And he's not looking back.

Q. At eighty cents an hour.
A. Yeah. Well, I'm gonna get him a raise.

Q. Here comes the famous part, right?
A. You gonna read it?

Q. Maybe.
A. Wha'd'ya mean, maybe. You gonna read it or not?

Q. I'll read the next page. Tell you after.

PART III

FAME

In college I knew an art student who got famous in the entertainment business. He had cultivated the ability to drink beer without swallowing. Standing, he could pour half a pitcher of warm beer into his open throat. You could hear it splashing in his stomach. Thereafter, he could sustain a single belch for as long as twenty seconds.

I haven't heard anything from him for years. His problem may be that of many young rock stars and some presidential candidates. He may have peaked too early.

Chapter XVI

The Expert From Out of Town

"It seems to me we ought to have heard of him. Everyone says he's famous."

The middle-aged woman in the striped dress was speaking to another who was shorter and wore black crepe and spotted stockings. The two of them stood in the center of the gallery, each cupping an elbow supporting an upraised arm and a plastic champagne glass. It was a kind of salute.

"Yes, seems we ought. I've seen his name mentioned. I'm sure of it. Or maybe that was somebody else," the shorter woman said. The two faced each other like totems, the crowd having to work around them. Both wore glasses chained to their necks, but they hadn't put them on. There was no hurry to see the paintings. Their makeup was identically packed, shaped, and sanded. They spoke to each other as though through body stockings.

"Wasn't he the one who did the cartoons?" This was the woman in the striped dress. She spoke looking over the shoulder of the other, scanning the crowd. She had painted some purple iridescence around each eye, the color of a serious bruise. That, and the faint redness in her eyes, gave her the look of a concussion victim from a high-speed crash.

"I know who you mean," the stouter woman said, also looking beyond her companion. "That was somebody else. No, this is the one who did Marilyn Monroe. I think that's who this is. Can't remember his name."

The taller woman took a sip and put her elbow back in her hand.

"He died," she said. "Couldn't have been him. I'll remember his name in a minute, but I'm sure he died."

"Maybe with all the terror. You know, kidnappings? Maybe he prefers to keep it quiet, who he is." The shorter woman didn't look like she had many ideas, but this was clearly one.

"Of course," the one with bruised eyes said, sweeping them over her companion to another part of the room. "That would be wise. Then nobody would know how famous he is."

"You can't be too careful," the shorter woman said.

"Have you talked to him? You were so long to get the drinks. Did you meet him?" She spoke looking at a group who had just entered, or maybe beyond them to something outside. "I think so," said the one with the good idea, who had definitely met somebody, "At least I thought it was him."

OK, we got a pretty fair start. We've penetrated that wilderness I'm trying to walk you through, but there's still a lot of lumber between us and our destination, if success is where we're going.

It's even possible — now that you've learned to take hold of your own destiny — to establish a camp where you stand and if you have a low threshold for content, to build something of a settlement there. But I'm guessing that your metamorphosis is similar to what mine was: the more you get, the more you want. You're not far from achieving the goal you always swore was all you ever wanted — making a living as a painter.

You've quit waiting for Guggenheim and you've learned to allow the buyer to buy. You've learned to confront the business world as it is. You've begun to look at your paint-

ings as currency and to ignore those who will chide you for it, who will call what you're doing unadulterated commercialism. Selling out. Prostitution. And some other names that are not so nice.

As long as we successfully divide our life as a painter between what we produce and how we sell — the artist and the peddler — none of the labels apply. Though I doubt you're as happy dividing your life as that coffee man, the Vegas low roller, you've learned by now to suffer it quietly.

And you're not making the deadly mistake of painting for the marketplace. It's not only your morality that brings you to the higher ground, any more than a flood victim climbs to the roof for a better view, but it's also the lack of alternatives. You don't paint for the marketplace because it won't hold still long enough for you to find it. Chasing it is chasing your tail. You'll fail as surely as the coffee man would if he were to abandon his slow-lose policy for the big-win tables.

Fortunately, you'll lose the company of the purist along the way. But you'll understand, as he won't, where your difference lie: you respect the buyer enough to want to communicate with him, while he wants to play misunderstood artist in trench warfare with the Philistines. He'll still be grinding his own colors and forswearing black.

But you'll both enjoy your roles and everyone will be happy. You, because you'll win, and he, because he'll lose and can wallow in misery and condemnation.

My guess is that you've got your calendar marked by now and you're waiting out the time when you can dump that nine-to-five. The good news is that you can get there faster than you thought.

If you've been paying attention, you've learned the buyer is your ticket to freedom. What I'm here to tell you is he's got another ticket for you. It's going to cost you that stake you just earned back. And a year of your life. But a ticket it is.

He's going to sponsor your year abroad and he's going to pay your air fare. But you'll have to act first, then wait

174

around a little until he gets his money together for you. So you'll need to put that air fare up front. And you won't need much more than that. If you follow what I want you to do for yourself, you're going to get that back in spades.

You're going to let the buyer make you famous. And you're going to help him. You will be wise beyond your years, the expert from out of town, way out of town.

Mark Twain, who did a fair amount of traveling himself, got it right about the expert: nobody expects him to be someone we know. If he's worth anything at all, he's got to come from somewhere else. And the longer he needs to sit on a train to reach us, the more confident we can be of his importance. If he comes from far enough away to have an accent, he'll be pretty smart. If he doesn't speak our language at all, he'll be better than that. He'll be a genius.

So, let's take on the world from where it's most likely to do some good. Let's find a country where they don't speak English very well. Almost from the moment you get off the plane and into the taxi line, you're going to be amazed at the number of people you'll find who are going to take your climb to fame seriously.

"That loal. I see you carry that loal on airplane."

He was Asian and looked a lot like all the rest of his compatriots forming a line in front of me longer than the runway we'd landed on. The three taxis in the distance were loaded. They headed toward the city. There were no others in sight.

"I don't understand," I said. I tried to look beyond him.

"Yes, the black loal." He pointed to the roll of paintings that I had rested on top of my luggage. He was smiling, a sign that indicated he was probably not with customs. I toyed with the idea of telling him it was a bazooka, but took the less dangerous expediency of leveling with him.

"Hah!" he shouted. "You paintings. Yes? That loal is you paintings. Hah!"

He was very pleased with himself. He passed the news on ahead of us. Apparently, half the line and he were re-

lated. There was a good deal of excitement — a lot of talk. When it died down, my questioner turned back to me. He extended a hand and shook mine gravely.

"Anyway, how old you are?"

He was still shaking my hand but now he was grinning. I told him, but he didn't seem to understand the numbers. When he had to use both hands to try to work it out, it gave me a chance to put mine in my pockets.

"You come paint my country. Yes?"

"Yes, well, sort of. I mean, you could say that."

"Hah!"

He passed this news ahead. Most of the line was facing my way by then. They took this last news more seriously. Most everyone was nodding. One of them came forward and began rolling my cart of luggage away. I managed to save the "loal." My friend invited me to walk behind the cart. The procession moved to the head of the line. As we walked by, his relatives bowed. Some of the women were giggling, their hands to their mouths. When the taxi came, some of his relatives helped load the luggage. As I got in, my friend touched the roll under my arm.

"Hah!" he said, grinning.

As we pulled away, I looked back. Half of the three city-block line was waving. Already I was famous.

There are many ways to be famous in the world. It's the artist's great good fortune to be blessed with an easy-going, benevolent recognition once he achieves fame. It's not the raucous fame of a rock star being ripped from his limosine and devoured by the crowd. The artist does not need to face the radical shifts of public sentiment as does the politician. You're not trailed by a pack of sycophants and weirdos as the movie star is who is faced with sneaking into the drug store for his hemorrhoid ointment.

You'll not be subjected to endless travels in buses and jet planes as you crisscross the world, continent by continent, in a never-ending series of gigs, performances, concerts, and sessions.

You'll not need to darken the windows of your car, to wear sunglasses, a wig, or a fake nose. You won't be tempted by a golden-skinned groupie rubbing against your hotel room door late at night. You won't need security guards and apes in T-shirts to clear your path as you make your way across the lobby. You won't be asked to endorse anybody, or play golf with the pros, or go on TV and chat with the late night host, or defend some fashionable principle like preserving the North American spotted tick from the ravages of chemical insecticides.

They tried Rauschenburg once. He was invited on a popular nightly news segment to participate in a discussion on contemporary art. They must have gotten him out of bed. They shouldn't have. Warhol, of course, had his moments as a celebrity in the rock star sense. To us, it just seemed a lot longer.

No, you won't have to electrify your fence or buy a pack of Dobermans. Nobody's going to tap your car phone or publish pool-side pictures of you in your altogethers in the tabloid press. The tabs will remain those little loops you pull when opening cans of beer.

When they talk about you or your work, they'll use your name with a whole lot of qualifiers and reminders and identifiers and such.

"Internationally known Blackpool, England, minimalist Dunkan Osgood today shot and killed an unarmed but rabid black squirrel in Hyde Park as passersby looked on with undisguised horror." You'll note the name Dunken Osgood does not carry weight of, say, Elizabeth Taylor.

It might also read, ". . . this is why we deeply regret that one of the world's greatest living abstract expressionists favoring the somber colors of the German school, Arnold Dudley, twenty-six, of St. Joseph, Missouri: (pictured here with a John Deere cap standing to the left of his Hereford cow) will not be keynote speaker at the symposium as planned owing to his untimely arrest on drug charges."

In other words, you'll never be the headline writer's dream. Your fame will need half a paragraph of explanation before they can get to the meat of what you did or didn't do.

Here's a test: Let me give you some names of the leading celebrities in contemporary art. How many of them are you able to put a face to? You may know their work, but how many of the artists behind it would you be able to pick out at a lunch counter: Cy Twombly, Roy Lichtenstein, David Hockney, Clyford Still, Franz Kline, Malcolm Morley, Richard Artschwager, Christopher Wool, Mark Rothko, Adolph Gottlieb, Julian Schnabel.

You've probably heard of them all — international superstars. For many, their work carries a price tag of better than a million dollars at post world-recession figures. For better or worse they changed the course of art history. Be honest now — and I'll give you Warhol and Rauschenburg — how many of their mug shots could you match with names?

Add to these, whose fame emanated mostly from New York, the *world list* of contemporary artists, and you'll really be out to sea. Now you'll have trouble matching names to work, and we're talking superstars, not the second tier crowd.

Is it any wonder how many contemporary galleries in the best and worst of locations operate with a license to steal?

You'll hear nothing but the creak of leather shoes as our contemporary dealer glides across the polished wooden floor of his gallery and slips up behind you, his breathing matching your own. A ballroom dancer, he shifts his weight as you shift yours. You've been puzzling over a piece on the wall, trying to determine why the artist went to the expense of framing it. The presence behind you doesn't help.

"Warbley Vankmiller," he whispers, nodding gravely at the painting. A pencil moustache. A lot of white teeth. He looks like an overweight David Niven. We study the painting together as it occurs to me that he wasn't introducing himself.

"Pardon?"

"An early Warbley Vankmiller. Before he shot his wife and moved to Madang. You're probably familiar with his later work. This is a rare find."

"I see," I told him.

"He's a young man here, but you can already feel the influence he would one day command over the entire Madang school. I wouldn't part with it, but I've got to make room for three Ivan Barsleys I got coming in on Monday. And you know the size of a Barsley."

"You kidding?" I grinned wryly, then, as though thinking of those Barsleys, I began to wag my head in sympathy. I found that we were swinging our heads together in a kind of rhythm.

"I'm going to have to let it go."

"The Vankmiller," I affirmed.

"Two hundred and fifty thousand," he said.

"A steal."

"Can't tell you when another Vankmiller will come on the market."

"Not one like this, anyway," I told him.

We resumed looking at the painting. I could hear him breathing again. I began a diplomatic retreat, sort of sliding on to the next painting doorside. He glided with me in a marvelous little *pas de deux*. He added a quick-step, a little dip and cut me off. One of his soft leather shoes released a complaining squeak.

"I could accept an offer." he said.

"I would have to come in much lower. Clearly this is not up to his later work."

"Ah, yes," he said. "Sadly." We waited in silence together.

"Anyway," I said, "I came in, frankly, to see if you had come across, ah, you know, a recent Lagerfeld. But since I don't see any . . ."

"Simon or Leo?"

But he had me figured. Already he was moving across the floor to intercept a couple who just entered. He moved on the balls of his feet, shoulders leveled. With a feint of the head, a sort of Latin shrug, he did a reverse step, a half pirouette, and took the lady's arm neatly. Together they glided across the floor to a painting at the back. For a big man he was light on his feet.

What I really want to do is head off your answer to a question you're going to get when you land in this country, the one you've chosen where the language and customs are different from your own.

You're going to meet the natives and they're going to look at your paintings, your catalog, your tearsheets, your photos of the show and they're going to be impressed. They may not know that your nearest big city does not in the least resemble New York or London. And, even if they do, they'll want to test you. Either way, you're going to have to field this:

"Are you famous in your country?"

Now, I'm not advocating you lie. But I want you to understand the difference between abject honesty and helping things along a little. Then, to make you feel more comfortable, I want you to factor in the art world and the hype and disinformation and the bilious dishonesty and bald lying that comprise a good deal of it. We don't need more of the same. And I'm not asking you to contribute to it.

I'm advising you to be your own best friend, to put your best foot in front of the other, to take a charitable view of your own position. It's time to crank up your own promotion mill. It's time to answer "yes" to the question of being famous in your country and to do it without dissembling or making ingratiating qualifications. The question's direct, the answer ought to be.

Are you famous? Of course.

Let me give you an example of the power of self-inflicted PR. I shook hands once and still hold the business card of the best all-around wood man in the world. I carry it in my wallet. You never know when you might have to call on a guy this famous.

He works the hurricane circuit in the Deep South coastal states of America. You'll find him, mostly, around places like Mobile, Charleston, Jacksonville. He doesn't do tornadoes. Says he's no inlander.

The big season is late August, September, October. He'll hit town a week to ten days after the hurricane does so

that the insurance money's out and government disaster funds are in place. He'll take a room in any hotel still standing and work the bar downstairs. He's a big guy, built out of slabs. His name is Shimidski, Bernie Shimidski. If he's looking for work, you'll find him at the end of the bar looking at his hands. This great boulder of a man perched on a spindly stool and looking at his two hands on the bar in front of him. A draft beer off to one side, untouched. You'll pass him going to the can. You'll think about him some. Coming back you're liable to ask him if anything's wrong.

"Look at these," he'll tell you.

It's a direct order, so you do. You look at two immense hands, carved and calloused, each finger as thick as a handle on a claw hammer.

"See anything like this?"

Tell him you do. Tell him you don't. You'll get the story just the same. He'll tell you to sit down. Then he'll tell you the hands you're looking at belong to the world's number one all-around wood man. He'll tell you his name. He'll tell you that name is a household word in every city and two-bit town in the South but this one. He came here in a well-marked truck expecting to be met and cheered on the interstate. He came to rebuild this God-forsaken place, and this time to do it right.

Instead, here he sits, the best all-around wood man in the world, looking at his hands.

He handed me his card. It had his name and at the bottom there was a line where he had penciled in the hotel's phone number. Beneath his name in bold-faced script it said: "If it blew away, you ain't had it nailed right."

I offered to buy him a drink, but he shrugged it off. He pulled a railroad watch out of his pants pocket. Told me he had to knock off.

"You from around here, right? Go tell them Bernie Shimidski's in town. Tell 'em the best all-around wood man is ready to rebuild houses from the ground up. Tell 'em it gets built by Bernie Shimidski, it don't fall down, it don't get blowed away.

181

"And tell 'em I don't come cheap. You don't get the best all-around wood man in the world for peanuts."

When he'd gone, I asked the bartender about him and he said that Bernie came in when he'd opened in the morning. Bernie had told maybe twenty, thirty guys what he told me. Beginning this afternoon, the bartender said, the clerk at the main desk was getting pretty steamed. People trying to reach this what's-his-name, the best all-around wood man in the world. The phone ringing off the hook. Clerk's mad because he'd taken a five dollar tip to answer any calls that came in for the guy. Said he didn't know he was a celebrity.

Chapter XVII

Paintings as a Foreign Language

U nless you live in a sealed boxcar, you've been notic-
ing how the world is changing at what has been
called an "accelerated pace." Though a student of
history might remind you that the world has always been
changing at an accelerated pace, you won't need a scholar of
current affairs to tell you something's afoot these days, that
there's an uncommon amount of goings on.

Not all the change is bad. Even though a lot of it seems
that way. The turmoil resulting from the disintegration of
the Eastern bloc, the shifting balance of powers, the
squabbles between trading partners, faltering economies,
flailing currencies, ethnic hostilities, wars and rumors of
wars are more than gas pains in the world's digestive system,
but chances are strong that we're going to absorb the prob-
lems without coming undone and that tomorrow morning
the sun will also rise. While it will rise on the same old
world, the way we live on that world will have changed.

I don't know how orderly this new world we're facing is
going to be, but I do know that as each day passes we be-
come more aware of who comprises it. While that doesn't
make everyone fast friends, it might be a step forward from

183

when parts of the world could safely ignore a good deal of the rest. That which divides the East from the West is not so easily defined anymore. Advances in communication have seen to that. For better or worse, our problems get to be collective ones: political and social changes effect us all. A world recession reminds us that we live together in a world economy, each of us dependent on the rest.

It ain't easy, but we're coming to accept that the world is also divided at the equator and that those south of it also belong.

I haven't forgotten you're an artist. That's why I'm passing along the good news. You and I and a good many others like us are going to benefit from these changes as they come. I'm suggesting two things: don't pay credence to the doomsayers — if they're right it won't much matter — and don't wait until everything gets better. It never seems to, except in retrospect.

I'm not up to giving any flowery speeches, but the geography out there is a lot more accessible to an artist wanting to absorb it than it has ever been. There are things going on and places to see and to record and people to talk to and learn from. We can somehow record it in paint, or part of it anyway, in a way nobody else can. We've got a way we can discuss it without the encumbrances of speech. We've got the human experience to report and we're proficient in the language: we speak fluent Mankind.

I can see you're unconvinced about the opportunities for a painter abroad. So don't believe me. Let me put it to you in practical terms. Here's the headline: There are art lovers out there who do not speak English as their first language or any subsequent one. There are art lovers who don't care whether they *ever* speak English at all. Reports are that these people are otherwise leading normal lives. As curious as it may sound, they're quite happy living in their own country. There's life — and buyers — out there, beyond the United States, even beyond the United Kingdom, if you can believe that.

I've traveled there and I've seen it. There are people

184

who speak Spanish and French and Portugese and Arabic and Turkish and Greek and Japanese and Korean and a lot of other stuff. Honest, I've heard them. I didn't understand them much, but I heard them talk, and it wasn't like the sounds we make. And the places they live in don't look at all like Chicago or Liverpool.

I've heard them talk when I went there and watched them do a lot of things we don't normally do. And you know what? Many of them live in a different way. Eating stuff you wouldn't believe. Some of them don't look at all like us. And they don't share our religious values. Despite these handicaps, they seem to be doing all right.

I've been a full-time foreigner living among them. I've seen them. They don't all break for tea at three or cocktails at five. Though they probably all have a near-by McDonald's, french fries and hamburgers are not their usual fare.

They're a different crowd. And those who like art and understand it will buy it sometimes. And they'll pay money you can spend, same as anybody else. I found out that a lot of them get to traveling around as much or more than we do, so that they come to know us better than we know them. That makes them pretty sophisicated folks, some of them, and those who know about art and buy it sometimes know about it on an international scale.

What comes from all this mingling of people is an international marketplace where art is bought and traded without regard to national boundaries. Since individual economies are subject to greater instability than a world market, people are more inclined to trust the international market. This is as it should be since art doesn't carry a passport.

This traipsing around and familiarization does not, as you might fear, spell the death of indigenous art. For that too prospers from exposure as it moves from country to country in exhibitions and exchanges. This benefits other artists as more of it is seen and understood and absorbed in the work of those who appreciate it. For those who have been priviledged to stand in the studio of the artist who created it and watch it evolve, the benefits are vastly greater. By

185

having first-hand experience with the arts in a foreign country, we may be able to avoid the silly excesses of most of Manet's Spanish work and some of Whistler's Japanese stuff.

On the whole, these are pretty good things. What I'm saying is you ought to go out there and get your belly fired up. At the same time you'll be able to level out those currency crises and recessions and the dips and drops of national economies that dry up the art market from time to time. When things get tough, move. Go somewhere where things aren't so tough.

Pretty Smart? Not very. But what is pretty dumb is to sit home and wait for the art market in your country to get better. If you live to your twenties, you've got maybe forty years to paint before your eyes go, your joints dry up, and you start wetting your pants. Don't spend any of it waiting for anything. You can't afford it. And, if you're any good, neither can the world.

But let me make a distinction between traveling and living abroad. It's a big one. What you don't want to be is a tourist. It won't do you any good. Tourists don't go anywhere. They only travel. Whether they do it alone or in groups, they'll end in groups looking at the inside of airplanes and buses and hotel rooms and Baedecker Guides. They'll eat in groups and talk in groups and tour in groups. They'll trample and foul in groups. What they'll see, mostly, is the back of the head of the tourist who is in front of them while listening to the personal problems of the guy behind. Not unlike **Pigeon Factor 66:**

> The reason why a pigeon is constructed with eyes on each
> side of the head is so that it won't go through life looking
> at the tail end of the pigeon in front of it.

You may think there are some redeeming virtues in being a tourist. That as one you are indeed seeing things of geographical, historical, and cultural importance and to see them under any circumstance must be better than to not see them at all. You may think that, but you're wrong.

I'm telling you it's better not to see them at all. Stay

home. Go to a ball game. See a movie. Take those pictures of your wife and kids, but put them up against the back fence, don't haul them to Rome. Leave your camcorders, your great sack of Pentaxes and Roleflexes and zoom and wide-angle lenses at home. Save the T-shirt with the funny saying for the bowling league. Your four days and three nights will be a disaster anyway. Your passports will be lifted, the cockroach in your room is going to be your fault, the kids are going to be hungry, and you're looking at fifty dollars a plate to fill them. And all of it will come back to you when you get home and get the pictures developed.

If you live there or somewhere else, it's different. You'll see the country as those who live there do. Countries and the people in them are not easy to understand. In a year's time you'll get a glimpse of the life they lead and their reason for leading it. In four days you'll get dysentery.

By living abroad your work will change. The experience will deepen you. Since all work is biography, this understanding will show. People will see new energy in your work. Those who live within the country you're painting will be interested in what you're doing. They'll want to see and to understand what a foreigner sees in the life they lead. As with Toqueville's writing on the United States, we can learn about ourselves by seeing us as others do.

You and others working abroad in the arts — even if it is only for a year — help lace together the fragile world fabric. You, in no small way, will begin to link the diverse.

Q. Stop already. Stop with all this.
A. What?

Q. Come off it. You're gonna have me in tears with this, the one world thing. Shoulder to shoulder, right? Everybody making a contribution. You're in Disneyland, man. "Lacing the fabric." That's great.
A. All right, you got me. It was a little heady. Maybe it's not all like that. But a part of it is. The living abroad. The influence that it has on your painting. And to the degree it has an impact on those who look at it, it's got to make a difference.

187

Q. Is this where you tell me about all those positive vibes floating around in the ether? That psycho-garble about — what is it? — everything comes around that goes around? This is what I paid the cover price for?

A. Art can move. It's got a lifespan of generations. Look at *Guernica,* the *Nightwatch,* some of Goya's stuff. You telling me this doesn't continue to have an impact on how we conduct our lives, or at least how we view ourselves conducting our lives?

Q. You're telling everybody else to go read the newspapers. *You* go read the papers. They're shooting people out there. They're firebombing folks because they don't attend the same house of worship or because they come from somewhere else and nobody worth a damn comes from anywhere but where these clowns were born. That's the Nazi crowd. Then you got the gang with the most powerful nations among them deliberately stripping the environment. I mean the air, sea, and land. Is there anything else? And you want your reader to go sit in Rome and paint pretty pictures.

A. They don't have to be pretty. And it doesn't have to be Rome. But OK, I hear you. I'll get off the soap box. But I think you underestimate art. The power it has to change.

Q. Like Goya, you say. Go read the papers again. They're still lining them up in courtyards and shooting them down.

A. What will you have us do, quit?

Q. It won't make much difference to the guy being dragged out into the street at night. Go paint if you want. But don't tell us it's going to change the world. "Lacing the fabric" stuff! I mean, come off it.

A. You got a point. So do I. Can we agree to that?

Q. I'll agree to half of it.

A. I like a guy who can compromise.

My detractor may be more right than I'm going to give him credit for. So let me take a different tactic, one I may even get *him* to appreciate.

Your year abroad is going to stoke your furnace. You're going to be mainlining adrenaline. You're going to be bursting at the seams. You're going to be juiced.

You're going to find paintable stuff everywhere you turn. You're going to discover color and light and faces and the way people move. It's going to be Columbus Day all year long. It'll be the little things you notice.

It was late afternoon and hot, though it seemed somehow cooler in the dim light of the tearoom in Sogyodong, one of those arbitrary neighborhoods which, when spliced together, become Seoul.

Near a lighted aquarium some businessmen were warming to an argument, their faces damp, ochre lighted. Across from me a young man read a newspaper, but he turned the pages too quickly, sometimes glancing at his watch, sometimes shifting his weight, crossing, recrossing his legs. His coffee cup had been taken away and only his *boricha,* a light tea, remained.

The young woman came through the door briskly. She was cool in a thin white dress and when she saw the man with the newspaper she smiled brightly and at once. In a single, continuous movement she weaved her way through the tables, past me, past the businessmen and slid into the booth across from the man. She moved as a dancer might.

The young man had seen her enter but deliberately he returned to his paper.

She spoke to him breathlessly, drawing a hand through her long black hair. She glanced around the room, flipped her hair back across her shoulder, leaned forward and waited. The smile lingered.

It seemed a long time before the man folded his paper. He did so carefully and when the creases were right he spoke to the girl.

He did not look at her directly, but at me or the businessmen or the fish in the aquarium.

The waitress clopped over, took their order and returned with another coffee. She placed an orange juice before the girl.

189

The man did not look at the young woman, even when she spooned some sugar into his cup and stirred it. Her dress was long sleeved and had filigreed lace at her wrists. Her fingers were long and delicate and she held the tiny silver spoon by the tip of the handle. When she had finished stirring, she placed the spoon noiselessly at the edge of his saucer.

As she talked, the smile played at the corners of her mouth. Sometimes the man nodded. Sometimes he did not acknowledge that he'd heard. He did not look at the girl.

Absently she stroked her glass. As she spoke her fingers caressed the rim, drifted down to the base of the glass and to the edge of her saucer.

She was not a beautiful girl. Her face was too angular, her mouth too full. But you could not help watching her hands. You could not help noticing the way they moved.

Sometimes she brought her hands together in a kind of prayer as she leaned forward on the table to say something. Sometimes they fluttered to the locket which hung from a thin gold necklace she wore. Sometimes they settled to the table like birds, but poised as though for flight.

When she finally lifted the orange juice to her lips, watching him, she did so ceremoniously, her two hands holding the glass.

Of course, it was a trick. It was a trick she had learned. Someone had told her of the beauty of her hands and she used them as others might use a certain way of walking or a laugh, a hushed voice, a confidential touch.

It was a trick. And it worked.

As she brought the glass to her lips the young man was watching her. For the first time as the rim of the glass grazed her lower lip, she smiled.

The man looked away.

But he had looked away too quickly and not quickly enough, as one caught seeing something he shouldn't.

He couldn't hide his own smile, though he tried.

I paid for my coffee and walked out into the noise and heat of the day. It was like coming out of a theater. I had

190

walked two blocks in the wrong direction before discovering my error.

When you are living abroad as a painter you will have moments of heightened reality like this, the stuff of painting. You know about them. And you know that you don't need to live in another country to find them, but you'll find more of them when you're immersed in life, and nothing makes you more receptive to truth and beauty than when you are taken from a world you know and placed in one you don't.

You don't need to learn the language. Beyond the words and phrases you'll need to get your needs met and deliver some courtesies, you'll find you'll be a lot happier maintaining some distance.

What you don't want to do is join up, take part in the neighborhood squabbles, voice your opinion about the way you'd like things to be, talk at length with the butcher, or understand anything the neighbor may have on his radio turned full volume across the street.

Keep as ill-informed as you can, though you ought to follow an English newspaper if they've got one. If they don't, ask your friend to knock on the door when the revolution comes.

This advice, of course, is greatly consistent with what became painfully apparent to my Spanish teacher in the tenth grade: my almost complete lack of foreign language aptitude.

A German friend of mine was not so fortunate. He was a recluse who enjoyed being around people. He didn't want to talk to them, to understand them, or in any way get involved with what they were doing. He was a writer and, like a painter, lived in a room all day. And that was OK by him, but by the end of the day, he'd want to get out among 'em. He'd want to sit in a darkened theater to listen to those around him rustle in their popcorn boxes. He'd go to a crowded bar just to be jostled. It was being a part of the human race without having to pay dues. Because he didn't

understand anybody — conversation was what he called ambient noise — he could work on his book or think about it twenty-four hours a day.

Unfortunately he suffered from a terminal illness. He was plagued with creeping comprehension. He had such a gift of languages that, despite all conscious efforts to the contrary, he'd find himself, in time, understanding what was going on, making sense out of the shouts of the street vendors, comprehending the late night drunk shouting to a sleeping neighborhood as he stumbled home. Before you knew it, he'd find himself taking sides in the ongoing marital problems next door. He'd catch himself singing the words of some ubiquitous radio jingle. Wherever you live these days you get thin walls and thick people.

Without ever owning a TV he had learned to follow "Dallas" in twelve languages. When he found himself understanding a language, his work would suffer and, he'd move on to a new country. He'd gone through all the romance languages pretty quickly; then he went to Turkey. From there to the mid-East. He'd stayed a good many months in Afganistan and got nearly a year out of India. He'd caught on to Japanese all too quickly and had to abandon his new found taste for *sushi* and *karoki* bars.

I met him in Korea. He was desperate. The day we met he had an argument on a crowded bus with a housewife who was standing on his foot, something he usually let pass. But he'd been a little tense about his book. He'd been stuck in a dry hole for days. He complained to the woman. He told her to kindly stand on someone else's foot, which, of course, she promptly did.

It was only when he got home that he realized he had spoken in her language.

He was in the last throes of his illness. I tried to help. When I suggested Borneo and New Guinea, he shook his head in despair. He'd been there already. When I told him about Alabama, he hugged me.

He lives just outside of Tuscaloosa now. Been there better than five years. Got a letter from him last Christmas. He is happy as a clam; he doesn't understand a thing.

You'll have an easier time, maybe. Let's choose a place. One that has survived the tourist boom with some of it's culture intact. Forget for now how you will do this. I'll get to that. Just concentrate on where in the world you want to live.

You're not going to find Hemmingway's *Montmartre*, sadly, but there's a lot of world out there and some of it is still worth living in. But we've got to get a little methodical about our research, so you don't make the mistakes I have.

First, let's divide up the world three ways: developed countries, developing countries, and countries where a Neanderthal population is still carving wheels out of granite boulders.

Assuming you don't want to paint standing knee-deep in a mosquito infested swamp in a Columbian jungle while taking sniper fire from a U.S. Drug Enforcement agent, we can forfeit the last category and move on to the first two.

You'll remember they used to be called developed and undeveloped countries. When the undeveloped countries pointed out to those more prosperous that the world's wealth was divided unevenly, the developed countries had a meeting. What was decided was that they would rename the poor countries so that they wouldn't feel so inferior and would quit asking for money. Someone found the word "underdeveloped" which had a nice tone, giving everyone a better feeling about the abject poverty that was their lot. Underdeveloped sounded like a hormonal problem, something which, while serious, would not prevent a full life, like late puberty.

This allowed the rich countries to perpetuate their policy of benign neglect for still more decades. Recently, and in answer to seriously threatening behavior, including perverse demands for sovereign rights, the have-all countries decided to apply the word "developing" to those they've benignly neglected. It's got a better ring. It sounds like the countries are coming on strong and only need a little time to get over their temporary misfortune, like outgrowing acne.

It's a good name, but I don't think they're going to fall for it this time.

It won't make much difference to your painting whichever one of the two kinds of countries you decide to go to. It may make a difference in the marketing. Make sure you are close enough to a major city to insure yourself a recognized international show, for that's what all of this is about.

Since there are all kinds of cities — it isn't always a matter of population figures — make sure yours is one with international overtones. Ouito and La Paz are important cities, but mainly to their respective countries. Buenos Aires and Rio have far greater international credence. Paris and Berlin, of course, have still more.

If money matters to you, as I suspect it does, you can still live outside of any major metropolitan area and live fairly reasonably. You'll want to choose your home and studio within a train trip away from the city in which you want to show, but not so far away from an urban center that your mere presence at the market is the day's entertainment for the natives.

For example, there is a lot of interesting geography in the outback of Turkey, Mexico, Bulgaria, Paraguay, Peru but village life is going to be difficult. What you do as a painter will be viewed as the greatest single piece of humor since the mule fell on grandma.

Painting is tough enough. I don't recommend you also become a pioneer. When you run out of cadium yellow, you don't need three days by ox wagon and two more by dug-out to renew your supply.

Unfortunately you'll be handicapped in your research by out-of-date library books and the slightly more current but hopelessly inadequate travel guides. Almost nothing is published for the guy who wants to go and live somewhere.

I had the most trouble with travel guides. I'm not proud of this, but I once went to the Dominican Republic on the basis of what I found in some of these books. While there are perfectly reasonable people living there, it couldn't be on the basis of an intentional decision. They were living

there either as an accident of birth or had come, like me, only they lost their return tickets.

I held on to mine and am here to tell you that I gained a new respect for capricious journalism and judicious picture editing. The photographer for the guide I read could make the smouldering thirty acres of the Istanbul city dump look like a place you'd want to hold a Scout jamboree. I tracked down the guy who had submitted the glowing testimonial for life in Santa Domingo. He'd been there for almost thirty years, the last ten of which were devoted to his increasingly frantic attempts to get out.

He was embarrassed when I told him I was there, in part, because of what he said in the guide. He told me it was fairly accurate when he'd written it twenty years before. Since then, he admitted, times had changed. When I pointed out the guide was current for the year and allegedly updated, he shrugged. He wanted to talk about another of the islands which he had heard was a good place to live.

I would like to do my own guide book sometime for people like you and me. I would not clutter the first half of it with history. If the place interested the reader, I'd let him seek out the history once he got there or after he got home. I wouldn't tell him about hotels and restaurants and how to find a taxi. I'd bet my reader would have the modicum of intelligence to find his way around town on his own. I wouldn't use a lot of filler. If the only thing you could show as a place of interest was an old church or a bronze plaque nailed to a tree, I'd leave the entry out. I'd want to include only things you could look at. If the church was Chartres, I'd include it.

Mainly I'd want to get a realistic idea of what the main city and surrounding area looked like. I'd dump all the artsy photographs and closeups of seagulls, indigenous fruit, and all that was panoramic. Anything can look good if you get too close or far enough away.

Apart from having the name of the place on the cover, my book would be a matter of pictures. And I'd make a pledge to the reader that all photographs in whatever coun-

try were done under the same strict limitations. I would require that all photos contained in the guide were taken during the taxi ride from the airport to city center. These would be the conditions: each half mile the taxi would stop. The photographer would be allowed to get out of the taxi and sit on the hood. From there he would have to take his best shot, then get in for another half mile. If, for reasons of personal safety, the photographer needed to remain in the cab with the windows up, this would also be reflected in the shot. If the best he could come up with is a side window filled with slavering beggars raking at the glass with bleeding fingers, so be it. I would charge a lot for this book, since I would know how much money in air fares and hotels and medical expenses I could save the reader.

While I grant you the most spectacular scenery of a place will not usually be en route from the airport, these pictures will tell you a great deal, in many cases, all you'll need to know. And it will save the reader the agony of that forty-five minute drive watching his mistakes unfold though the grimy window of a taxi while wishing he could get back on the plane he'd just left or wondering if he could wait out the four or five days in the airport bar until the next one.

Another qualifier you might want to impose on your selected place for a year abroad is the degree to which the population has transcended its wealth. There are vastly rich countries today which a few decades ago were sand dunes or steaming swamps. The abundance of oil beneath them changed all that. There are other countries that were once blackened battlefields and now possess an industrious population, driving themselves to recovery and wrought riches where ruin had been.

If you choose to try one of these countries because you have heard, as Cortez had, that your pockets will be lined in gold if you go there, take care that the population which can afford art has evolved beyond Rolex watches, BMWs, and Jane Fonda exercise videos. When you hold up a canvas for inspection, you don't want your potential client to ask how many yards of it he'll need to make a tent.

196

A few years back in Korea everybody, from middle-management upwards, clogged the streets in black chauffeured limos curiously displaying a single box of tissue paper on the back shelf, usually contained in an elaborately embroidered cloth cover. In the morning, half the male population of Seoul would climb into the back of their identical sedans for their trip to work. All were timed so that they could converge downtown in a raging sea of black. The exec-cum-potentate would sit reading a newspaper, impervious to the cacophony around him as chauffeurs battled, swore, and honked over inches of precious terrain. The Inchon landing was nothing.

At midday half the female population would command the same limos. This was the lunch and shopping bunch. The timing here was pretty good as well. Like the men, they would converge downtown, each limo containing one lady and one box of tissues. They would do their nails as their drivers engaged in battle against a black and raging sea.

During this period in Korea, there was a lot of talk about art and the need for a fully developed industrial society to understand its great and mysterious nuances. But unless you were into imaginative embroidery for the side panels of tissue boxes, there was little market for the arts.

Conversely, there was a big market for Rolex watches. That's where I got the idea to add to my travel guides a sort of Michelin rating with a minus factor: I'd picture five little easels for the most culturally aware country, five little Rolexes for the least, and grades in between. This was a badly needed ten-point system.

Finally, I'd like to advise you on when you should embark on your year's junket, the one you're taking at your buyer's expense. You ought to go as soon as you can quit your job, sell or store your furniture, put the car up on blocks, and pack your bags.

Monday will be fine.

Chapter XVIII

Getting You On the Plane

You already have your start-up money right? If you don't have it because you have borrowed it in the first place and paid it back from the sale of the twenty paintings, you're in an excellent position to borrow it again.

We're talking air fare. You won't need a whole lot of spending money. A week after you land in your selected non-English speaking country, you and your wife (if you've got one) are going to be teaching English as a second language, part time, until the money for painting sales starts to come in.

The balance of your time you'll devote to painting and preparing for what will put you on the road to fame: your first sellout international exhibition.

As I promised, I'm going to take you through it step by step, from where you're going to show to who's going to pay for your catalog and framing. This sellout will be different from the first. You're going to keep the money. You paid your dues to charity. Now we've got to make you famous. You'll need lots of walkin' around money for that.

But let me get back to that in a paragraph or two. I'm hearing some grumbling and quaking out there. There's ter-

ror in the wind. Reluctance is rearing it's ugly head. And, even as I type, you're amassing your arguments against it — bracing for your defence. All your reasons are in line, your pigeons, beak to tail.

I'm asking you to loosen up. Listen to me. You've got to win the war that's keeping you from success. I want to prod you to overcome your biggest enemy: the guy in your mirror.

I'm not going to inflate you with a lot of gas, the confidence building routine and all the psycho-drivel. There are far too many books around if you want that done to you. Instead, I want to own up to what I believe are your legitimate concerns. But, before I do, I'm going to offer a single statement that you can take as advice or not. This road to fame we've been talking about is traveled by those who claim it. That's all. It's not deep, and I'd be the last to tell you it's profound. What it is, is true.

So, let's see if you can manage the decision you made when you went to your mountain and walked away as one who was going to quit talking about becoming an artist and start being one.

Let's get to all those excellent reasons why the world is going to keep you from doing what you want to do, why you can't go abroad and be successful, why getting yourself famous is out of the question:

— "I can't quit my job. It's what I've been trained for." You *can* quit your job. You've been trained for art as well. Which do you like best? You get to choose.

— "I've got ten years before retirement. I'll wait it out." You can't live life waiting for retirement. It's a contradiction in terms. Life is not death. Death will come soon enough.

— "I'll wait until I save more money." Why? I told you you don't need any more money. You're going to teach for a while. You're going to sell some more paintings. You're going to have a show and sell a lot more. What is it you need money for? You're going to have to find a place to put the money you're already going to make. I told you that having a lot of money will be a big headache. And you want more?

— "I'm not sure it's necessary to go abroad." I haven't

199

done my job if you're not. I'll try some more. If you can't think of it as necessary, think of it as an improvement. A year abroad — I'm not asking for long — will broaden your experience. You'll be a better artist for it. The success I can spell out for you will enhance your confidence. Your paintings will get better, your sales will show it. You'll come back a hero, or you'll move on to other countries, new successes.

— "I could never convince my wife/husband to make such a move." Then you better take a look at your wife-slash-husband. Whose life are you leading? If he or she insists on remaining home for the sake of a job, you can understand that. He or she will understand that you need a year away. Is there anything written that you can't spend a year apart?

— "But the kids. I can't leave the kids." Nobody's suggesting you do. Why not take them with you? They'll benefit from a year abroad. They'll learn geography at last, and maybe even another language. And they've got refrigerators everywhere.

— "But I can't take them out of school." Why? Why in the hell can't you take them out of school? There are schools everywhere. English schools if you need them. You can take books. In America kids are arming themselves with automatic weapons just to make it through study hall. Home study in some states is an option many parents are increasingly taking. You can do home study anywhere you've got a home.

— "I owe on a mortgage and I owe on my credit cards. I'm just able to live and pay off the bills." You need to look at your life. Is this how you want to be in ten years?

— "What if I quit my job, sell everything, go there and there's no job?" You're reading this book. It's in English. If you speak it, there's a job. Even without it, if you can paint, you can eat. You paint good, they'll break down your door and feed you.

— "Why don't I apply for a job from here? Get a job first, then go?" You're going to end up teaching English in a rice paddie, some rural outback for eight hours a day. You'll have room-and-board employment conditions that will

make those migrant camps in *The Grapes of Wrath* look like a vacation in Bali. Pay your air fare. Get your own job. You know those swarthy fellows who stand around airports as you come out of customs holding upraised signs with people's names on them? If you contracted in advance as an English teacher, you'll find someone hoisting your name. Keep walking. Pay a taxi. A free ride will be a one-way trip to slave labor.

— "I want to take full advantage of my year abroad and I intend to learn the language first. It's the only way one can fully appreciate another culture." I agree languages are important. And with a conversational ability in a language you will learn a lot more about the people and the culture of the country you're proposing to live in. But I wouldn't readjust my priorities. You don't need to be a linguist to paint well.

— "What will my friends and family say if I up and leave?" They'll express shock, wonder, and dismay. They'll all but forget you in a week. When you return, they'll hold still for your answer to two questions about your year abroad, provided your answers for both occupy less than thirty seconds. They'll be far more anxious to tell you about *their* year and what you missed by living in some God-forsaken place which has nothing to do with them.

— "What will I do with my car, my dog?" Let's take them one at a time. If you tell people you're planning to spend a year in the Bornean jungles tracking down and painting portraits of headhunters, the first question will be about your car and what you plan to do with it. You probably hadn't realized how you were so inextricably linked to this chunk of metal until you got the same question from half a dozen friends. Some people don't believe there is life beyond their car. You'll understand that you've always been seen, in part at least, as a gray, slightly battered Volvo.

The dog part is another matter. I like dogs. And I can understand how you can worry about them and hurry home to feed them. You ask how can you give them up? Or find someone to care for them for a year? You'll have to resolve this without my help. I remind you that you're an artist first.

201

After that you're on your own. My only advice is to make a decision when the dog is not resting its head on your knee and looking up at you.

— "I don't want to go because a new country is dangerous and scary and filled with terrorists and kidnappers and people who want to steal my wallet." Have you been to cities in America or England lately?

— "What if I fail? What if I can't paint? What if I lose my passport or the plane gets shot down?" What-ifs are responsible for more missed opportunities than there are rich old men bedding very young women. The what-ifs are imagined catastrophes, but the real one is denying your talent.

— "But I'll have to start all over again when I get back home." You're practicing the fine art of prophetic failure, the old self-fulfilling humbug. Whatever happens, you'll never go back to square one. A far more compelling possibility is that you will come back successful or, having found the freedom of life abroad, you don't come back at all.

— "What about the allegiance I owe to my own country?" There are people who still maintain that in order to be a loyal, taxpaying citizen in good standing one leaves his country only on vacations and then with some distaste. The term expatriot conjures for them visions of Benedict Arnold. I view these people with an alarm greater than that which they view me.

— "It's dirty, you can't drink the water, and if I get sick the doctors will kill me." There are countries less sanitary than our own, or at least dirty in a different way. I've lived in many where you can't drink water from the tap and where it's a bother to drink it boiled, bottled or otherwise purified. But one can manage. The quality of medical treatment abroad is, like anything else, inconsistent. But if you've accommodated yourself to medical treatment in America or England, you'll be inured against the worst of it.

Chapter XIX

Living and Working Abroad

The first task upon arriving in your foreign country is to locate the expatriot community wherein reside those who speak your language and who have lived there for a time. Don't be a purist here. You're an artist, not an anthropologist. Of course you want to deal with the native population — and you will — but it will take you three generations to find out in a foreign language what you can learn in a twenty-minute conversation with a compatriot about the living conditions in your new home, the problems and possibilities of life in general.

If you want to make it easy on yourself, let your first house or apartment be in that expatriot community. You don't want to be the foreign sensation on the block. Additionally, you've grown accustomed to some comforts which your native population may not have, like sit-down toilets and indoor baths. Also the shifting population among the expats. will work in your favor. There will be places available for rent. Company employees from abroad come and go. Retirees drink themselves to death. Folks get fed up and move on — planning for a lifetime retirement in a foreign country can look a lot better on paper than it turns out.

After six months of raging arguments, a couple may want to get back to their trailer park in Arizona.

With everyday pretty much like the day before for most of these people, your arrival from the world outside is going to trigger what is inherent in the human race — the desire to teach others about the life one is leading, where you have the rapt attention of the student and absolutely no need to restrain the use of the personal pronoun "I."

In short, teachers abound. And for the first few days you need to listen. They'll tell you the ins and outs, where you should live, where you shouldn't and how to get your English teaching job or your first students if you intend to free-lance for a while. But if you choose to free-lance without the appropriate visa, do so temporarily. In time, you'll need to do it right. You'll need a company to sponsor you.

I'm not talking morality here. In most places you can pretty easily avoid the tangles of bureaucratic thinking. But I have a plan to tell you. One that's going to get you your international show, your catalog, your buyers, and your fame. To implement it, you need to be squeaky clean.

Once you get a place, begin to set up your studio. Remember, North light is a lot cheaper and a lot more available in a tube. Take a week or two, if you can afford it, to walk out any remaining anxieties you may have about the country and to get you a start toward your acclimation as a painter. Wear out a pair of shoes. Take notes, sketch, and do some photography. These are exciting times. In them you want to go full-out native. You want to go to places they go, watch them do things they do. Take in how they walk, talk and act. However nonobjective your paintings, you want this country and your experience in it to bleed through each of them, to make them indelibly "here."

You'll be leaving your expat. friends behind. You may make a lasting friend or two, but you're just not going to have as much time as they for the social swim. They won't believe your refusal for lunch or a few drinks. They'll suspect you of snubbing them. They're convinced yours is not a serious occupation, that you have an unlimited amount of

time. They have a friend who is an artist. They'll want to introduce you. He paints alpine scenes on the door panels of trucks and vans. And *he* never refuses a drink.

They won't understand that smouldering flame in your belly and why after four or five straight hours in your studio, the last thing you want to participate in is dinner party talk. They don't understand that you haven't retired, that to earn a living in art takes discipline. They don't know that when you're not working, you're thinking about it, or ought to be.

Let's look at the device of teaching English as a second language in order to pay for the habit you've cultivated of standing in front of an easel for hours. As you'll learn, the teaching you're going to do is more than an expediency. You'll need the money, but more important than bringing food to your table, it's going to bring buyers to your door. Trust me.

OK, don't trust me. I'll tell you, and you judge.

A college degree or — God forbid — a teaching credential isn't necessary. What you'll need is to speak English as your native tongue. If you use a lot of swear words, you'll have to clean things up a little. Otherwise, there are not many qualifications to getting a job and to doing a good job once you've got it.

It may be helpful to know that a predicate nominative is not a liver disease. Beyond that, your requirements as a grammarian are limited. You should know that most of your students have worked on the grammatical side of your language more than you have. You will have to learn how to deflect questions. When someone asks what a dangling gerund is, feign stomach cramps.

To those of us who have problems here, we owe a great debt of gratitude to those who studied the teaching of foreign languages. Somewhere along the line they determined that grammar was not the road to conversation and communication, something I had tried to tell Miss Bradley, my high school English teacher, years ago. The guys who studied this second language thing found that the best way to learn to speak a language was to speak it with somebody who was

born to it. And to speak it in a natural situation, as in conversation. And I wouldn't argue with them. It turns out to be a pretty good way to make enough money to support what we really want to do.

What you do in these conversation classes is talk a little and try to get your students to talk a lot. Another nice thing is that it doesn't matter a hoot what you talk about, as long as you don't advocate a political assassination or a coup d'état. In advanced classes you'll end up being a kind of moderator. And if you're smart, you'll get your class to tell you all the nuances of their culture, all the problems of the country and where the good pool halls are.

And if you do a good job and concentrate on their problems learning your tongue, and don't take yourself too seriously, they'll tolerate you. In the Eastern countries you've got Confucius working for you. He, as you'll remember, put teachers above bottled *Saki*. In the East you'll be treated with the respect and dignity that's hard to deserve unless you spent your early childhood as an emperor.

You can teach kids. You can teach adults. I recommend the latter so that when you absently swear, you'll not be corrupting a juvenile. It's also closer to the mark for my secondary reason for your teaching. It's called, getting everyone to help you.

If you're teaching company executives, college students or housewives, privately or in groups, your mission will be to explain to every class your success as an artist in your own country and your reasons for being in theirs, which include finding a sponsor for your first international one-man show in the best venue possible, finding a printer and a sponsor for your catalog, and finding a framer and a sponsor for your paintings. This approach provides a good legitimate conversation subject. You can have your students discuss all the important things you've written on the blackboard. You'll sign a catalog for each and you'll invite them to your studio. There, you'll not fail to tell them the paintings you brought from home are for sale and at what price.

If you're teaching forty students over a ten-week course

on your half-day schedule, you're going to have forty emissaries. Some of them will be clients, others in influential company positions, still others married to people who count. All will be acting as your agent, all getting doors open for you, all telling you who is important in the community, who the likely sponsors are, who buys art and which company is most likely to get behind a catalog as good or better than the one you gave them. If you're married, you've got eighty of these translator-advocates.

This is all in the interest of conversational English, of course. But there better be nothing devious, underhanded, or exploitive about your method. Your students will see it a mile off. You've got to stand in front of them with a clear conscience, and the only way to do that is to be open in the *new* way you've learned to be open — positive, confident, and dedicated to the art you produce and where it will one day take you. Before I leave the business of teaching, let me squash your great idea. Why not teach painting, you ask?

Because people don't need or want you to teach painting. Because you don't speak the language and people won't understand those profound criticisms you make of their mistakes. Because those you teach will not be able to help you in establishing yourself. Because governments will arrest you for working outside your visa. Because local artists will beat you up on your way to the grocery store. Trust me. I've been there.

With an army of zealous advocates working for you — an army that multiplies with each new class you teach — your opportunities and your troubles will mount in about equal portions.

You'll gain a new respect for communications. That's what absence will do for you. You'll find you'll need to spend more time than you'd like getting things done. Since you are in the main part of what needs to be done, your many friends are going to take increasing demands of your time. While much of it will be a waste of time, enough of it will more than warrant your getting away from the easel.

You'll be called out at all hours to meet high mucky-

mucks from business, public service, and political life. You will shake hands. This mucky-muck will say a few words about you as an artist. You will thank him and tell him how pleased you are to meet him. Thereafter you may go to sleep if you've learned to doze with open eyes while looking thoughtful and attentive, because for the next two hours they're going to talk about you. You'll know that only because you'll hear your name from time to time and there'll be references to your catalog and paintings. Nothing will be said in a language you'll understand. Later, when you ask your friends what happened, it won't be much better.

You'll be conducting business in sign language, napkin sketches, endless synonyms, noises, facial expressions, hand gestures, mime, psychic power, anything. The problem you'll come to note is that your friends speak a common language among them. If the meeting went well, you won't be caught up in the enthusiasm.

Sometimes it's nice not having to participate. You can watch others in the hotel coffee shop or wherever the meeting is held. What you do say will manage to take on the best and wisest interpretation. And you get to play the "What Are They Talking About?" game.

But there are times when it's frustrating. If you or your friends show up ten minutes late, it might take forty-five minutes in explanation. Knowing it might take the better part of an hour to get an answer, you'll tend to ask your questions selectively. You'll let a lot of things go by. Like where you're going and why.

You may find yourself as I did one night in Seoul. I was riding in a van with four friends and a driver. They had picked me up at my studio, a place they had found, rented and furnished for me. It was apparently beneath my status to work out of my home.

"Where are we going?" I asked.

"What?" One of my friends broke away from a conversation the group was having.

"Where? *Odi?*" This was one of four Korean words I'd learned by heart.

"Yes," she said.

"I mean, where are we going? This van. This thing we're riding in. Where is it going?"

"The car?"

"OK, the car." I indicated the space around us as we bounced along some city street. "Where is car — where is all this going?" You tend to lose a lot of your own English.

I regretted my persistence when she turned and talked to her friends for a long time. Finally, she turned back to me.

"Where you want it to go?"

Things will get done among your multiplying minions, but it will take some waiting, and the order in which they're done might be different from what you anticipated. If you ride with it and don't intercede, mostly everything will work out.

While I would often be consulted about matters that concerned me and could thereafter maintain some control over my destiny, sometimes everyone seemed to know more about art and my business than I. Often when I was consulted, it seemed a matter of courtesy, since the decision had already been made.

Most every meeting was held in places where food was served. I learned later that it was because everyone thought I was too thin. The theory extant in Korea at the time was that Van Gogh and Gauguin died not of suicide and syphilis as historians report, but because neither had someone to stuff food in their mouth from morning to night. That same theory prevailed in Japan, where "eat" should not be considered an invitation, but a threat.

"Did you have breakfast?" my friends might ask me in the late morning.

"Yes. I ate at home."

"Then you're hungry."

"No, Really, I ate. I already ate breakfast. I have eaten breakfast at home. Before I left." You'll find yourself saying the same thing a lot of times.

"Do you want menu?"

"No thanks. I'm not hungry."

"Another restaurant?"

"No."

"Coffee?"

"OK."

What follows is an exchange between my friends and the waitress. She delivers a coffee, a club sandwich, a glass of milk, and some french fries. They note my surprise.

"Maybe you want Korean food?"

"No. This is fine," I tell them and eat my club sandwich while they talk together.

When there is something important to be asked of me which involves a degree of delicacy — like why I don't have a wife to shove food down my throat — it will take a lot of waiting to find out exactly what it is. There's a process and it must be followed. It's called backgrounding. Background-ing is saying everything except what you really want to say. If all but one thing is said, deductive reasoning will lead you to the answer.

Two things work against this arrangement. It takes a long time to talk about everything but the subject you're introducing, and I'm not good at deductive reasoning.

But whatever the communication difficulties, stick with your friends, your advocates. They're on your side. Though they'll err — sometimes disastrously — it will be with the best of intentions. This is not so with the corporate translator.

This is the guy the president will bring out of a back room to translate sensitive negotiations. Until the moment he sits at the table, the president and your friends had been managing fine in a sales discussion or a sponsorship pro-posal.

He'll bring a black cloud with him. He'll probably have spent some years in residence in the U.S. or England and he's going to get back at you for everything that happened to him, including bouts of bad weather and a racist landlord.

Instead of translating your question, he'll give you the answers. And they'll all start with "no." What he'll convey to the president will be a modified version of what you tell him. For instance, your suggestion that the corporation purchase several of the paintings which are to be exhibited since two

other corporations had done the same in the interest of associating themselves with an artist of merit, becomes, in the translation, something like this:

"This no-good slouch and his friends who are taking your valuable time propose you buy a bunch of his ridiculous paintings at God-knows-what price and have all the problems of insurance and security, right when we already lost a computer when somebody left a window open in the mail room, or didn't you know about that?"

When the president suggests to you or your friends that he brings in a translator, urge him to reconsider.

Also be prepared that things in a foreign country are going to be done differently from the way they're done at home. In the Far East, for example, the chairman or president needs to give his assent to a project before it is brought to the operatives.

The best venue for an art show may not be a museum or a commercial gallery. In Korea, for example, corporate galleries of museum dimensions play an important role in art. In Japan you may be showing in a department store.

In each of the four or five giant retail stores in Tokyo, an entire floor is devoted to Fine Art. When the elevator doors part, you'll have left the bedlam of department store shoppers and smartly uniformed sales personnel with white gloves and voices that can shatter crockery. You'll walk into the cool and carefully designed environment to come face to face with, say, twenty paintings by Géricault and sculptures by Ernst and Modigliani. You'll also be greeted with the respectful quiet to study them.

It is the difference in countries and cultures which is the tonic that you've needed. It's what you gave up the TV for. It's the real world beyond our own. And you're the interested spectator. You're the observer, allowing the life you see unfold to filter through your work. So stay awake and watch.

It was a dark night in southern Seoul. Bus 135 and I had been shuddering across construction bridging and banging along back streets for forty-five minutes when the young

man boarded. He was swept up the stairs in a crowd of other passengers, but when the bus lunged forward only he failed to find purchase. He reached for a ring that wasn't there.

He was pitched into a family behind him. Still he couldn't find a ring and, just as he reached for the bar above, the bus lurched. He tumbled and slammed headlong into the door. He smiled. It was the loose, lopsided smile of one who had dipped rather heavily into the deadly rice drink, *soju*. In an effort to smooth his hair he brushed his hand across his face, blinked and — despite the persistent tugging of the uniformed bus girl to get him up and away from the door — he closed his eyes to sleep.

It was not uncomfortable there. It was better to be leaning against the doors than to be thrown around the bus. He didn't feel like climbing the stairs again. It had been a long night. He would ignore the bus girl and sleep. Later when he was rested, he would figure out how to get in or out of the bus.

I'd liked to have sketched him, but I had nothing except an English book with me. A class had taken me out to dinner. It was late when I boarded the right numbered bus going the wrong direction. I decided to stick with it while it made the loop. In case you haven't had the pleasure, a lot of humanity gets on and off a city bus in Seoul in an hour and a half as it bounces through parts of town you hadn't known existed, or cared.

As I watched the bus girl tug at the drunk my thoughts were less than charitable. Somebody ought to throw him off. He oughtn't to be here and he oughtn't to be so drunk. If the bus girl got him to climb the stairs again, he'd only fall, perhaps hurting someone.

I considered whether, as a younger man, I had ever permitted myself to get so drunk. I tried not to remember.

Across from me a well-dressed businessman stood, worked his way through the crowd, reached down and pulled the young man to his feet, then up the stairs. The crowd near the door gave way and he was able to lead the drunk back. He aimed the young man at the seat he had vacated.

The drunk dropped into it like a sack of rice, his head lolling at his chest.

The businessman talked to him and the young man replied, though he could not turn his head far enough to see who was speaking and who brought him to his seat. Also it was warm in the bus and I imagine it was nice to be sitting down and not leaning against doors and being bothered by the bus girl. It seemed to be a better place to sleep.

The businessman stood next to the young man. As is the custom, those seated accept the parcels and cases of those standing in front of them, but the businessman could not get the young man to hold his briefcase in his lap. Each time he dropped it the businessman would pick it up and put it back on his lap. The fourth time it fell, the businessman kept it.

They rode like that for four stops. On the fifth the businessman brought the drunk to his feet and guided him to the door. He was careful to see that the young man did not fall down the stairs again. And as the bus pulled away, he looked to see if the young man was all right.

Three stops later, the businessman got off.

The businessman and I were about the same age. I am sorry to report it never, never occurred to me to relinquish my seat to this drunken young man, even when I thought he'd hurt himself or others.

Sadly, as a foreigner it never occurred to me. Despite the kindness this country extended me, I did nothing. And I had a responsibility. I was an artist. He was a drunk. There's not a whole lot of difference.

Chapter XX

Getting Your International Show

Probably the biggest danger you face in establishing international credentials when you promote a prestigious exhibition in the country of your choice is to underestimate the intelligence and sophistication of the population. You're not going to be trading mirrors and glass stones to a dumbfounded tribe of natives intent on presenting you half a dozen wives. You will not be Ponce de León.

Though you will still find among your fellow expats. those who will raise their voice if at first their English is not understood, you'll likewise find the stoic patience of the native eroding. The word's gotten out to everyone but the most hard bitten colonialist and the my-flag-firsters that there's a global village out there and everyone's got a lifetime pass.

You need to stay with your reality. Your paintings, your catalog, and your credentials from your sellout show will establish you as a good artist from abroad. That will earn you respect, but not adoration. If you play it right, it will get an audience at the highest level. But you and your advocates will need to view your project clearly and accurately. It is one thing to present the best side of what you've got, it is another to lie.

The arts occupy a small part of the world. Wherever you travel, wherever you live, you will bump into the same people. This is particularly true in the business side of the arts, where increasingly business is done on an international scale. The impact on every practicing artist is obvious. While we gain great access to buyers in the international market, we are subject to greater accountability. Those in the arts — from whatever country — will know you or know about you, or they'll know those who know about you. It's the reverse of the technique we used before, the one that goes: you're but two people away from knowing someone. But this time it will come back to get you unless you've been honest in your dealings.

So, don't get overly colorful in describing your achievements. You did not paint the ceiling of the Sistine Chapel. You didn't even help. The Tate, the Louvre, and the Prado are not simultaneously seeking your retrospective. Yet.

Though sophistication prevails, you'll still need to overcome some provincial thinking: if my corporation supports you, an international artist, it will be neglecting those artists native to my own country.

First, it's weak logic. If I do you a favor, I have to do everybody a favor. Why? Who says you can't do one a favor and no others. But, of course, the decision to support you, the internationalist, is not a matter of granting favors. It's a matter of intelligent buying. If he sells your collection — they really do say de-access — he's got a world market to sell it to. And in time, with consistent sales, you'll establish a global fair market value for your paintings. That helps you sell and him buy.

Since art nourishes art, both in the practice of it and in the business, he won't be neglecting the native painter. His purchase of your work will stimulate the market generally. His presumption that he neglects one by buying another hangs on the misunderstanding that there is a finite money supply. As a businessman he knows better than you that money is not like the Brazilian rain forest or the California Condor, which once gone, they're gone forever. Money earns money. It's a tool — a renewable resource.

215

What the businessman may mean is that by purchasing international art he may be earning the wrath of the parochialists among his stockholders. But he needn't worry. People buy and maintain stocks because they believe in management's ability to make money, and a part of that comes from spending it wisely on stable investments.

It is said that there are between 500 and 600 art galleries in Tokyo. According to one of my student-advocates who had better reason to know than most, this is not much of an exaggeration. On my behalf, she had been to most of them, sometimes twice. I think it was on her third round that she won the attention of the most feared predator in art: the Japanese broker.

Before I introduce him, let me tell you about the species, *carnivorus tokyitis*. Even if you never intend to go to Japan, you should be attentive, for only slightly less lethal numbers survive wherever art and commerce meet. With voracious appetites they are not selective in their eating habits. They'll consume artist and buyer alike, sometimes simultaneously. In manner and dress they may appear unthreatening, even cordial, though you'll note some behavioral changes and restlessness with the onset of a full moon.

Though it is common for these creatures to lurk in obscure upper floor office-galleries, they can be found at street level in what would otherwise appear to be respectable places of business. Their bite is extremely toxic, hence their popular name: the three-step leather viper. After shaking hands, you won't get three steps away before your wallet's missing.

We were some blocks off the Ginza art district and the elevator to the fourth floor had a decided wobble, or it may have been my stomach. I carried two paintings and my dutiful translator-advocate carried the case of slides I'd been asked to assemble representing everything in my life I had ever painted with a serious intent.

I didn't have your advantages. That was more than ten years ago and for the twenty years before that I had been

diligently doing everything wrong in order, as it turned out, to save you the trouble and expense of making all my errors.

I had been bitten by the lessor varieties of this creature so many times I limped with scar tissue. I carried enough residual venom in my bloodstream to dissolve a sixteen-volt car battery. It was like the beekeeper who is warned that one more sting and he's out.

He had a wide tie and an owl face, his eyes dramatically magnified behind thick, rimless glasses. He wore a Van Dyke beard and a full head of gray hair. He looked like a Japanese version of Burl Ives, but in a better suit. His gallery walls were all but bare. The two small pieces I could see were minimalist work, apparently native. A man in a rumpled suit was being invited to leave as we came in. He did not look at us as he shambled out the door to the elevator. He was trembling. His face, livid.

Carnivore-san and I shook hands. As we were ushered into the back room, I checked my wallet. Through my translator he asked if I knew the man who had left. He said a name, but I shook my head. He said he was very famous. I said I didn't know him. He said that the man was very angry with him, and it made him sad when artists got angry with him. He was shaking his head. He seemed to be smiling.

There was a small, bronze Gaston Lachaise on a shelf just off where we were sitting. On the wall above it, a Modigliani. Across from it was a small still life, a Nicolas de Stael. An assistant brought in a large portfolio of shows, allegedly done in the gallery.

I paged through it and stopped at a printed invitation for a show of a well-known German colorist of the '60s. Carnivore-san was watching me, again, shaking his head.

He told me through my translator that the show had first been held in Tokyo and was an enormous success, but the artist was still very angry. Only his lawyers would speak to him, Carnivore-san said. It made him very sad. He said this while smiling.

He looked for a long time at each of the two paintings I brought. A second assistant came in, set up the slides, and

dimmed the lights. There were nearly seventy-five slides and after we saw them through once he had his assistant go through them again. This time he asked when each was painted taking a long time with each slide before ordering his assistant to move on to the next. He sought to determine the order in which they were painted. When I contradicted myself with a date on a landscape, he corrected me.

The third time through the slides he outlined my life with a startling accuracy. He knew more about me than my mother. He told me what I was feeling with each painting and how my life was during it and what was happening in my life to effect the work. He showed me when my divorce came and how it was for me after. He took a long time with another part of my life. It was hard for him to explain the time, my translator said, but it was something he could feel.

He read my paintings like tea leaves. He told me about the venom and where my life began to change, despite it. He told me — to the exact painting — where the better times started.

He was called to the phone. I told my friend that I knew some used car dealers I'd trust more, but that he seemed to know about painting. But my friend was listening to the argument he was having on the phone in the outer office. There was a lot of barking in Japanese, short, choppy expiations then silence. After a while, another outburst, then more silence. He returned. He was shaking his head and smiling.

"You know who is that?" He spoke to me directly and in English, of sorts. When I shook my head he told me the name of a well-known Japanese artist who lived in Mexico and South America for a time. His paintings command six figures.

"I know him," I said. "He's dead." He didn't blink.

"Very mad. His family. Estate is big problem, you know? It is because of money. Everything is because of that. Sure he's dead. So how I owe money him? You tell me that?"

Still another assistant, this time a middle-aged woman, brought in tea. It was a two-room gallery, a small office and a room. I wondered where these people could be coming from?

"I thought you didn't speak English," I said. He looked at my friend as though for translation. When it was not forthcoming, he dismissed the idea, waving it off. "You painting is good. Inside them you have feeling. That's no problem."

I was pleased and tried not to show it.

"But this is very little thing," he cautioned, showing me with his thumb and forefinger just how little he considered it. He cocked his head at me. A refracted eye loomed crazily. "It should not make you happy, so little a thing as this."

The balance of what he had to say that first day was in Japanese. He spoke directly to my friend and ordered her to take notes. Later she briefed me.

He said that I should "think famous." That if I was to become famous, it would be a product of my thinking in this way. If I were not to be burdened with fame, thinking myself famous wouldn't work. But since this thinking would make me only slightly more arrogant than most, it would harm only my relationship with other people. He told me that I should make the first of a series of full-color catalogs if I were ever to be taken seriously as an artist. If I didn't want to spend the money, I should consider making the teaching of English a career.

Then he said it will take time to broker a quality show. Tokyo, he said, was not waiting for my arrival. But time was no problem. I would use it to produce better paintings than he had so far seen.

He believed a percentage of the sale of the paintings I show will pay for the venue and himself and that I should sign a lengthy and specific contract outlining the percentages and the conditions, which would include repaying him for the work his good friend, the framer, did.

He said he would graciously accept the gift of one small — but not too small — painting. He continued by telling me that I ought not expect to make much money on the show. That, he said, would only create arguments between us which he'd be certain to win.

After that, we shook hands. It was the last time I would

see him smile. While the elevator wobbled to street level, my friend and I managed to contain our delight. Before I invited her to dinner, I checked to see if my wallet remained. Her name was Suzi.

She would work almost full-time in Tokyo and for the better part of a year toward making the catalog and show a success. Every two months or so I would return to Japan and the two of us would engage our adversary, Carnivore-san, in raging battles. These battles would extend beyond him to everyone he touched — the man who would get us to the man who controlled the venue and the committee of men behind him. I was to show in Isetan, Japan's oldest and perhaps most prestigious department store. They had a seemingly endless chain of command on the art side: museum directors, art counselors, cultural advisors, lighting and hanging experts, publicity people, sales and receptions staffs, the team in charge of posters and banners, and the twelve or fourteen guys who would sweep up.

Suzi had blistering arguments with each. Sometimes Carnivore-san would lend his support. Sometimes he teamed up against us. These arguments raged into the night. When we were thrown out by a cleaning crew, they'd continue into the alleys surrounding the giant store.

Later, after I'd delivered the paintings to the framers, they wouldn't release them. Carnivore-san wouldn't pay the framers until after the show. I wouldn't pay the framers because he was under contract to do so. And when he finally did, the money was applied to frames that hadn't been paid for the last show. It went like that.

Once in his gallery a couple of months before the show and during a lull in our war, he showed us his collection. He opened a wall half the length of his gallery. It slid on hidden rollers. That and another space he revealed when he lifted off a partition between the main and inner room together contained what I would guess to be more than 150 paintings, some crated, some boxed, some framed and stacked. I saw at least one of the following: A Dubuffet, de Stael, Vlaminck — and some other Fauve paintings I couldn't iden-

tify — Sisley, Toulouse-Lautrec, Beckman, Matisse, Braque, Picasso, Bacon, Hopper and what I took to be a Rothko. There was a Corot, a Degas, and a small Cézanne. All looked genuine. The rest were in boxes or stacked out of sight.

When I asked whether he owned these paintings and what he would do when the fire came, he nearly smiled. He closed the walls. Only the two minimalist pieces showed, the same two I'd seen months before on my first visit. Another battle ensued before I could question him further.

We were never again civil to each other, though we managed to get through our business episode by episode. He wouldn't have it any other way. On reflection, neither would I.

I think I can explain the war.

Long before I came to Tokyo, I met a Japanese businessman who wanted to see my paintings. It had been a long dry spell and when he began negotiating fiercely, I yielded, thought we'd settled, then yielded again. He paid in cash, what little he needed to come up with. He put the paintings in the trunk of his Mercedes. He handed me a business card and drove off.

It was as though he'd stolen the paintings. The card said he was in construction. They all do. But the interesting part was the message at the bottom. "Business," it said, "is war." I laughed in derision.

In Tokyo years later, under the good offices of Carnivore-san, I signed on. I got myself deployed to the front. I've stayed there ever since.

Carnivore-san, in that first meeting and when he last smiled, clearly demonstrated that he had read my paintings and liked them. That separated him from the vast majority of his fellow predators. He really did like art. He had eyes. He could understand. Yet he was right when he said that was the smallest part. He would end our year of warfare with a not overly modest profit from the sales of my paintings, mostly — as I'm sure he noted from the outset — engineered by the indefatigable Suzi.

He had read the scars on my paintings and, I expect, in my face. If I didn't go the distance, he would lose. He had it

figured I'd stay the course and make enough of a show to allow him to keep face among his colleagues, to keep the avenue open for him to present the next guy.

I am not the first to report that the Japanese are wholly dedicated international businessmen, shrewd, plotting, often lethal. It is not because they like money more than any other nationality. I suspect they like it less than many. What they do like is the fight, the all-out war to succeed. They're at it sixteen hours a day.

It's a tiny island, a crowded one. They've learned competition with their back to the sea, whichever way they face. They live that way. They like it that way.

No, they don't follow all the rules, but they strictly adhere to their own. Face or pride is paramount. You can count on it. However difficult it is to get their verbal assent to a business proposition, once reached, you'll need nothing more than a handshake. Face in Japan is power. That's what their war is about.

Carnivore-san, as fight promotor, apparently has a string of successes, all of his adversaries angry. All of them, I'll wager, a good deal smarter for the combat he brought to them.

Art is a small island too. The artists that comprise it must fight for a foothold. Among those who do, few rise to the top. They do so because they haven't been trampled to submission or finessed into abandoning the dream. They've tasted war. And they're prepared to taste it again every day for the rest of their lives. You'll see it in their paintings. This brings us to **Pigeon Factor 67:**

> Behind all the cooing and preening and love dancing, pigeons too face a Darwinian struggle for existence. Weak pigeons never have a nice day.

If you paint good and want to stay around, you better own up to a long-term fight for your right to hold a brush. *This* is your war. In it you will engage the circus system and what it produces, the contemporary claptrap that serves as art. Your war is against pomposity and sham. Your fight is

with the show-biz troopers, the smug little clique that puts museum box offices above art. Yours is a war against double talk and hype. It's against those who believe art is a linear progression to absurdity and that history is dead. You're not into fashion. You're in for the long pull. You've got to defend yourself or they'll get you. And they'll get you in the one way that hurts the most: they'll ignore you to death.

Chapter XXI

Death of a Parakeet

Back in Korea, my first meeting with Carnivore-san behind me, I was ready to begin a year's work. It was autumn and the bite of the winter ahead was in the air, the sky the color of a celedon jug.

Since my landlady, who occupied the major part of the house below, slept late, I left early for the studio. I could not take another row over who would pay for heating once the winter came. I had already learned about her accounting methods. I did not want to pay for half the heating bills she would present, particularly when I couldn't read them. When winter came I'd buy a little heater. I would be painting all day in another part of town anyway.

When I got out of the taxi at the studio, I noticed a new sign on the building face, just above my row of windows on the fourth floor. It was about a yard wide and ran half the length of the building. The raised letters were phosphorescent orange on a field of white plastic. The message, of course, was in Hangul. It was so new and so stark against the other advertising that it could have been lit by neon lights. At each of my windows hung a small American flag.

"It's for welcome home," one of my students told me

after I reached him on the phone. It hadn't been hard to track him. He had mentioned in one of my classes his strong family connection to the biggest sign company in Seoul.

I remembered him for that and the way he would shake hands when we'd meet on the street. He had a brimming smile. When I'd extend my hand, he'd step back. He'd rub his two hands together in anticipation. He'd look at his right hand, then rub it on his trousers. He'd look at it again, spit on it, and rub his hands some more. At last he'd shake my hand as if pumping water from a deep well. Smiling all over himself.

It was an invariable routine. I asked him on the phone what the sign said.

"Yes," he replied. "It's my present."

"I hadn't thought about a sign," I told him. "It's only a studio, you know, where I do my painting."

"Everybody has a sign. Yours is number one."

"But what does it say?"

"The reading part?"

"OK, the reading part."

"It say your name and the other thing. No problem." When anybody in Korea says there's no problem, you can count on one.

"Perhaps you better tell me all the sign," I said calmly. "What does it all say?"

"It say your name and world number one painter."

"It says that? In those words? World's number one painter?"

"No problem."

It took some delicacy to explain my position, that his good work, though appreciated, had to be lain aside just as soon as he could get it off the wall, that there would come a day, of course — soon, I hoped — when he could put it back. I told him about truth in advertising. When I told him it was a custom of ours, he felt much better. I told him just as soon as I became the world's best painter, I'd get on the phone to him. We'd get that sign right back up where it belongs, that it was a great sign and the flags were a fine touch. Could he come out immediately and take it down? I would be hiding in the coffee shop across the street.

After the sign had gone, it took me the better part of the morning to move the studio back to my house. I did not pause to chat to those who sought me out. And I ignored those who were rude enough to point.

I decided to buy the kerosene heater that afternoon. The sun had warmed the day considerably, so, naturally I bought the smallest they had. It would do fine. It was only a sort of back up anyway.

I made the second mistake on my way home. My landlady and I lived in Itaewon-dong, famous for outdoor shopping, discos and as a red light district servicing, among others, American GI's from the nearby base. My flat was just down a steep hill from a notorious house. Lautrec would have loved the proximity.

When the cab let me out at the top of my hill, I spotted a bird vendor with the two parakeets that would keep me company for the winter. They came with a brass cage and I mounted it above the kitchen window so they could get the warm autumnal air that moved gently through my sunny apartment.

The landlady, hearing me clomping around, knocked on the partition that blocked the stairs. She invited me down to talk about the winter's heating one last time. I was adamant against paying half. My apartment was small, her house large. Most days she entertained a pack of beefy housewives. They drank *soju* and played cards. I was the quiet, single tenant above her with two parakeets. I drank mostly beer. I offered a compromise. She threatened to leave the heater off all winter. It was *ondol* heating, the warmth rising from the floors. I knew she and the housewives couldn't do without it. I knew hers was an empty threat. And I was armed with my new heater, if it ever came to using it.

The next day winter closed in on me and my parakeets. It blew in from Mongolia, a glacial wind that put the chill factor below that of artic permafrost. The heater sputtered and roared. You could freeze ice cubes on it.

As any veteran of the Korean War can tell you, winter

226

there is a special blend of cold: cold and colder. When the wind comes with it, you can lose body parts and not care. True to the resolute tradition of the Korean people, the landlady did not ignite the heater then, or ever, that winter.

After a week, I pounded on the partition. She met me at the foot of the stairs bundled in fur. I conceded my position. Fifty percent would be OK. She told me she would be spending part of the winter away. She needed seventy-five percent. I pleaded the lives of the parakeets. She stood at seventy-five. I was outraged. She said she'd see me in the spring.

I very nearly didn't make it. I painted in long johns, track suit and overcoat. If I stood any closer to the heater, I'd be behind it, as the joke goes. The first thing that went were my toes.

You're an artist. You know about the other reality you achieve when you're immersed in a painting. You know how you can sometimes sustain that other world for hours at a stretch. I came out of such a state one snowy day with my toes barely tingling. When I took off my shoes and socks, my toes were a cobalt blue, the tips of each masterly glazed with variegated washes of phthalo and turquoise green. While it was a nice, painterly effect, it did not bode good health.

It could have been worse. They could have been black, and they could have had feeling. I did a lot of warm paintings that winter — mid-summer, blazing sun stuff. I went through most of my cadmiums and a seven ounce tube of yellow ochre.

I taught classes at night, so I had all day to myself. In the morning when the water pipes weren't frozen, I'd boil a great brass pot of water on the stove while I waited beneath the covers. I'd take my bath in a round, plastic tub. It took some experimenting, but if you sat in near boiling water like a Buddha, you could thaw your lower extremities while the steam would permit you to maintain enough feeling in your arms and face to allow you to shave.

I used the same tub on wash day. With bleeding knuckles I'd hang out shirts and socks and underwear until they became little frozen sculptures. Then I'd stack them in the

corner near the heater. Sometimes it was fun to break away from painting just to watch the clothes sag.

The parakeets, surprisingly, faired the winter better. The lucky one died early, which was a great bonus. At times Emmett and I envied his brother's apparently painless departure.

Emmett, as it turned out, could have taken on the landlady and a platoon of those GIs. He was nothing if he wasn't stoic. Each morning I'd expect to find that he had followed his brother. I had rigged his cage with a small light bulb for warmth. At night I'd wrap a piece of bedsheet around the cage and tuck it in. I couldn't tell whether it helped or not. He remained uncomplaining.

As I'd remove his shroud in the morning, I'd expect to find him feet up on the floor of the cage. Instead, there he'd be, gripping his perch, staring out at me with those hollow eyes, his little knees a-tremble. He looked like the survivor of a death camp.

He lived between the stove and the refrigerator. At night from my bed, if I lay sideways, I could see his illuminated cage. The shadow which played across the sheet was a much enlarged version of himself. On cold nights his brass cage would tremble. The shadow he cast looked like a raven with palsy. But he held on. Unlike his brother, he'd face down the cold and make it to spring. Emmett, it seems, was a teacher. As an artist, I had learned from him.

Chapter XXII

The Better Times

From the coffee shop window I could see the Isetan building just up the street, some tiny figures working on the roof. I was early, waiting for Suzi. Together I'd hoped we could close the annals of a year's warfare when we went to supervise the hanging of the exhibition. There'd be more pitched battles with Carnivore-san.

Ahead of us were sales and after-sales, with subways and trains and meetings and dinners and talk, endless talk, nearly all of it in Japanese.

The money coming in was blood in the water with the sharks closing in. There would be contract arguments over performance, who didn't do what and why. With more money than anyone expected, everyone reassessed his worth. There would be teeth-grinding dinners, and presents and thank-yous, and afterward a lot of bowing in the street, retreating ass-end first.

There would be those who were slighted or said they were.

But we could also tally up the accomplishments:

• A 128-page, full-color catalog.

- In it was a written introduction by Princess Masako, Emporor Hirohito's eldest daughter.
- It would carry a preface by the director of Christie's Contemporary Art.
- There were full-color posters of four of the paintings, sold country-wide.
- Feature stories and color photos in several leading magazines. Interview by NHK television and Japan's gigantic daily, the *Yomiuri Shimbum*. A leading fashion magazine carried eight pages of debate between me and Okomoto Taro, Japan's most visible sculptor celebrity.
- The nation-wide publicity carried my partiality for the *kimono,* the traditional dress for women. The reception was attended by unprecented numbers, most women arriving in their delicately colored native silks.
- The show, endorsed by the Korean, Mexican and American embassies, opened a permanent market in Japan for my work.

Waiting for Suzi, I idly watched the workmen on the roof of the Isetan building while I drank my coffee. They were wrestling with something. Was someone trying to jump, Carnivore-san's final gesture?

It was a roll held by ropes. As it was lowered, it became a red and yellow banner. It unfurled for six stories. It had the first letters of my given names, the balance, presumably in Japanese. The English of it was a six-story message, the name of my show: THE BETTER TIMES.

It could have been a happy accident that I was there to see my own banner unfurl. Much more likely, it was why Suzi was late.

You may not have thought of this. Maybe nobody has. If so, maybe I'm stuck with discovering one of those overlooked gems of understanding that will illuminate and enlighten a new age. Afterwards, my name will be linked to the idea as is Einstein's to $E=Mc^2$. I haven't done his kind of research, you understand, but accidents happen, right? And since I still owe you a little on this book you bought, I

thought I'd get the news out to you first, let you think on it, spread it around some, give it a chance to take hold.

I won't keep you in suspense any longer. Sit down. Let me give you the principle I thought up. It's this: The world is also divided between those who can count money and those who can't.

What do you think?

All right, it takes some explaining. If it were so simple, anyone could have offered it. Deep thinking is like that.

As you know I've done a lot of living around, East and West. I have looked at how people live. I have noticed that Western folks don't know how to count money while Eastern folks do.

Hand a packet of bills to anyone in Asia. They'll take it, shake it out like a wet brush, fold it over the knuckles of two fingers of their left hand, and feed it out with the thumb. They'll tick off the count with their right hand, the bills fanning toward them. The flourish is optional. It comes with the last bill. A snap of the finger on the pack. Flutter. Flutter. Bang. Like that. Nimble Asians can count, maybe, 300 bills a minute, including the snap.

Now, hand the same pack of 300 bills to a Westerner. He's going to dish them out like cards. He's going to need somewhere to put them as he counts. He'll need a table. He'll need to sit down. Some of the bills are going to stick together and he'll have to fuss with them, get them sorted out, then add the number to what he's got in the stack on the table and continue: twenty-one, twenty-two, twenty-three . . . like that.

If he's lucky and doesn't drop a bill, lose his place or the count, he'll finish up with the 300 well before lunch. Provided he starts early and doesn't take a coffee break.

No one in the Western world has ever mastered this Asian way of counting. Except one old lady in Newark, but it's believed she doctored her birth certificate as a child coming over on the boat from Foochow. What, you may well ask, does this piece of esotaria have to do with you?

There are two reasons why I brought it up. I'll tell you the first now. If you have chosen to live in a country in the

231

East, do not — repeat — do not count money where anyone can see you. You'll be the funniest thing since laughing gas. You'll bring tears to those watching you. They'll ask you to do it for their friends. They'll hold their stomachs and roll on the floor. Here's how I know this.

Three days after the exhibition and about a thirty minute bullet train out of Tokyo, I was presented a new, crushed leather flight bag by a man who owned a fairly sizeable chunk of Tokyo. We were in his country estate. It was country because he had bought out and ploughed under the town that once occupied it. There was nothing visible from the house to the distant hills that surround it. You could have been in the Blue Ridge foothills of Virginia.

What made the bag especially important was that it was filled with American money, in fifties. What made it awkward was that he asked me to count it to make sure it was right. I declined. He insisted.

The bag represented the asking price for fifteen paintings which he had bought at the opening. We had just finished an elegant lunch. He sat me down in the living room facing a large bowed window with a spectacular view of the hills. He poured me brandy and told me to help myself with the bottle.

He returned to the music room where he would resume his conversation in Japanese with Suzi and his wife.

I unzipped the case, took out a stack of bills and began to count by twos, which I figured was a clever stroke: one hundred, two hundred, three hundred . . . I took a sip of brandy, looked around . . . four hundred, five hundred . . . I noticed that he'd hung two paintings above the fireplace — one was mine, the other, a Corot. It was true. By squinting I could read the name. A Corot! I took another sip of brandy and started over. One hundred, two hundred . . . a Rouseau! There was a Rouseau and near it another one of mine . . . one hundred, two hundred . . . It went like that for fifteen minutes. Once I got up and confirmed a Monet. It was a damned Monet! I returned to the table. Filled my glass, tipped it up and faced the stacks I'd arranged. Of course, I'd forgotten where I was.

I managed to jam all the money back in the bag and zip it up, moments before they joined me. He asked me if I found the sum correct. I was tipping the brandy sniffer. "Mmm," I said into the glass, the brandy burning my nose. "It's exactly . . . as it should be." By then I had forgotten the amount I was to confirm.

Apparently that was clear. He unzipped the case and brought out the stacks for me to count again. He told me how I mustn't be intimidated. When handed money, count it. There's no insult there. Mistakes happen, he said.

I didn't think about it until later, but he undoubtedly had seen me counting when I had been too engrossed to notice. I started counting again . . .

It was the highlight of the afternoon. I could have sold tickets. I'd wait out the laughter. But as soon as I began, it would erupt again. Finally, with tears in her eyes, Suzi took charge.

While she fanned through the count, my host invited me outside to admire his collection of vintage Rolls Royces. I followed him through the house. He would stop to explain a painting, a print, then carry on. As he passed his mammoth parrot, he stroked the side of its head and moved on. I was doing likewise just as he called back the news that the parrot only tolerated its owner. Even his wife couldn't approach it, he said. By then I was trying to tear my finger from its beak. The parrot was working at it like a dead mouse. I got back most of it.

By the time we had reached the front door — he was chatting about a missed opportunity at a recent Southeby sale of French furniture — I had my finger wrapped in a handkerchief and my hand stuffed in my pants pocket. I hoped it wouldn't bleed through my trousers.

It was hard to concentrate beyond my throbbing finger, but as I remember, he had four or five of the cars all aglitter with restored chrome and new paint. By the time we had inspected them and had taken a walking tour of his estate, the bleeding was staunched. Later, I was able to clean it up. I don't think anyone noticed.

I still carry a tiny scar. It serves to remind me that we

occupy, this powerful money man and I, two distinctly separate environments. Each of us controls terrain alien to the other. Though we share painting as an interest and as a commodity, we view life through separate windows. And so it shall always be, the artist and the money man. **Pigeon Factor 68:**

> No one has been able to successfully crossbreed a pigeon with a turkey buzzard. Partly because there doesn't seem to be an overwhelming need.

I've also kept the crushed leather bag. Though I've come some distance from that day, I hang on to it to remind me of the part money *does* play in my life as an artist, as it does or will in yours. Money represents the second thing I wanted to tell you about the counting business.

Whether you count it fast or slow, you better learn to have enough around to count at all. You've got an obligation to your talent and to those who appreciate it. It takes money to keep you at what you do best. Though money — and making it — is your second responsibility, without it art will not be your first.

What I've been trying to tell you is that there is a business side to what you're doing, if only because that's what trading money for goods is all about. Since money is a common denominator, putting a price tag on your paintings seems to be a better way than most to assign a value which people can understand. Your landscape may also be worth six boxcars of Idaho potatoes, but the trade would be a little clumsy.

If you like to eat, you'll be wanting to cash in from time to time. It will take some energy that you'd much rather apply to your art. I don't blame you. But if you know, as you should by now, that nobody's going to rescue you from your poverty, that Hollywood's over, it should make this business of raising money, if not easier, at least more understandable.

Realizing this will help you quit feeling sorry for yourself. It will help you to chase the starving artist myth out of your garret. It will help you get on with life as it is.

Art isn't easy. Neither is business. Having an aptitude for one often doesn't leave a lot left over for the other. You're going to have to work around it.

Take the pigeon.

Go to a park. Bring a sack of breadcrumbs. Scatter them at your feet. Don't save them. Stale bread doesn't cost anything. Dump it out. When the pigeons come, let them eat. Don't move. Let them eat for a while. Note that they are very good at eating. Now, stomp your foot. Notice that the birds fly away. See how they all get off the ground even though they'd rather stay. What you particularly want to notice is that while they don't do this neatly, they manage to get airborne. That with a great and determined flailing of ragged wings, even pigeons fly. When they have to.

Q. That's it? What you got written down here. That's the whole of it?

A. You want more?

Q. You're tellin' this guy, this artist you're writing this for, that his way out of poverty is by pushing art like used cars.

A. I've known some dealers who've made the transition. I'm saying he needs to look at himself and his prospects for being "saved" by some dealer.

As I see it, he's got a choice, this artist. Be his own best friend and dealer or go pack groceries.

Q. You can't make an artist a salesman. He's not a peddler. God didn't give him suede shoes.

A. Let me tell you about a guy who got written up in the international press. A graduate of Pratt Institute. First mistake. He sets himself up in a cold-water loft in Brooklyn thirteen years ago. Wants to be in the scene. Second and third mistakes. Says he works every day and stacks 'em in the corner. Hasn't had a hot shower in thirteen years. Eats off a hot plate. He's waiting for the miracle, right? Even with the feature story and photo, it won't happen. He went through the crazy eighties and it didn't happen.

Q. But he didn't sell out.

A. If there's any virtue in not being invited. Look. I'm on his side. I want to help this guy. You know what he's doing?

Q. You're the writer.

A. For thirteen years he's been putting together press kits and mailing them to galleries. Thirteen years. High point is he got his loft on a shopping tour organized by a New York gallery owner.

Q. So what's your point?

A. This guy's being taken. He and his picturesque studio are being used to sell the dealer's stable of artists. That's my point. He's not selling out. He's being sold. But let's get off him. He's not alone. How many others are sitting around waiting for a dealer to make everything right? To make years of penury an old story you can tell your grandchildren from the porch swing looking out over your fifty acres, Lassie at your feet?

Q. It happens. There's money out there. Some galleries are tracking it. There are shows. Artists are promoted. Some get rich.

A. Some get hit by lightning. I'd like to see the artist improve his odds. Since a lot of people still believe that a gallery is where you buy art, go choose one. Don't send press kits. The *press* doesn't read press kits. Show the gallery how to earn money from your paintings. And watch, the dealer will get behind success.

Q. You're talkin' sensitivities here. What artists do is paint good, maybe. You want them in a shiny suit and pounding on boardroom doors.

A. This mixing is what worries you. Art and business. Separate it, right? The only separation I see is the artist from the money he deserves. Listen: I heard about this group of artists, sawed up a piano. In pieces, you know? Sent the pieces around the world to other artists. A guy in Nairobi gets, maybe, a piano leg. He can paint it any way he likes. Sends it back. All the pieces are assembled. You have an international piano. Whatever. Somebody plays it, maybe. I don't know. But the point is these guys make a statement right up front. They say they don't want business to sponsor it. Up front they say they want this to be pure art.

What the hell is pure art? Where in art history has an artist not been paid? Or tried to be? It hurt Michaelangelo?

236

Broke the back of Titian? Crippled Rembrandt? They traded talent for pay, whether from church, government or royalty. Pure? Art needs business. Business needs art. Let's let business drape our cars in company logos, buy our brushes, endorse our skivvies. Is that going to change what we do? Do you need to be hungry to paint good? You're in business right?

Q. So?

A. You told me once. What? You assemble computers?

Q. Sell 'em. You also don't read so good.

A. Then you know what I'm talking about.

Q. We don't have the guy who designs computers go sell 'em. We got guys like me for that.

A. But if guys like you couldn't sell computers, guess who gets to peddle them? That's where artists are. They're going to be businessmen by default. They got to take control. Manage themselves. Promote themselves. Sell — or make damn sure somebody sells — their work. You said computer salesman?

Q. Is this a crime?

A. What are you doing reading this thing?

Q. You got to have credentials? I read a lot. Sometimes I spend my time unwisely. Anyway, I told you. I'm an artist. I sell computers on account of my family has taken to eating.

A. You working at it? The art, I mean.

Q. Sure, you know, when I have time. I work forty hours. Weekends, wife wants to get out. Kids want to do something. So I don't paint all that much right now, but when the kids are grown, I'll have more time.

A. When they're grown you'll need to put them through college.

Q. Maybe. But I just might take a year off. You know, chuck it. Like a Sabbatical. I've been with the company for a while. They'll hold my job.

A. Take a year?

Q. Go somewhere, you know? Brushes, paints, some old clothes and head out. Put everything on hold. I'm gone. Florence, Tahiti, Cornwall, who knows?

A. Then what?

Q. Paint. I mean straight painting. Every day. Like in school. You know how it is: you get up in the morning, you're thinking of the work ahead, when you go to bed, you got the next day and what you're going to do with it. Nothing else. Just painting, twelve, fifteen hours a day.

A. After the year? What happens then?

Q. Come back with my stack of paintings. Some good ones, some great ones. Who knows? Maybe I'll fail. Maybe I'm not the painter I think I am. It will be a kind of test. But I owe it to myself.

A. And if you fail, you'll go back to computers?

Q. I've been good to my company. They need me. Maybe I'll make a proposal. They do some things for the arts. I'm their own guy. Maybe I'll get it to sponsor me, or buy my paintings, or use me for advertising. Whatever.

A. You'll wait for that?

Q. No, I'll get my year in whether anybody pays for it or not. I'm just sayin' sponsorship is a good idea.

A. A great idea. Maybe they'll send your wife and kids with you. Air fare and a country house. Meals. Car rental. Servant allowance. Models flown in.

Q. All right. But the year stands. I'm going to get that year in.

A. When?

Q. In time. Soon. I've talked to the wife. She doesn't think I'm serious. But I can make her understand. She knows I was a pretty fair painter in college. Oils. Big stuff. Impasto. Deep, heavy colors. A Rouault look to them. Gutsy. Got two up at home. You walk in, they're all over you.

A. Stay home.

Q. What do you mean?

A. Don't tell your wife your idea. Don't get a sponsor. Stay home.

Q. Why?

A. It took Rouault a lifetime to paint like Rouault. He didn't take a year off, a leave of absence. He took a life off. If

238

you don't take a life off, or what you got left of it, this "testing," as you say, is going to be all over your paintings as thick as that Impasto.

Q. That's so?

A. That's so. If you're a painter you don't live life as a computer salesman. You live it as a painter every day for as many days as you're given. You start now. If you have to do it part time, you do it beginning now and you do it until you can do it full time and then you do it until you're dead. That's how art works. Being an artist is living as one. A year's paintings is nothing. It's less than nothing.

Q. I might surprise you.

A. You won't. I guarantee you. You'll come back and put a year's paintings under the bed, where they belong. They haven't touched life. There's nothing behind the brush. It's a year's vacation. An extension of college, student work. Great unripe ideas untainted by reality. Reality *is* struggle. It's triumph. It's despair. Go see a Van Gogh. Anything he's done. You'll learn how life is painted. All of it.

Q. So you say, if you can't do it all, not painting is better than painting.

A. Sometimes a lot better.

Q. You're saying I'm finished before I've begun?

A. No, I'm saying you've begun only when you've finished. When you've finished talking about what you're going to do. When you've finished thinking about taking a year off. When you've finished believing that someone will pay your way. If you want to be a painter, that's where you begin. When you're finished with the world as it is and you're ready to paint it as you want it to be.

Q. Big speech, right?

A. Sorry.

Q. You're going to look pretty stupid when I get to be a famous artist my way.

A. It won't be the first time.

239

Epilogue

In certain Bulgarian farming villages broad-beamed women are still lovingly measured in axe handles. The affectionate way these women are described by some of the farmers, roughly translated from the somewhat obscure village dialect, goes this way:

If she sat on a pigeon, you wouldn't hear its cries for help.

Outside Plovdiv, for example, there's said to be a three pigeon woman. She's the youngest daughter of a prosperous potato farmer. Some of the men speak of her with husky voices and tears in their eyes.

While this is not a Pigeon Factor in the strict sense of the term, it does demonstrate the depth of my research. It also serves to illustrate two points. We'll call them demi-factors.

The three pigeons who gave their lives to measure the beauty of the potato farmer's daughter will, like some artists, live beyond their years by the record they leave behind.

If they did not do this willingly, it serves to illustrate the second demi-factor, which is, by far, the more important lesson — the depths to which pigeons can be exploited if they don't get off the mark.

240

About the Author

W. JOE INNIS was born in Chicago, Illinois, in 1937. He spent his early years there and in Canada before the family moved to Southern California. He earned his B.A. in Journalism at San Diego State University and, after some years in France, returned to the West Coast as a political writer and editor for several newspapers. In 1969 he moved to Mexico were he earned his Master's Degree in Fine Art from Instituto Allende. Almost twenty years later he would return to the school after being appointed professor of advanced painting.

Recently Innis returned to the U.S. after two years in Turkey and Cyprus. In each of those years he was to stage successful exhibitions in Istanbul. The last, "Impressions, Turkey," was held in Topkapi Palace. It was sponsored by Mobil Oil Corporation and several Turkish owned multinational companies.

In Cyprus he completed work on *How To Become a Famous Artist*. He has lived and worked in many countries throughout the world as a teacher, writer, painter and sculptor, exhibiting in Tokyo, Seoul, Buenos Aires, Istanbul, and New York.

Innis, living with his wife Suzie and daughter Sunny, has established a studio in a nearly century-old house he owns in the downtown historical district of San Antonio, Texas.